GUWEIZ

THE ART OF GU ZHENG WEI

3dtotalPublishing

Website: www.3dtotal.com
Correspondence: publishing@3dtotal.com

Guweiz: The Art of Gu Zheng Wei © 2020
3dtotal Publishing. All rights reserved. No
part of this book can be reproduced in any
form or by any means, without the prior
written consent of the publisher.

First published in the United Kingdom,
2020, by 3dtotal Publishing.

Address: 3dtotal.com Ltd,
29 Foregate Street, Worcester,
WR1 1DS, United Kingdom.

Hard cover ISBN: 978-1-912843-16-9
Printing and binding: Everbest Printing
(China) www.everbest.com

Visit www.3dtotalpublishing.com for a
complete list of available book titles.

Managing Director: Tom Greenway
Studio Manager: Simon Morse
Assistant Manager: Melanie Robinson
Lead Designer: Fiona Tarbet
Publishing Manager: Jenny Fox-Proverbs
Editorial Project Manager: Sophie Symes

ONE TREE PLANTED
FOR EVERY BOOK SOLD

OUR PLEDGE

From 2020, 3dtotal Publishing has pledged to
plant one tree for every book sold by partnering
with and donating the appropriate amounts to
re-foresting charities. This is one of the first
steps in our ambition to become a carbon neutral
company with carbon neutral publications, giving
our customers the knowledge that by buying
from 3dtotal Publishing, we are working together
to balance the environmental damage caused by
the publishing, shipping, and retail industries.

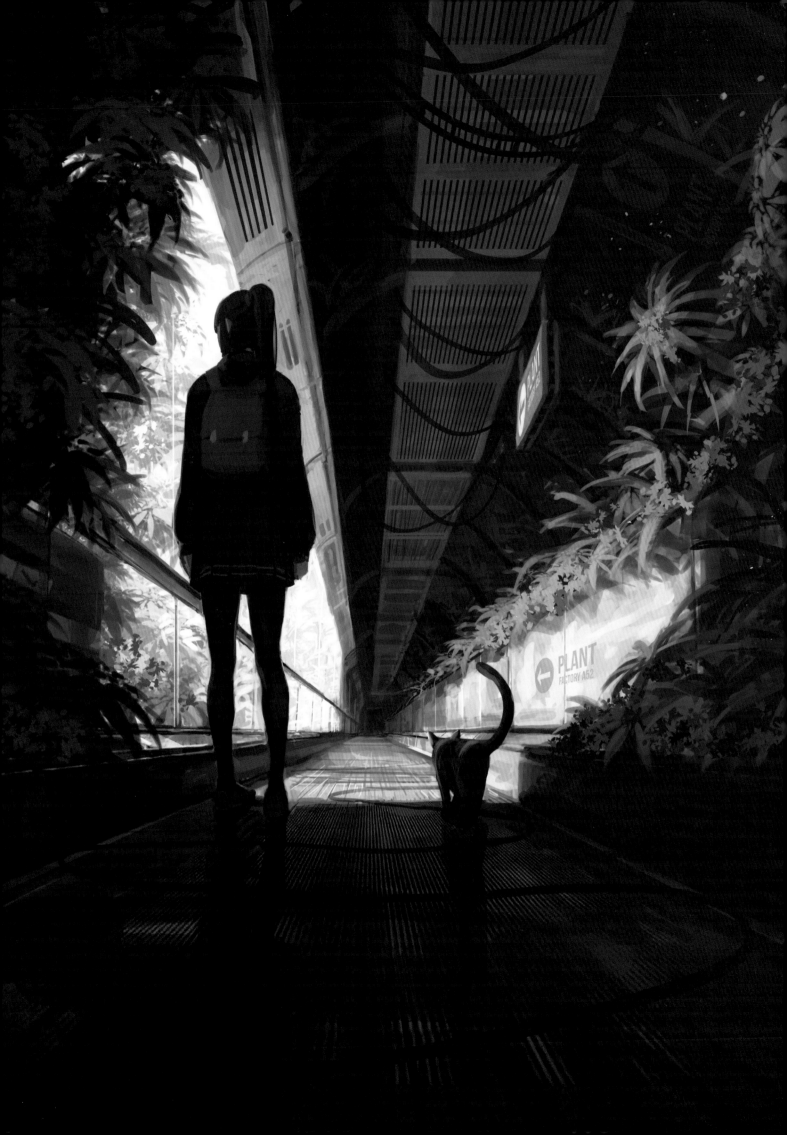

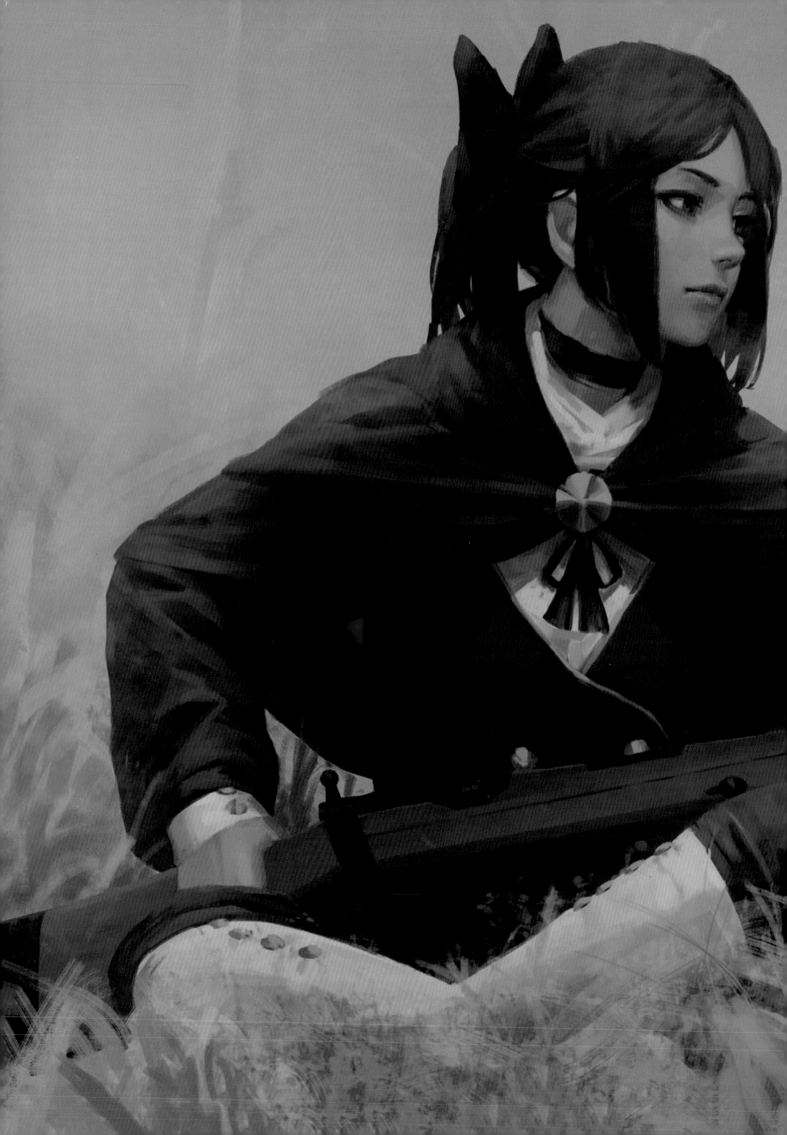

contents

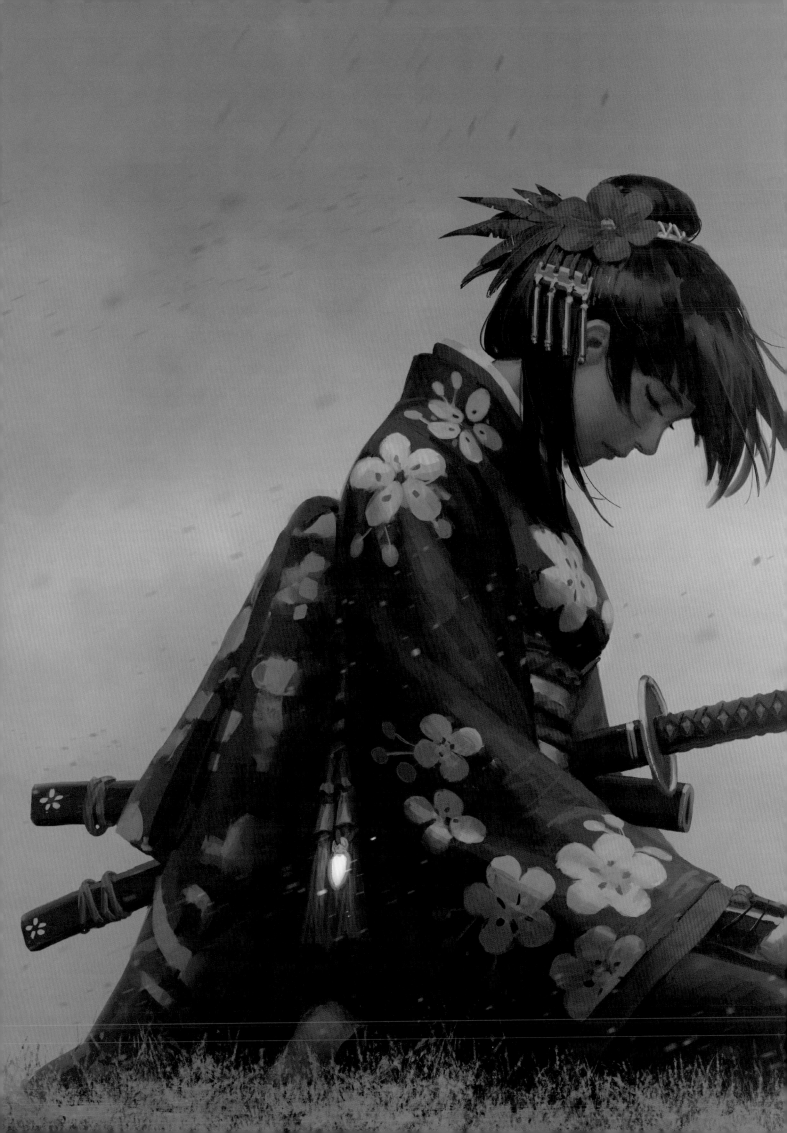

introduction

I have reached a point in my artistic career where I feel that there are a few things I have learned along the way that are worth sharing with others. When posting my work online, I like to post the art on its own, to allow it to speak for itself. However, I believe that connecting with your audience is at the core of being an artist, and part of my desire to explore my limits is fueled by the ability to show it to others.

For me, a love of creating new artwork and pushing myself further originates from deep within myself, but being able to share this process and celebrate achievements along the way is also extremely valuable. I see it as a catalyst of sorts; it amplifies the enjoyment I get out of the creation process greatly. We all have hobbies we keep to ourselves most of the time; but if you love something you have created, do you not feel a desire to share the product of this intense feeling with other people?

I am very grateful for the number of people who follow my progress, waiting to see what I come up with next. *Guweiz: The Art of Gu Zheng Wei* provides a unique opportunity to answer all the questions I receive, and to reveal my deepest thoughts about my work. I see this book as an offering of substance and value for my supportive audience, as well as a tangible milestone in my creative adventure. Through this book, I chart my journey and the experiences that have helped shape my work into what it is today. I provide background into why I do what I do, along with a few entertaining anecdotes, and reflections on my daily habits and practices. I hope to provide practical inspiration, by covering topics such as how I deal with artist's block, my approach to "fixing" a drawing, as well as how I start a new piece.

My creative career is something I put a lot of energy and effort into. I spend numerous hours by myself working on a digital canvas, without saying a single word. The enjoyment I get from those hours of problem-solving and putting the image together is immense, but at the end of all that effort, the most rewarding part is just being able to share it with my fans.

Art development is an ongoing process, so this book provides a good reflection of my progress thus far and where I plan to go in the future. I hope you enjoy my honest work; the great pieces, the breakthrough works, the clumsy attempts to try something new, the pieces with silly mistakes... they are all very precious to me and I hope they will be to you, too.

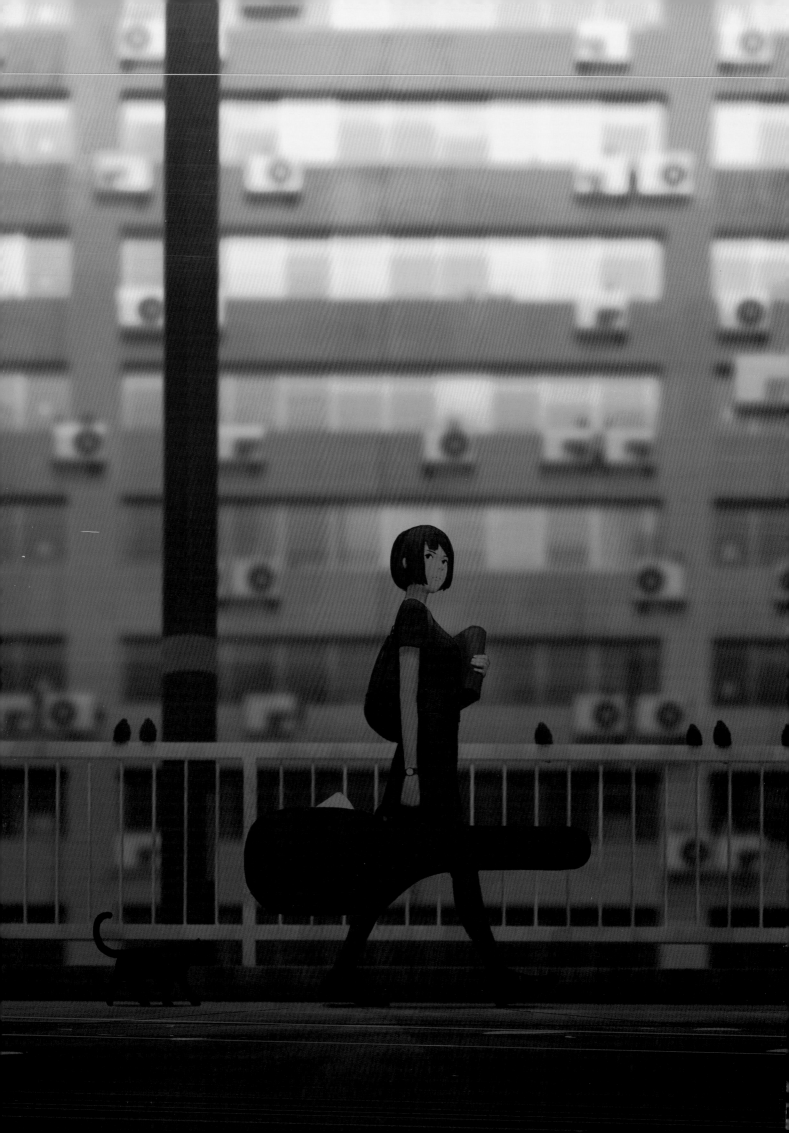

- ARTISTIC JOURNEY -

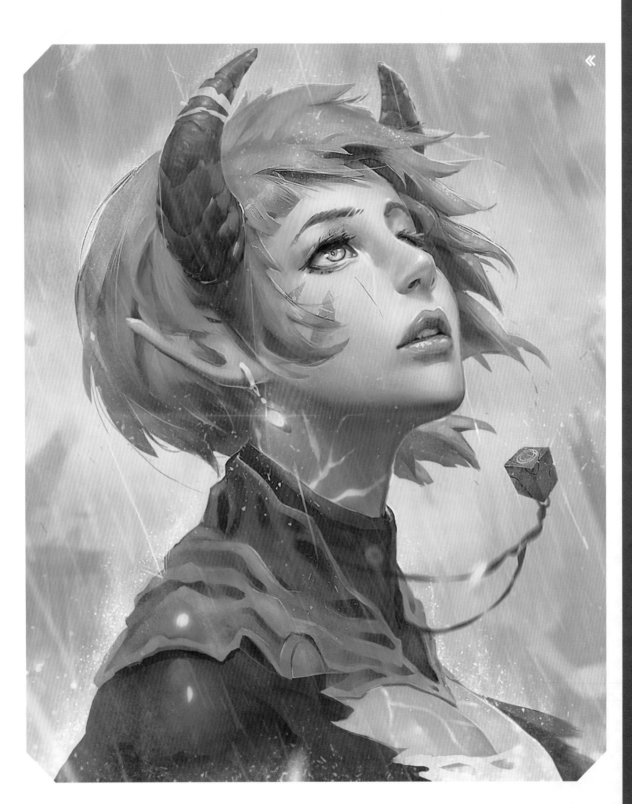

HORNED

A blue-haired demon looks longingly towards the skies. My early pieces didn't make much functional sense, but instead concentrated on capturing the fantasy "look." This was a big breakout piece for me.

ESCAPE

Created in early 2016, this piece was produced at a time when I began to experiment with more concept-driven visuals and effects.

early days

As a child, I hated mandatory art classes in school and if I did draw, it would almost always just be stickmen or adding silly faces to pictures in my school textbooks. When I became too old to doodle stickmen, I stopped drawing entirely.

The first time I was impressed by illustrations was in a well-made ancient history encyclopedia. I can remember being amazed at how beautifully the illustrations were drawn. In that moment, I felt respect for art as something that could be impressive and enjoyable, and not just exclusive to museums.

A huge artistic influence on me was, and still is, video games. From a young age, video games offered me more than just a fun way to pass time; they told incredible stories, brought out emotions, and taught me valuable life lessons. I would recommend the medium to anyone; there's so much that can be found in them, so there's something for everyone. The way in which many elements come together in a game – the narrative, visuals, and audio – is an art in itself. With the huge variety of genres and formats out there, the art form is almost limitless, a strength that many other forms of media lack.

It was really exciting as a kid to imagine making a game like those I'd played, being able to add whatever characters and events I liked, and to present it to an audience in any way I wanted. The experience opened my eyes to the creative world. Without these early impressions, I don't think I would necessarily have found my current creative path.

I began to take art more seriously when I was about seventeen. One day, I saw an easy-to-follow tutorial about drawing a portrait. I felt an immediate connection with drawing. Even though I was simply following a tutorial, producing a drawing felt magical. I continued to work with pencil and paper for the next six months, copying images of interesting characters I came across on the internet.

Somewhere near the end of 2013, I bought a small Wacom tablet and started playing around with the digital medium. It was so much fun to finally be able to work with colors, having no way to color my pencil drawings before. However, at that point in time, drawing was still very much a hobby, as I was still in full-time education.

Singapore has a conscription system, much like Korea and Taiwan, so right after completing my secondary education, I enlisted to serve for two years as a full-time soldier. I found Singapore's conscription system to be a double-edged sword. On the one hand, it took up time and physical energy, but being much less mentally rigorous than school, it left me with a lot of brain power to spend on drawing at the weekend. It was during that period of time where I progressed the most, going from extremely amateurish drawings to something that at least started to resemble a professional piece of work.

> FROM A YOUNG AGE, VIDEO GAMES OFFERED ME MORE THAN JUST A FUN WAY TO PASS TIME; THEY TOLD INCREDIBLE STORIES, BROUGHT OUT EMOTIONS, AND TAUGHT ME VALUABLE LIFE LESSONS

3 July 2013 | One of my very first serious attempts at drawing, at age seventeen. In retrospect it looks like a seven-year-old drew it, but if anything, it goes to show there's always hope!

14 December 2013 | For my birthday that year I received a small Wacom Intuos, and immediately abandoned my pencils in favour of my shiny new toy. This was the first piece I created on it. I remember being super excited about it when I'd finished because, finally, coloring didn't involve hours scratching at paper with pencils. It was at this point that I became completely enamored with digital art.

22 September 2013 | This piece was created about two months after the piece I drew on 3 July, by which time I had become slightly more ambitious. It's still a very generic "anime girl" piece. But I dug out some old coloring pencils to try to add another level to the design.

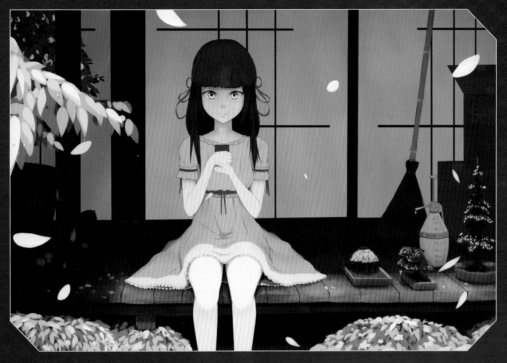

22 February 2014 |
I made this piece just after enlisting as a recruit. I had slightly more control over the digital tools and started messing around with creating full scenes and environments. However, I still needed practice to be able to effectively draw characters, hence the simple frontal depiction of the character.

25 JULY 2014

25 July 2014 | I had become a bit more confident, perhaps misguidedly, in drawing characters in different poses. As you can see, despite my best intentions, I didn't have much control over anatomy or 3D space. Some of the shadow shapes were drawn directly from reference without much thought. However, I did graduate from flat cel shading to colouring in a more professional rendering format.

27 March 2015 | At this point I had become a little bit better at managing color and tone. However, the skill of drawing faces was still very much in development

27 MARCH 2015

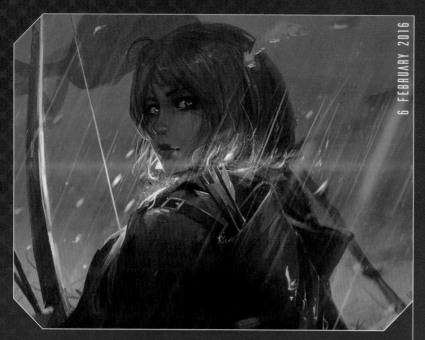

12 February 2016 | I began to experiment with new color schemes and wilder themes. Looking back, this piece marks the start of my journey into drawing fantasy characters and settings. Here, I am still having trouble with managing volumes, but the concept behind this piece really stuck with me.

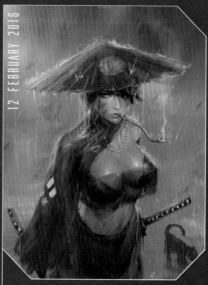

6 February 2016 | At this stage in my artistic development, I started to work with mysterious atmospheres, using moody rain to add texture. Look closely and you will notice that I still had plenty of work to do in terms of my abilities to accurately depict volume and perspective. But, overall, I am still happy with this piece, especially how I utilized lighting effectively and implemented blur and depth-of-field tricks.

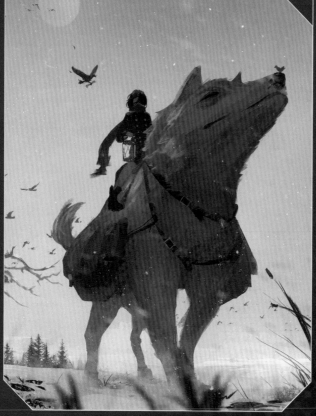

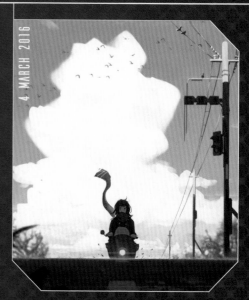

25 February 2016 - 4 March 2016 | Something happened in this period of time that made me hungry for exploration. I put together my first "full-body character in an environment" piece, followed closely by an urban-themed piece of the same format.

26 March 2016 | Previous works piqued my interest in creating scenes where the complexity was lower and the feeling was calmer. However, I still enjoyed drawing fantasy themes, and had a desire to draw portraits, culminating in pieces like this.

Here, I used a photo reference for the pose, but I decided to draw everything else on my own. It's a good example of why it's helpful to use references carefully. By using a photo to check, you can make corrections easily, especially if you are less experienced in perspective and volume. This does initially restrict you to the framing of the reference image, but it's a good starting point before you gain the skill to take only what you need from the reference and create your own original scene.

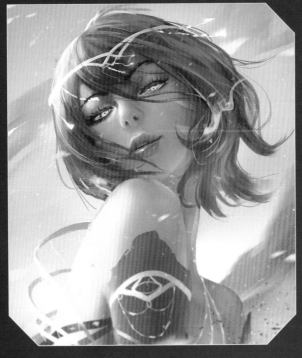

TODAY

PERPETUAL DEVELOPMENT

Today | This is not the end of my artistic development. I work hard to continuously improve, and always make time for personal projects.

There's still a very long way to go in honing my skills, but that development is precisely the part that I find most amazing and enjoyable. The idea that I could get better with practice, and produce works I can't even imagine at the moment, is a very attractive one, and it makes up a huge portion of what drives me to keep drawing.

With every fresh drawing, I learn something new. Without that perpetual movement, I wouldn't be where I am now.

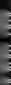

6 April 2016 | To develop an understanding of how to create a unique scene, I practiced by adding my characters into simpler scenes without any distortion of the lens or difficult angles. Two months after creating the initial piece, I returned to a concept with slightly better skills in achieving dimensional volume. I created the alleyway and character's pose from imagination, only taking reference from images of an alleyway from other angles, in order to work my imagination more. From this point, I have continued to learn and adapt my workflow to solve problems that arise as I draw.

self-learning and the leap of faith

I don't have any formal art education, but I'm hesitant to claim that I am self-taught because the term always sounds incorrect to me. If you don't know what you're doing, you can't teach anyone, yourself included. I prefer the term "self-learning."

The process is about guesswork, observation, trial and error, and repeat. You can never quite be sure if something is correct the way you think it is. It can take me hundreds, even thousands, of attempts to solidify and make a concept my own. I can look at a reference image, think I understand it, and then draw it and find I've made fifty mistakes. A lot of mileage is involved in this type of self-learning and even some experienced artists who have completed a formal education say most of the learning is still achieved on your own, even if mentors are available to give direction.

In the current digital age, if you have the motivation and desire, self-learning your way into a career is without question absolutely possible. The sheer volume of accessible, high-quality resources and references that can be found in books and via the internet are more than enough to get you started.

Yet, while we are lucky to live in the age of the internet, the internet can't necessarily motivate or move you to put in the hard work and hours. You have to find that strength on your own. Every artist develops in different ways; some do well starting out with a structured education, while others find more enjoyment and success in simply following where their passion takes them and learn to manage on their own.

When I began university to study Pharmacy in mid-2016, I was already receiving illustration jobs for game companies and being paid decent industry rates. Prior to this I was taking very low-cost, individual commissions, which while good experience, was financially insufficient. I juggled working professionally as an artist with my schoolwork for the first semester and ended up extremely tired, and with terrible grades. It was then that I made the decision to leave university, forfeiting my place in the school for a chance to have a career doing something I really loved.

While many of my friends went on to graduate with degrees and a guaranteed career, I chose to take a chance on myself and my art. Until that point I'd been a good student and had done well academically, so it was definitely a difficult choice to make.

Over the next three years, I spent all of my spare time outside army camps focusing on my art technique. From this melting pot of circumstances, I was luckily able to find the energy to tackle some of the big challenges that were keeping me from improving my art.

POOL
A swimmer sits quietly as the pool cat enjoys the pitter-patter of rain outside.

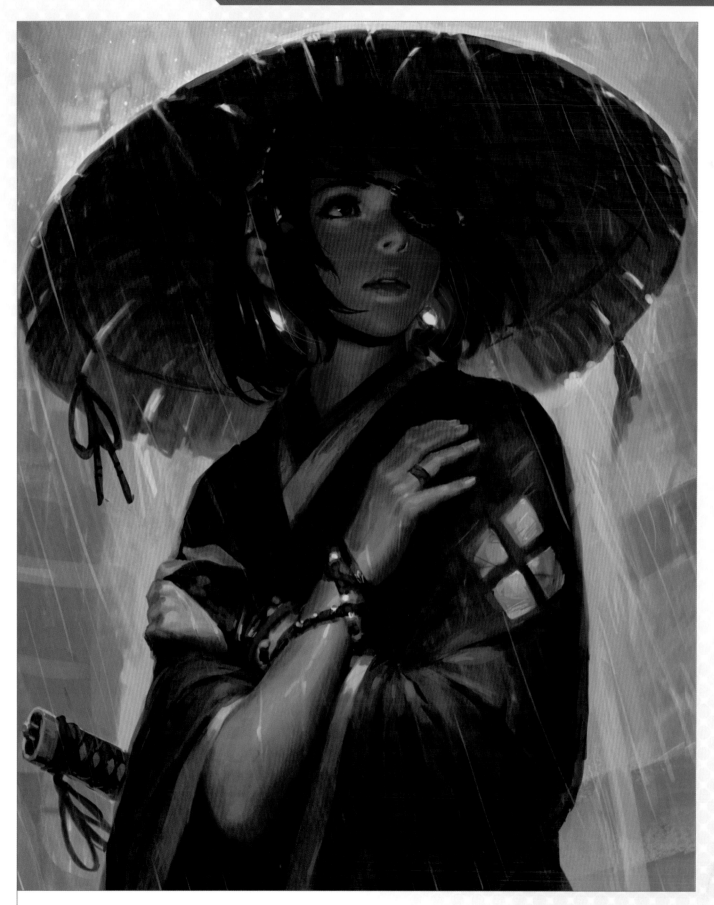

COLD

A lost girl wanders an unfamiliar part of town in the rain. Here, I focused on achieving a low-angle perspective on a character. Originally drawn a few years previous, in 2019 I revised the pose and perspective because I find it incredibly rewarding to be able to uncover and fix mistakes in older pieces.

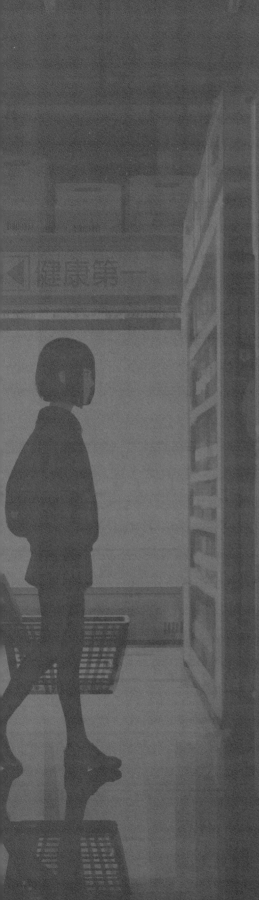

growing into an artist

Understanding how to create 3D shapes accurately on a 2D canvas, while considering sources of distortion such as perspective and light, with no prior knowledge, was extremely challenging. For example, successfully drawing a portrait involves understanding the form of a head, and transferring it onto paper or screen in a way that remains accurate to your own vision.

I needed to learn the "fundamentals" of art, a word commonly used to describe the set of basic foundational skills, including, among others, anatomy, light, and perspective. A set of rules hardly comes across as exciting, so as a beginner I was tempted to skip it in favor of the more interesting parts of drawing. However, I found the fundamentals to be quite different to what I had expected.

Some readers are probably hoping for a secret practice regiment that quickly covers the fundamentals so you can move on to more fun stuff, but I have a confession ... fundamentals are actually very enjoyable to practice and doing so will improve your work by leaps and bounds. It can be hard to imagine, but continue reading and hopefully you will come to agree!

As a beginner, it's really easy to notice certain outstanding features in your favorite art pieces and become obsessed with them. If you love the way someone draws eyes or another feature, it's a common trap, especially as a new artist, to become absorbed by that, thinking that this is entirely what makes art great.

Similarly, it can be very common among those just starting out on their artistic journey to pay excessive attention to select elements in their work, producing poor results because of it. I myself fell into the trap of focusing on exactly how the outline of an eye should look, while neglecting the obviously foundational requirement of constructing the head and skull first. As a result, there was a period of time when my work had an illusion of polish, behind which there were frog-eyed people with eyes sitting way too far out from the recessed sockets. It was a very embarrassing moment when I realized I was so intent on replicating the shape of an eye from somewhere else that I didn't even understand how important the face was as a whole. That is just one example of tunnel vision in art and the consequences of neglecting the fundamentals.

I don't want to shame new artists; my hope is that by sharing this, others will be able to avoid similar pitfalls. As a result of those mistakes, my ability to progress was limited until I realized that in order to be able to draw what I wanted, I needed to focus my energy on finding out exactly how drawing really worked.

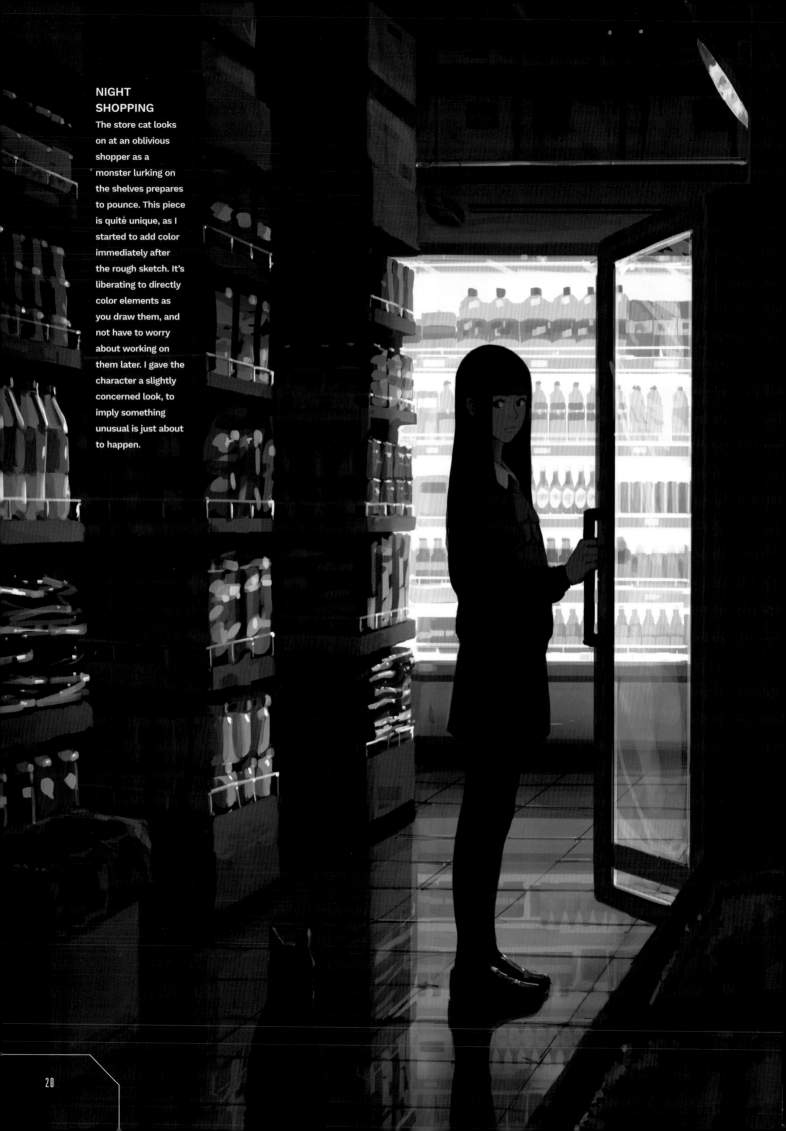

NIGHT SHOPPING

The store cat looks on at an oblivious shopper as a monster lurking on the shelves prepares to pounce. This piece is quite unique, as I started to add color immediately after the rough sketch. It's liberating to directly color elements as you draw them, and not have to worry about working on them later. I gave the character a slightly concerned look, to imply something unusual is just about to happen.

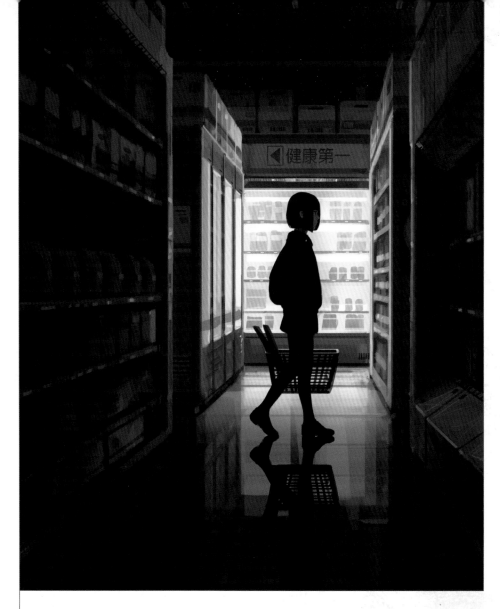

AISLE

A late-night shopper walks past a dark aisle. I sometimes find that a simple composition can be the most effective. Here, it highlights the nuances of the character's silhouette while providing just enough light to reveal detail in the surroundings and make the image feel richer.

Be critical of fundamental errors in an image – be on constant lookout for structural faults in your rendition of reality. Being vigilant and scrutinizing is not always easy; there will be many times when you feel that you're scrutinizing yourself into a corner and works-in-progress appear so full of mistakes that they're impossible to salvage. Sometimes you might be on a confident streak, stopping you from checking back in on your work.

It feels great when you think you've completed the perfect piece, but there's no better feeling than when you learn from a mistake and ensure every future piece is better because of it. Looking back, those tough experiences were huge moments of growth for me, where I started to be able to internalize the

fundamentals. It's a big part of how I was able to improve, simply by correcting foundational mistakes, one at a time. So many more possibilities open up just from improving my ability to accurately present what I'm imagining.

A good example would be many of the night-shopping pieces I have created. There isn't much going on in the frame, and the only thing keeping the pieces interesting and believable is that they're drawn with depth and fairly accurate form. Lending a degree of believability to your depiction is massively valuable, as it allows the viewer to maintain the belief that the setting is real. The resulting ability to keep your audience's imagination engaged can really add to the narrative, or make the audience more open to the narrative you're presenting.

project insight:
town

This piece demonstrates the value of building fundamental skills and constantly aiming to improve technique. After initially conceiving and creating *Town* in 2016, I decided to revisit it several times to make technical corrections and imbue the character with a stronger sense of personality. This process of reworking a drawing made me analyze how far my skills have come and where they can still improve.

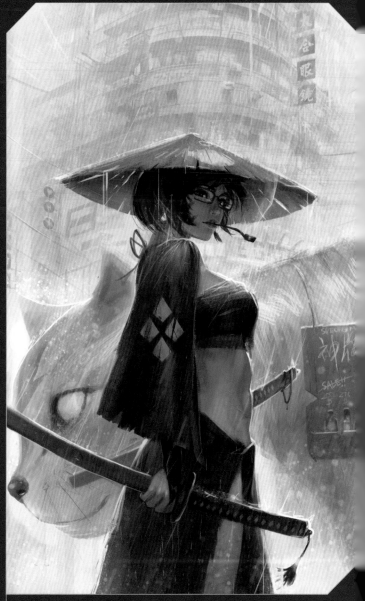

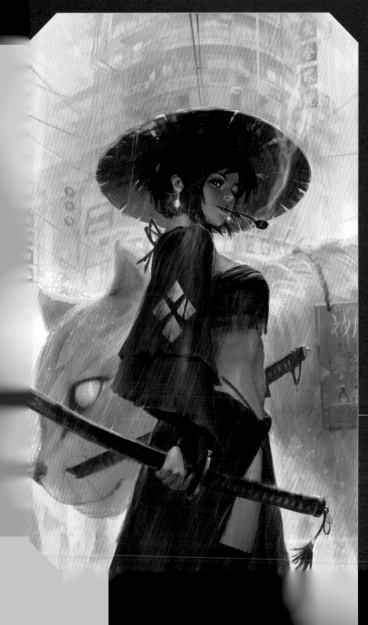

2016

A magical giant cat plies the street, peddling its wares. You might tell from the image that I managed to carefully draw the cat and background using references but when it came to the character, I decided to improvise and work from instinct. The resulting image offered a great concept, but my lack of practice in fundamentals really held it back.

2017

I decided to revisit the piece in 2017 because I liked the peddler cat concept so much. I mostly focused on patching up the character, but I was only able to improve it as much as my knowledge allowed. However, the camera angle I chose was a little extreme and went beyond what I could realistically paint at the time.

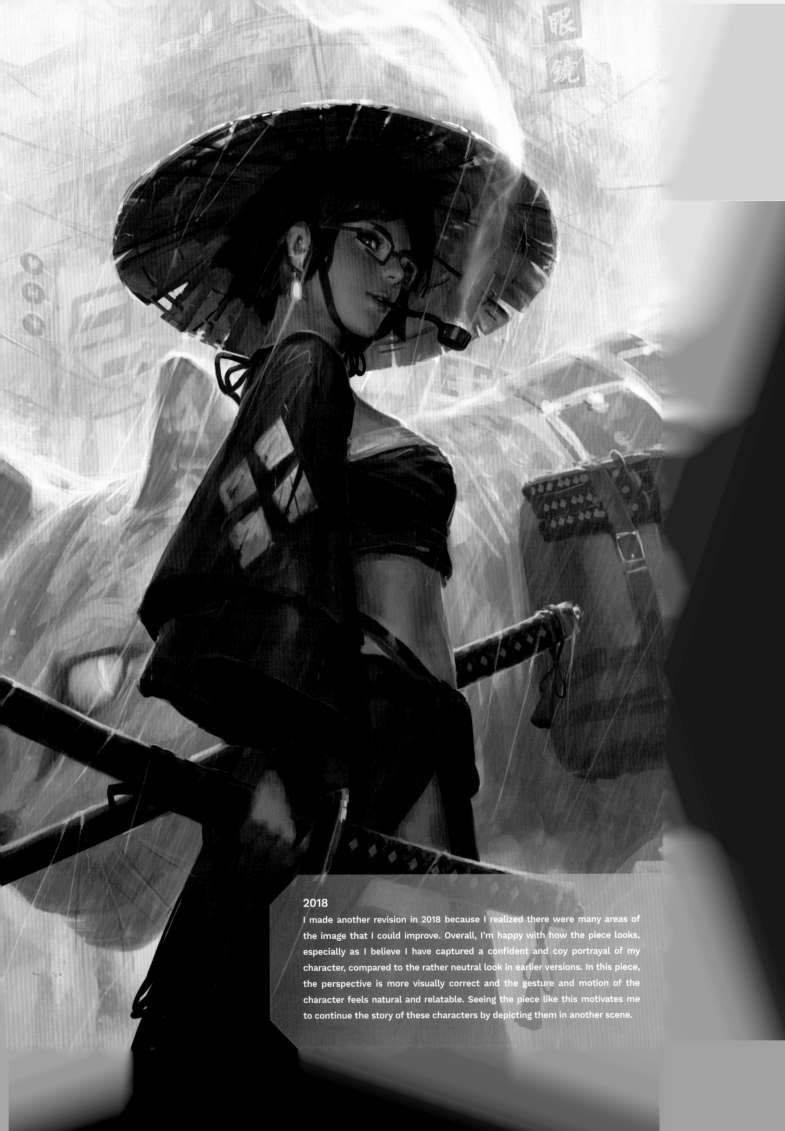

2018

I made another revision in 2018 because I realized there were many areas of the image that I could improve. Overall, I'm happy with how the piece looks, especially as I believe I have captured a confident and coy portrayal of my character, compared to the rather neutral look in earlier versions. In this piece, the perspective is more visually correct and the gesture and motion of the character feels natural and relatable. Seeing the piece like this motivates me to continue the story of these characters by depicting them in another scene.

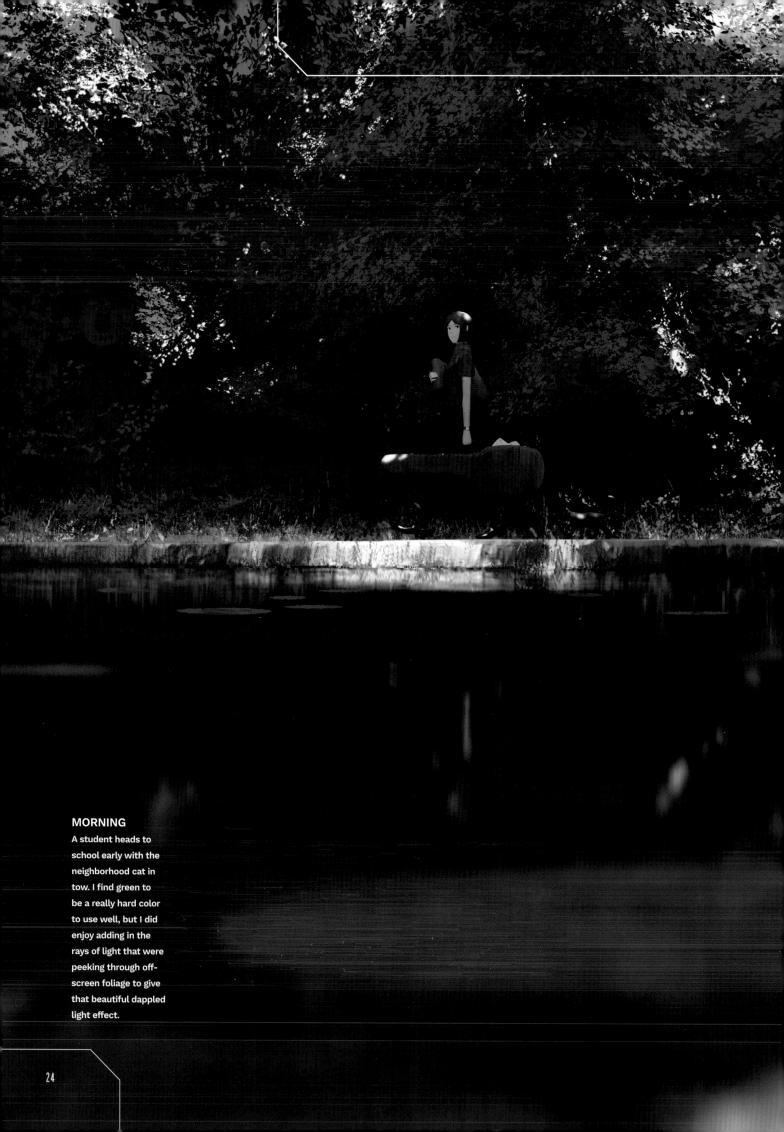

MORNING

A student heads to school early with the neighborhood cat in tow. I find green to be a really hard color to use well, but I did enjoy adding in the rays of light that were peeking through off-screen foliage to give that beautiful dappled light effect.

gathering inspiration

As well as focusing on art fundamentals, it's also important to constantly expand your visual library. Usually that's not too difficult, as most of us watch television shows and movies, read books and magazine, or play games for recreation.

These sources provide a constant stream of visual references that we enjoy and can recall for use later. However, the more difficult and potentially tedious part begins when you need to analyze your references beyond the surface level. It's effortless to simply look at things you already like and to indulge in them superficially, but that's unfortunately very limiting.

There's so much amazing material and inspiration out there, but it's highly worthwhile to dive deeper and wider into things you don't yet fully understand. Over the years I have begun to appreciate more and more forms of media and genres, and I feel each and every one that I've come into contact with is oozing with richness that's just waiting to be explored. That's not to say that we as artists shouldn't have any strong personal preferences, nor that we should frequently change how or what we draw. But we should understand that often there's a lot more to be found when we're willing to explore and give the unfamiliar a chance. You might still love a certain style or genre the most and focus your work around it, but an expansive visual library lends a lot of depth and perspective to your work.

I'm always on the hunt for interesting visuals, be it short clips of animation, film screencaps, photography, or paintings. An exercise I find very helpful in forcing myself to think more about the material is to categorize my references. I have quite a few sub-folders and categories of material in my reference folder and assigning each new image a set of best-fit tags is an easy way to order them to find similarities and strengths.

> THERE'S SO MUCH AMAZING MATERIAL AND INSPIRATION OUT THERE ... DIVE DEEPER AND WIDER INTO THINGS YOU DON'T YET FULLY UNDERSTAND

style evolution

I used to believe "style" referred to a way that artists deliberately tweaked their own work to make it look more interesting. Over time I've learned more about it, and as a result, changed my perspective on how style comes to be, and how my own style has solidified. When I first started creating art, my goal was to improve as quickly as possible. In order to do that, I thought that if I simply drew like someone else who drew well, and made a couple of changes, I could fast-track ahead of all the troublesome box-drawing exercises I'd heard about, and make my work full of "style." As it turns out, that's a hard lesson waiting to be learned. Since then, through experience, I have discovered that style isn't something you can just decide to have.

I would advise against looking at the work of artists you admire and simply thinking: "This is my goal style." You can't aim to be a different person; you have lived and will live different lives, have different experiences, personalities, and preferences. Not only will it be impossible to improve beyond the artist you imitate; you will also waste your own potential. Beginners often get trapped trying to emulate someone else's style because of the illusion that they

suddenly seem to increase in skill, or are able to draw things they weren't able to before. However, just replicating certain elements that give their image a vaguely similar look will not be helpful in the long term. It's a quick form of gratification, but it also stunts your growth as an artist. This isn't to say we should completely avoid learning from those better at the craft, but it's worth being aware of the limitations of this method as it's a very common trap that less experienced artists often mistake for a shortcut.

One aspect of my style that hasn't changed much is my preference for darker images. Night scenes, dark-clothed characters, and moody settings all have an intrinsic appeal to me. I'm open to drawing another type of look, which I often do for commercial work, but if left to work on personal designs, I find it much more enjoyable to paint something gray. I think it's the ability to keep certain things in darkness while highlighting other areas that motivates me to keep my paintings set in low-lit places.

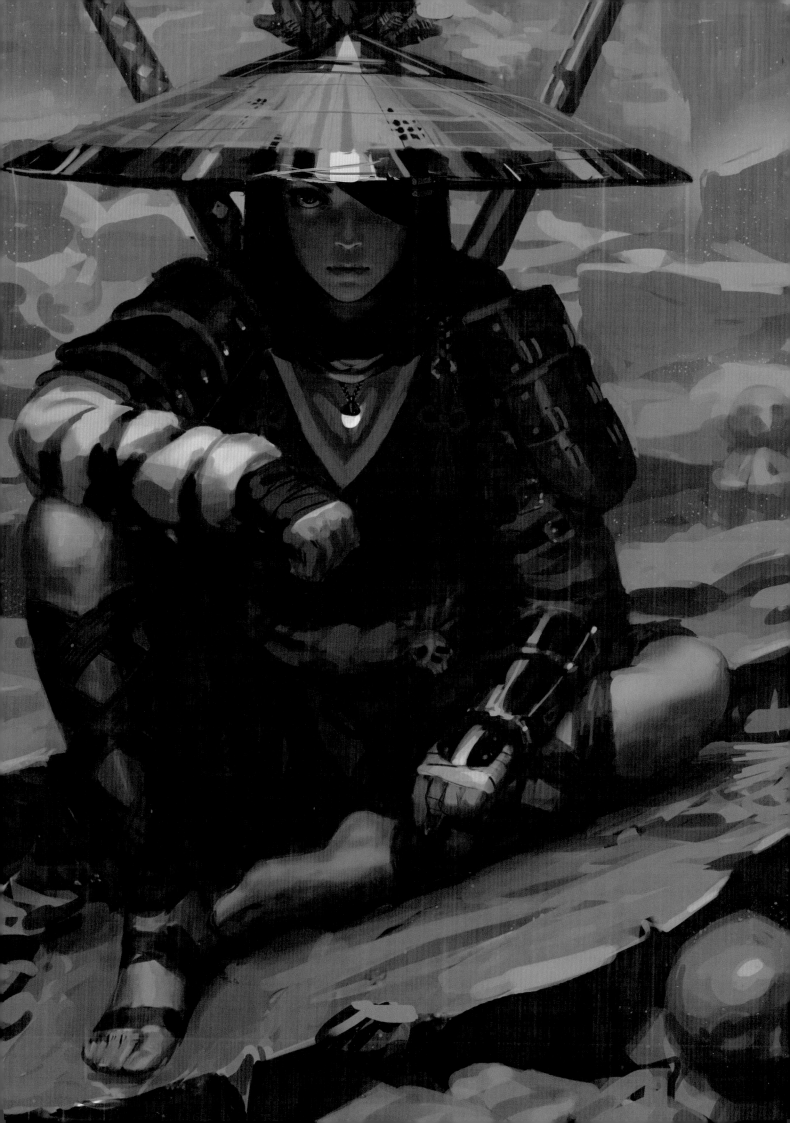

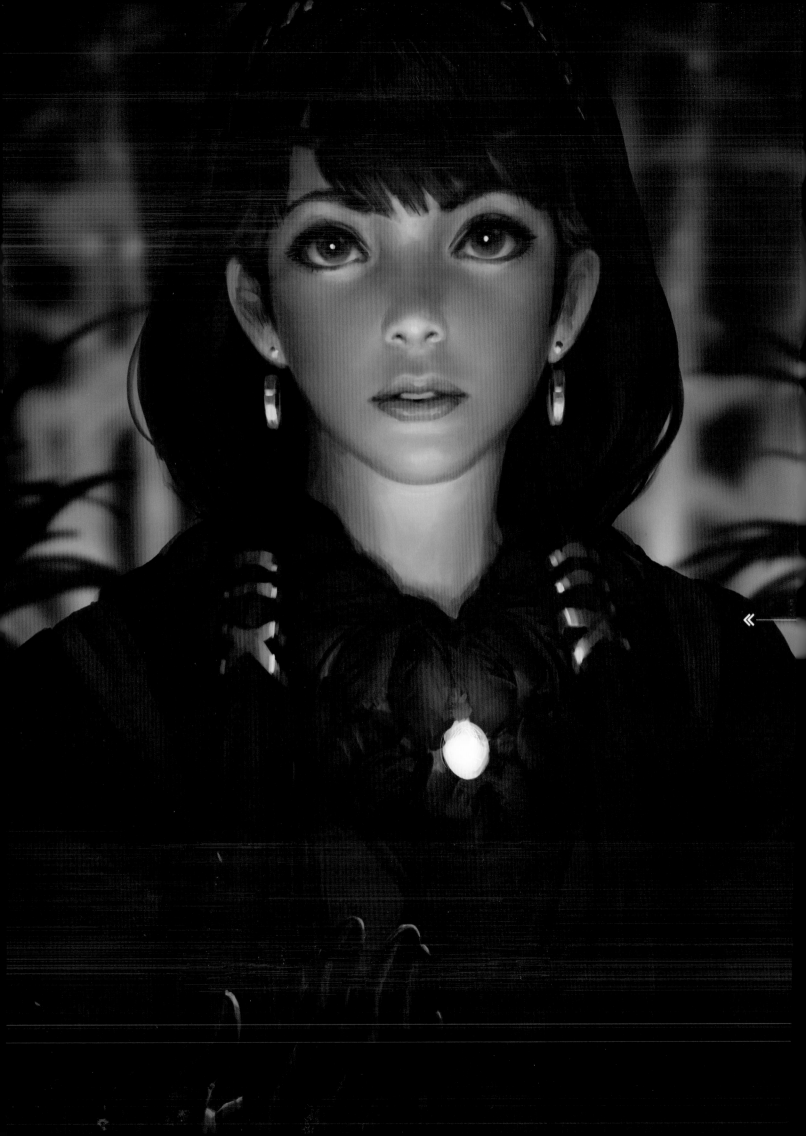

MAKE IT REAL

Working with a basis in reality has been extremely important for me in developing a set of habits, and therefore a natural style. Forming habits surrounding the interpretation of reality will help you a great deal as you practice. The more you practice with reference images, the more intuitive the process will become. With enough mileage, it becomes possible to draw anything well, as long as you have effective references.

LUNAR

The moon shines overhead while a girl makes her wish. A simple portrait, incorporating low-angle lighting. I'm happy with the gesture, but the moonlight feels a little too weak, so it's definitely a concept I will revisit.

There are numerous ways to learn from other artists respectfully which can benefit your own growth greatly. Rather than copying another artist directly, break down the superficial appearance and analyze the form, comparing it to your understanding of reality. This solid understanding of the fundamentals is essential when subsequently approaching the creative process. For example, if you understand that an outstretched arm should look a particular way, you can then compare that reality with the painting of an artist you admire. It then becomes possible to analyze meaningfully how they portray the form differently from reality. With that information, it's possible to come to an accurate conclusion on how exactly the artist modified reality to create a more dynamic representation of that object, for example, said outstretched arm.

At that point, you are finally ready to play around with a version of reality you have already practiced, using hints and insights picked up by dissecting a strong piece of work.

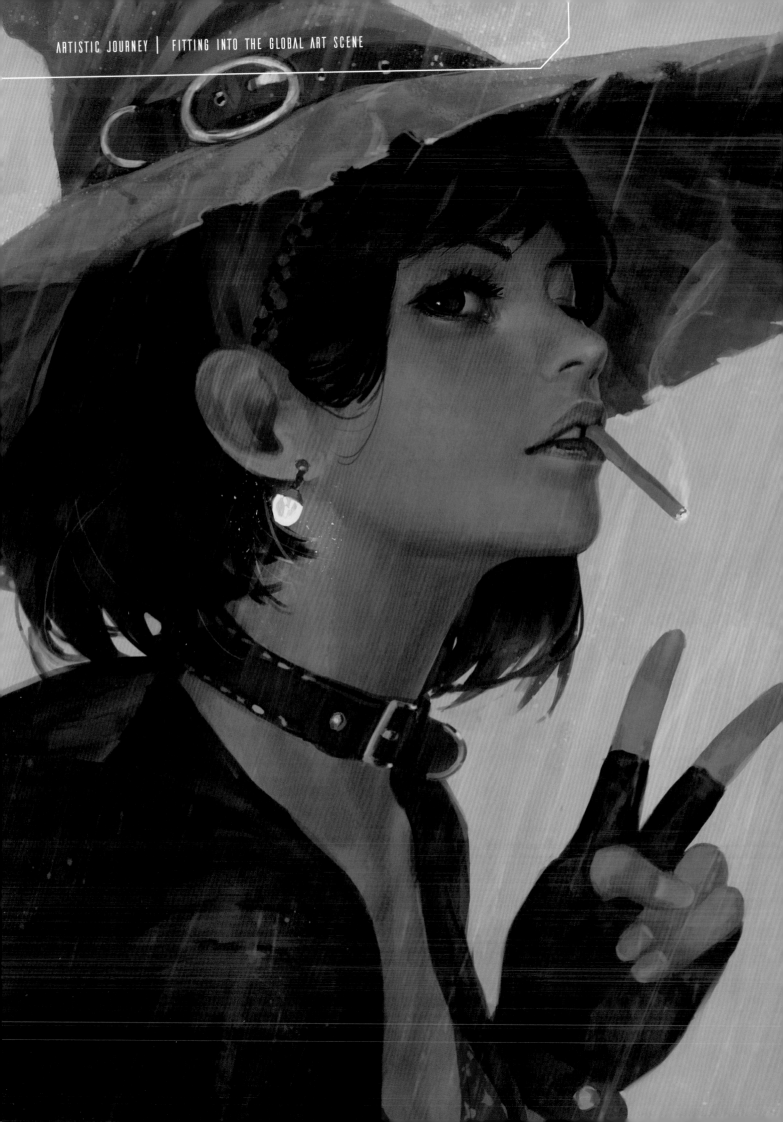

fitting into the global art scene

Earlier in my artistic journey, I created art in-line with some of the bigger trends I observed on platforms such as Instagram and Deviant Art, for example, creating lots of realistic portraits. Looking back, I realize that it caused me a lot of undue worry. At certain points in time I wrongly subscribed to the idea that people would only enjoy art they were familiar with. I then only created art in formats I'd seen successful artists use and often drew fan art of things I didn't actually care much about. While in the short term it worked by gaining me new followers, it wasn't something that was sustainable mentally or practically in the long term.

Over time, I grew to care less about what others drew and started to be bolder in following my own interests. Freeing myself from the checklist of popular elements was initially a little scary; I was worried that my ideas would be too idiosyncratic and that very few people would relate. And at the time, public engagement was low, but for a different reason – my basic art skills were poor from months spent chasing trends and not paying attention to foundational skills and knowledge. While the ideas behind some of my early pieces may have been decent, I didn't understand how to take the concept and match it with basic art fundamentals. For that reason especially, my work only began to improve in quality when I started paying more attention to these aspects.

Over time, I have moved further into following my own interests, taking on influences from media more naturally. Fortunately, this turned out to be a great move and my audience was very receptive to me trying out new things. The artists I follow also create their own characters, concepts, and worlds that steer clear of prevailing trends, which I find is what makes their pieces so attractive. It's excitingly unpredictable and always a pleasant surprise to see their next piece

ANTIQUE

A curious shophand takes a peek into the storage aisle. The intriguing story I had in mind motivated me to spend more time polishing the setting. The perspective distortion was difficult to achieve, but I think it's close enough to tell a good tale.

of work; it's something you can tell they really believe in and spent a lot of time bringing to life. It is the essence of this feeling that I hope to harness in my own work, for my audience.

Finding a place for yourself in the global art scene is neither convoluted nor confusing, but it takes a lot of elbow grease and grit to have the confidence in yourself to keep going. A good starting point would be to decide for yourself what you want to draw, and supplement this with practicing art fundamentals.

People are constantly eager to see original work, and it's our job as artists to develop the skills to communicate those unique concepts clearly. I see myself as a work-in-progress, and the learning process never ends. I've learned so much since I started and yet there is increasingly more to discover and learn. Despite that, I have a good foothold in finding my own place within the art scene and I'm looking forward to seeing what I'll be able to produce in the future.

WITCH

A cheeky witch flashes a peace sign. I went for a more "punk" look compared to the rest of my more innocent-looking characters. I really enjoy how this piece looks as though it could be a candid photograph taken by a camera on a mobile phone.

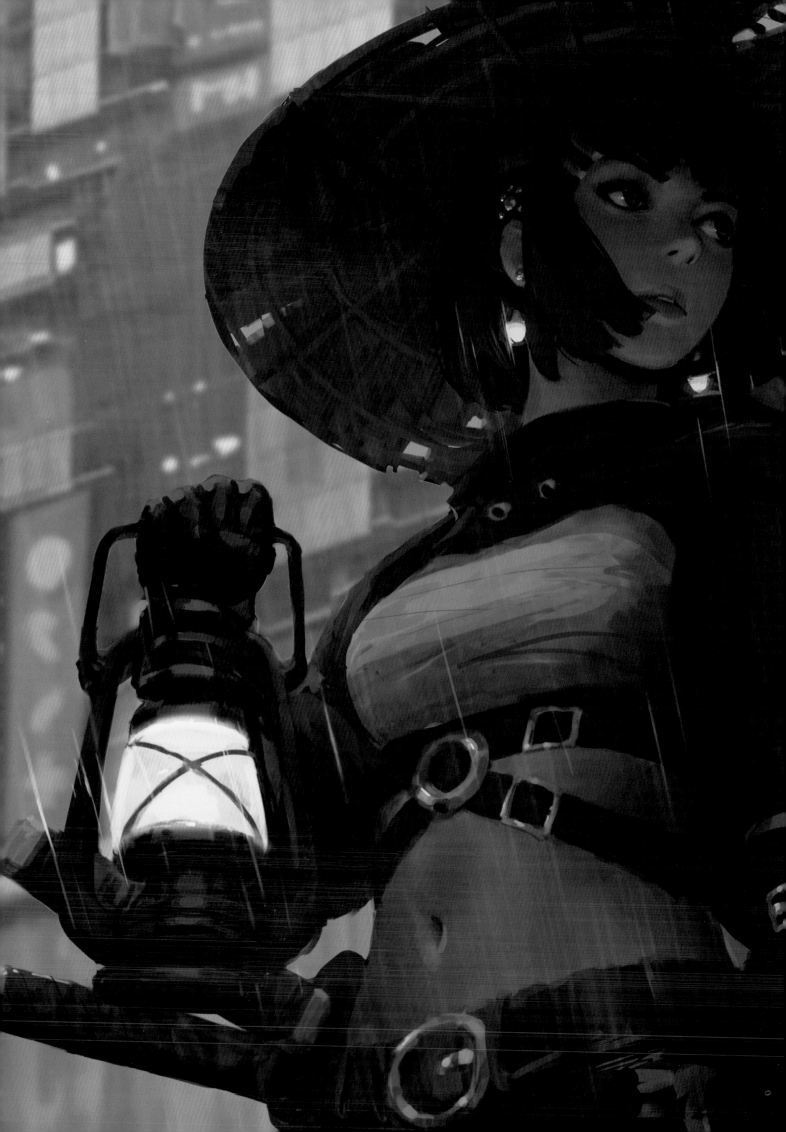

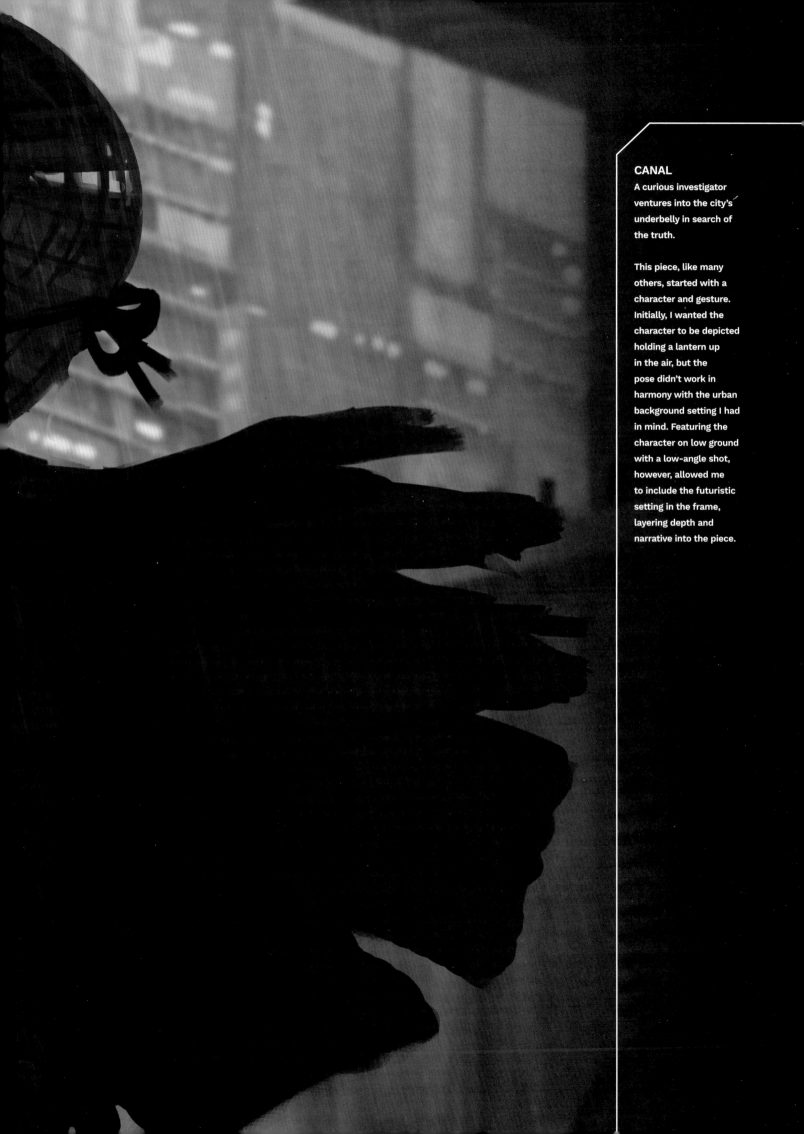

CANAL

A curious investigator ventures into the city's underbelly in search of the truth.

This piece, like many others, started with a character and gesture. Initially, I wanted the character to be depicted holding a lantern up in the air, but the pose didn't work in harmony with the urban background setting I had in mind. Featuring the character on low ground with a low-angle shot, however, allowed me to include the futuristic setting in the frame, layering depth and narrative into the piece.

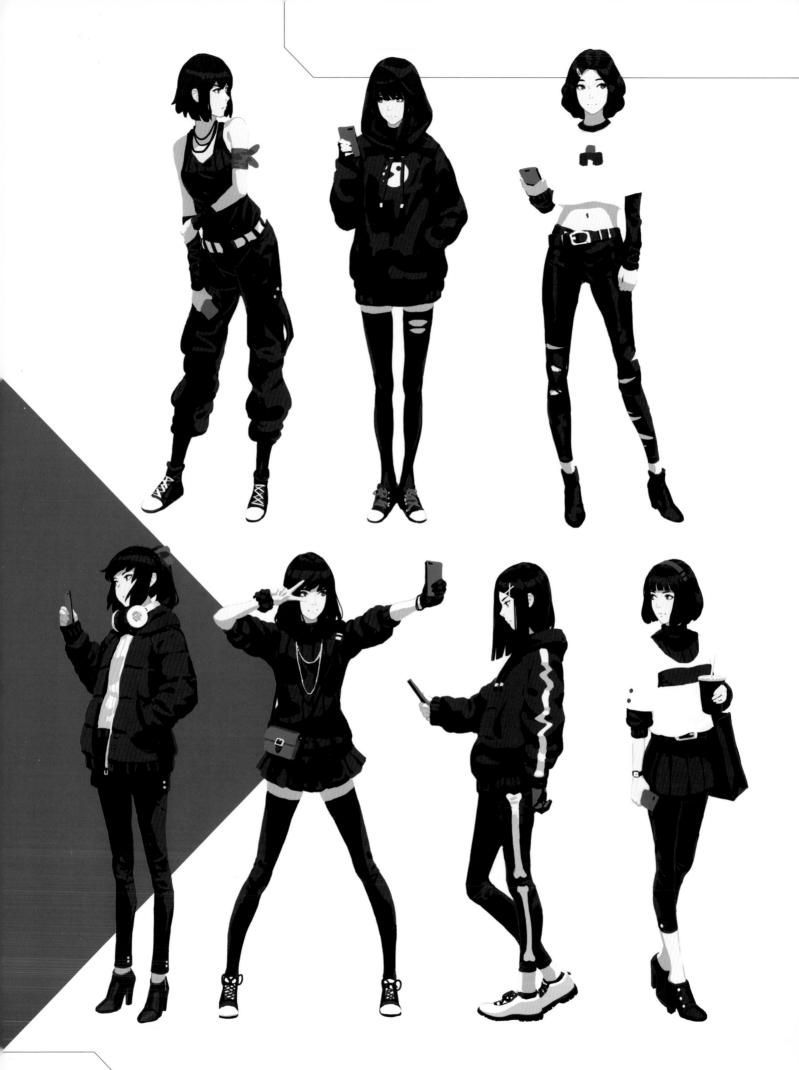

validation

It is human nature to yearn for validation. I believe it first began as an evolutionary response to find out if the things we do are useful to society, or appreciated by others. Being social creatures, we need some sort of self-correcting mechanism to guide us in our interactions. In this capacity, I think the audience shares a symbiotic relationship with the artist. The audience is welcome to view artwork which they can enjoy personally, and in return their response provides feedback to the artist.

However, the big question is: should artists be paying attention to their audience at all? Maybe the integrity of the work can only be preserved if the artist works in a vacuum? My answer to that would be to use healthy discretion. It's possible to fall into a trap where all you do is try to please your audience. This hurts everyone in the long run; the artist struggles to grow, while the work the audience sees becomes increasingly restricted in scope, losing the originality and beauty that attracted them in the first place.

UNDERSTANDING YOUR AUDIENCE CAN ACT AS ANOTHER LEARNING PATHWAY ALONGSIDE YOUR STUDIES

If you think your audience likes a certain piece more than others, don't immediately jump to the conclusion that everything in that image is exactly what you need to do more of, rejecting everything else. Over time, I have made observations about my viewers that have become very useful. For example, I drew a quiet scene in monochrome and my audience liked it a lot; however, my next piece wasn't as well received, even though it was aesthetically similar.

I continued the series because I really enjoyed the format and I was learning new things. Over the next few pieces I was able to understand much better what was actually speaking to the audience and what wasn't working as well. I found that drawing the character doing something in the piece, as small as the action might be, added an attractive sense of dynamism to the scene. It was also important to direct the lighting to make sure secondary objects were mostly drawn in low contrast, with a small percentage being well lit, to keep the image from appearing too crowded.

Understanding your audience can act as another learning pathway alongside your studies of the fundamentals. In fact, the two often corroborate each other, as the art that audiences enjoy is often based in strong fundamentals and good composition. I am extremely grateful for my audience as a source of feedback. Although I haven't organized many events and giveaways at the time of writing, I think it's an exciting aspect of art that social media enables uniquely, and something I will look into in the future.

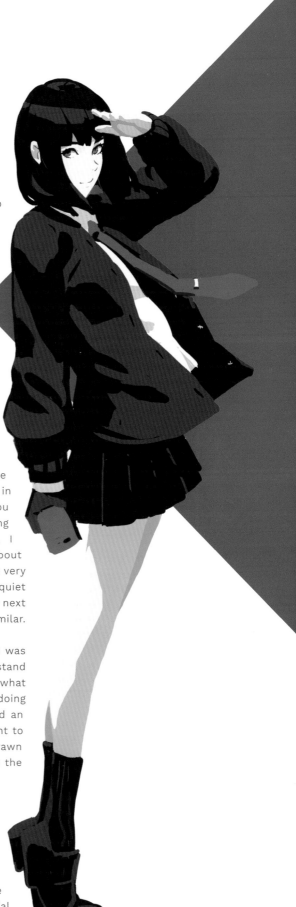

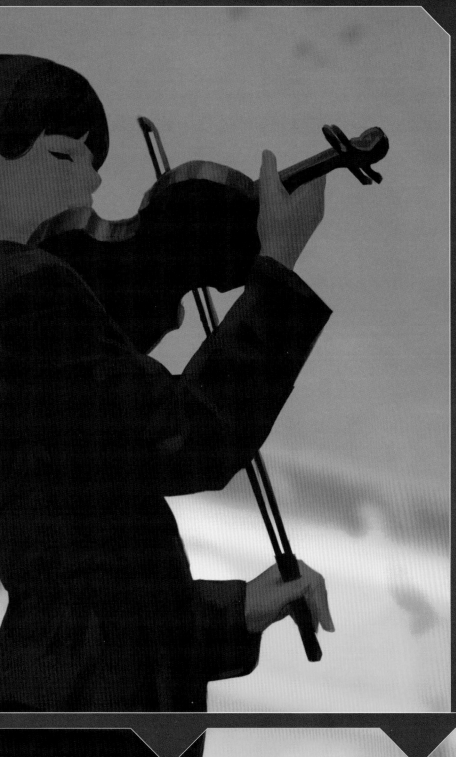

GALLERY | URBAN

Urban-themed character-focused drawings help me to relax and take a break from the complexities of fantasy pieces and my original style. The best part about creating these pieces is the diverse subject matter I can cover. From mystical red forests to rainy streets and golden-hour rooftops, I find this format allows me to explore every interesting theme I come across.

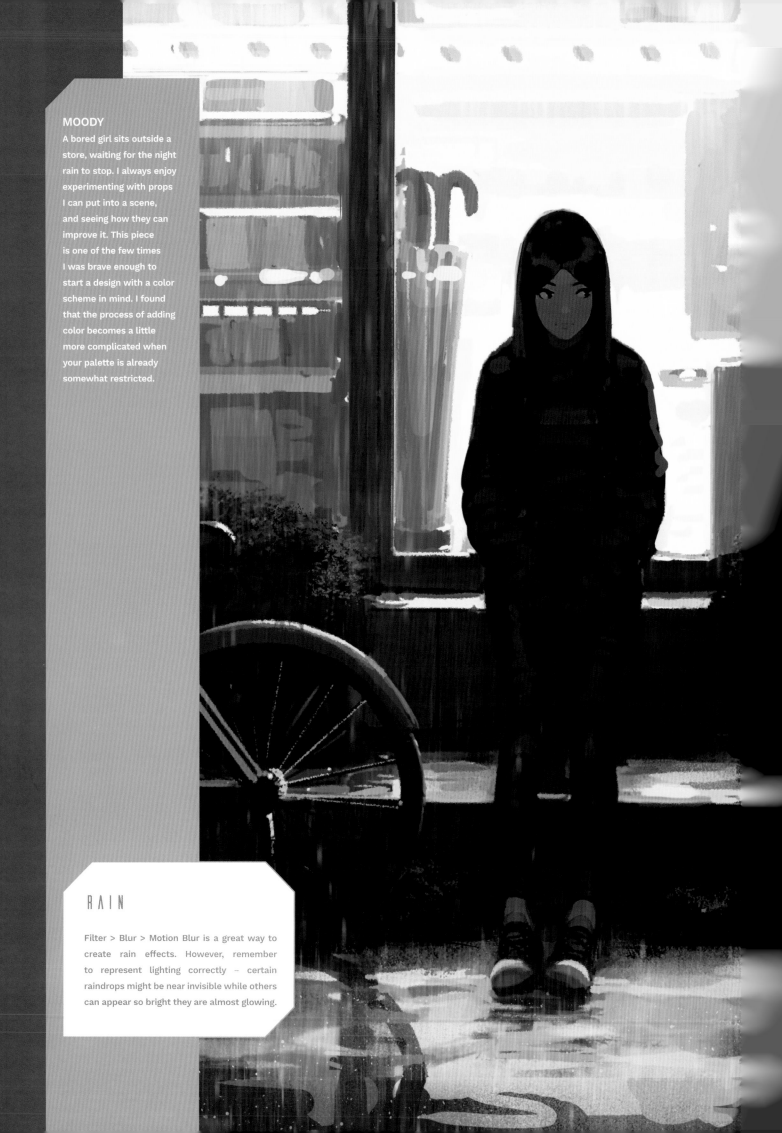

MOODY

A bored girl sits outside a store, waiting for the night rain to stop. I always enjoy experimenting with props I can put into a scene, and seeing how they can improve it. This piece is one of the few times I was brave enough to start a design with a color scheme in mind. I found that the process of adding color becomes a little more complicated when your palette is already somewhat restricted.

RAIN

Filter > Blur > Motion Blur is a great way to create rain effects. However, remember to represent lighting correctly – certain raindrops might be near invisible while others can appear so bright they are almost glowing.

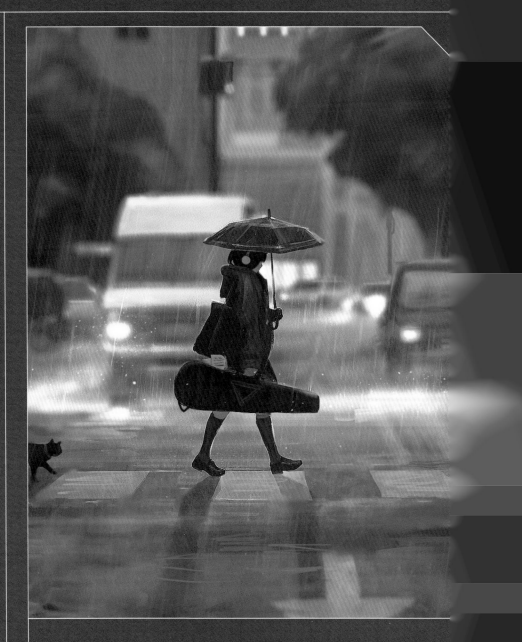

AFTER PRACTICE

A guitarist walks home after band practice, stalked by a curious cat. The biggest challenge when creating this piece was finding a strong color palette. Fortunately, I discovered great reference images that also gave me an idea of how to imply depth. I was honored and surprised when Neil Tolman (Roguefx) 3D modeled and animated the scene.

THE PROCESS OF ADDING
COLOR BECOMES A LITTLE
MORE COMPLICATED WHEN
YOUR PALETTE IS ALREADY
SOMEWHAT RESTRICTED

GRAYSCALE

To break an image out of grayscale, start with the brightest colors in the setting. For example, the red board and red highlights on books. Another thing is to ensure that colors don't get washed out by the gray tone. For example, brown books still appear clearly brown, even in a sepia-toned image.

BOOKSTORE 2

A customer looks for a rare book as something stares into the shop windows. I really like the concept for this piece and the way in which I set up the overall composition, but I think the foreboding narrative happening in the window is a little too subtle and weak. If I had to change something about the design, I would make it more obvious that something was breaking into the bookstore.

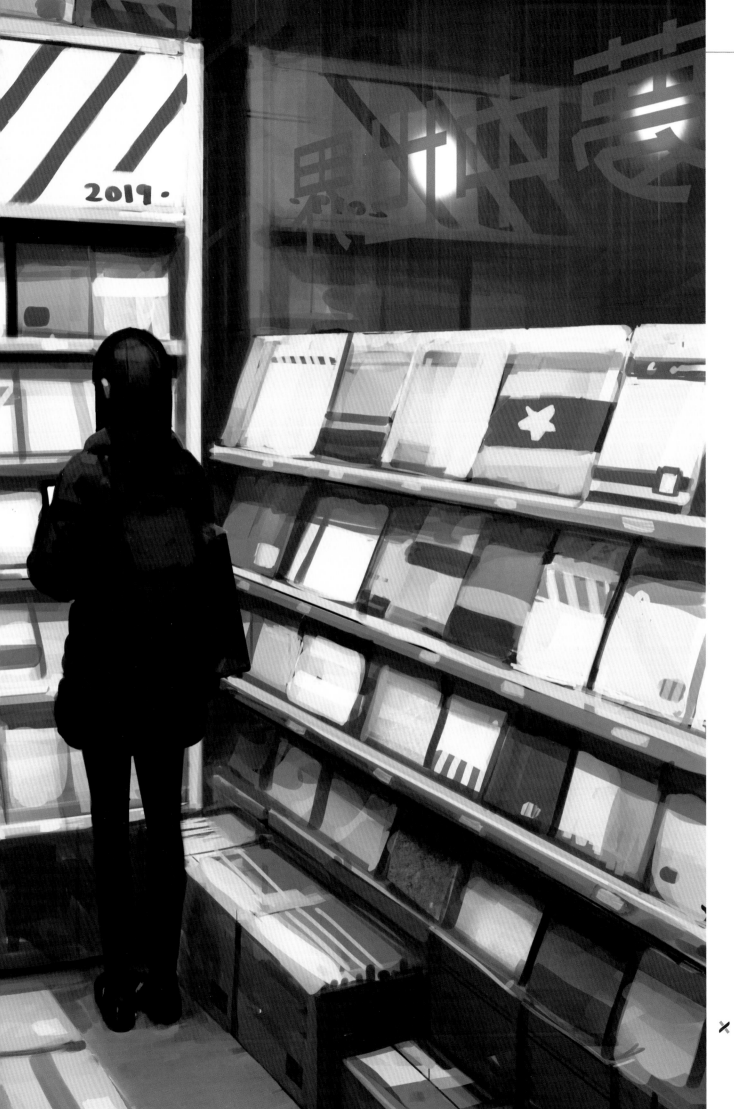

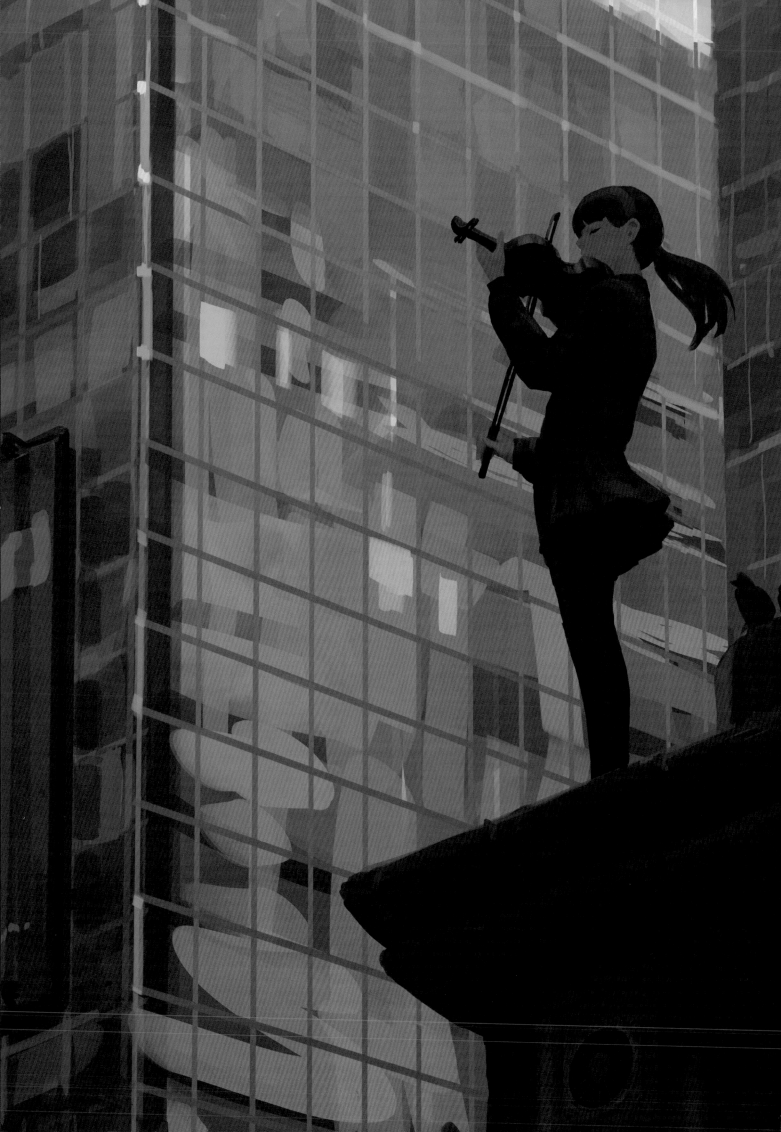

PEOPLE ARE CONSTANTLY EAGER
TO SEE ORIGINAL WORK, AND IT'S
OUR JOB AS ARTISTS TO DEVELOP
THE SKILLS TO COMMUNICATE
THOSE UNIQUE CONCEPTS CLEARLY

VIOLINIST 2
A musician plays a somber melody atop a big city roof. This
piece is a companion to *Violinist* as I really liked the angle and
pose and wanted to try it again in a different setting. Managing
scale and spacing in a scene has been challenging for me but
I feel it's all worth it to present a believable yet dreamy scene.
See the project insight of *Violinist* on page 86.

AWAY

A cyclist stops and watches as astronauts take off into space at sunset.

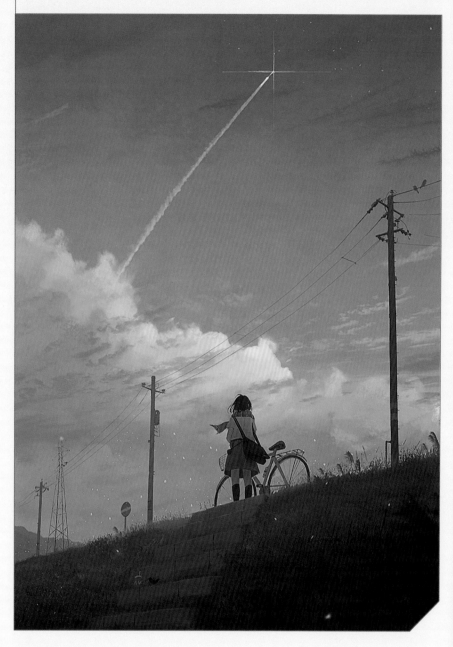

SEE THINGS FROM A
VIEWER'S PERSPECTIVE AND
CONSIDER NOT ONLY WHETHER
THE SCENE CAN BE READ
CLEARLY, BUT ALSO WHETHER
IT IS INTERESTING

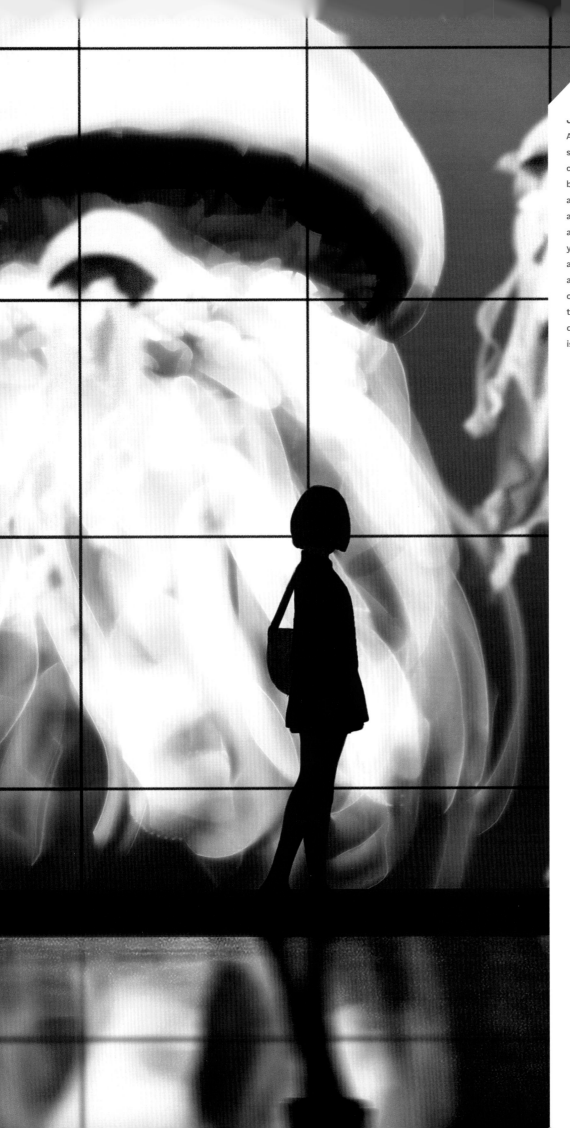

JELLY

A pedestrian walks down a street as massive, brightly colored pixel jellyfish float behind. Silhouettes are always fun to play with as they can be quickly and easily adjusted as you work. Make time to attempt to see things from a viewer's perspective and consider not only whether the scene can be read clearly, but also whether it is interesting.

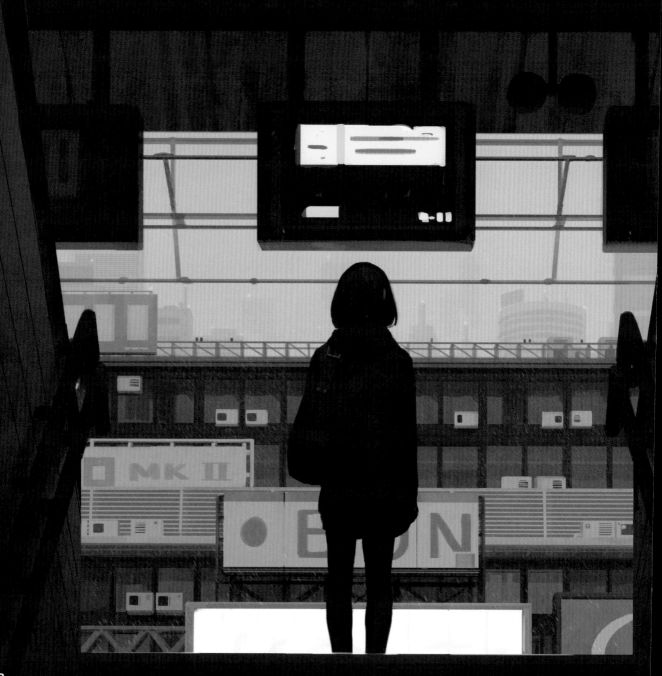

COMMUTER

A student waits for a
late train on a dusty,
dark afternoon. Weather
doesn't have to be generic,
sometimes even mornings
or afternoons can be dark
and dreary and it can often
lend an interesting vibe to
an image.

PLATFORM

A smiley cat sits on its resident train station platform, unfazed by the crowd and loud trains. This was an experiment with an unorthodox composition and perspective. With our usual human character essentially being a prop, everything else receives more focus.

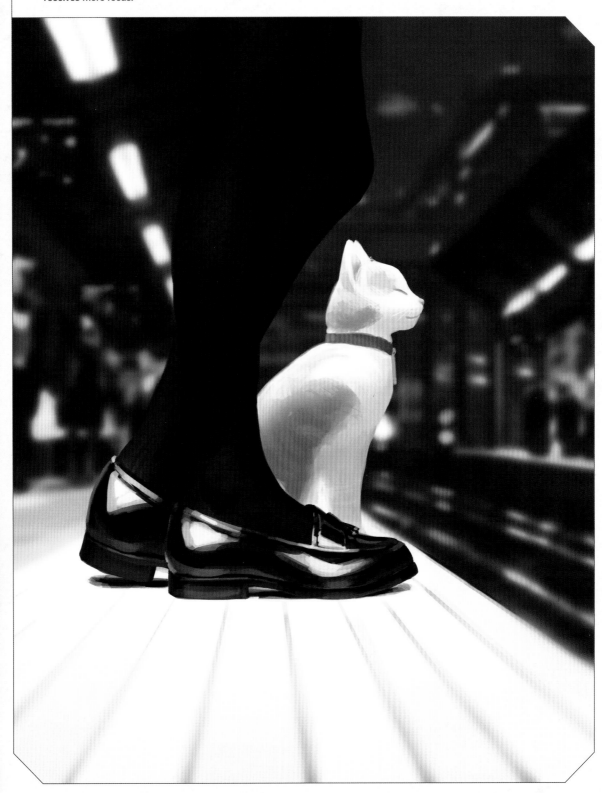

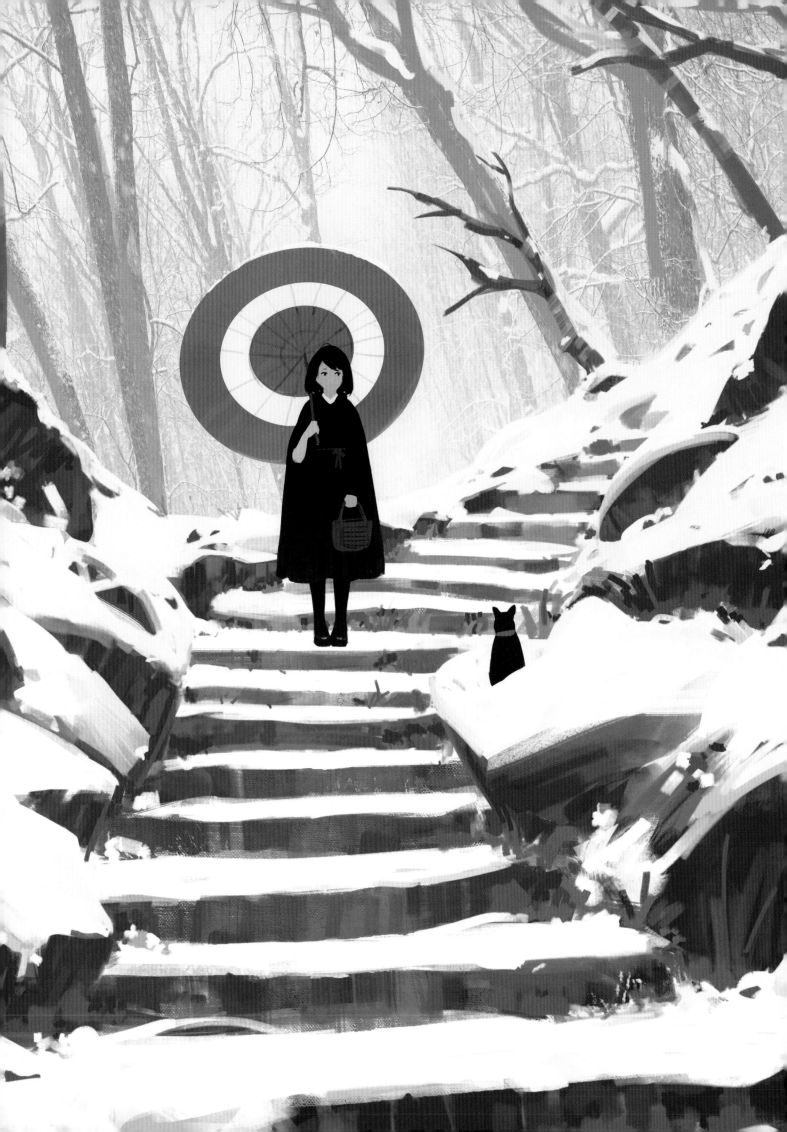

STEPS

A girl stops as she encounters a strange animal on her way to the market. This was a really challenging piece to create and I can remember revisiting it many times. I found the depth really difficult to portray accurately and ended up keeping the steps "clean" to help the image read more clearly. The aspect I enjoy the most is the cool, minimal color palette.

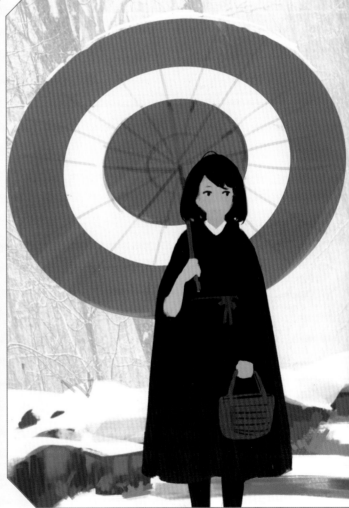

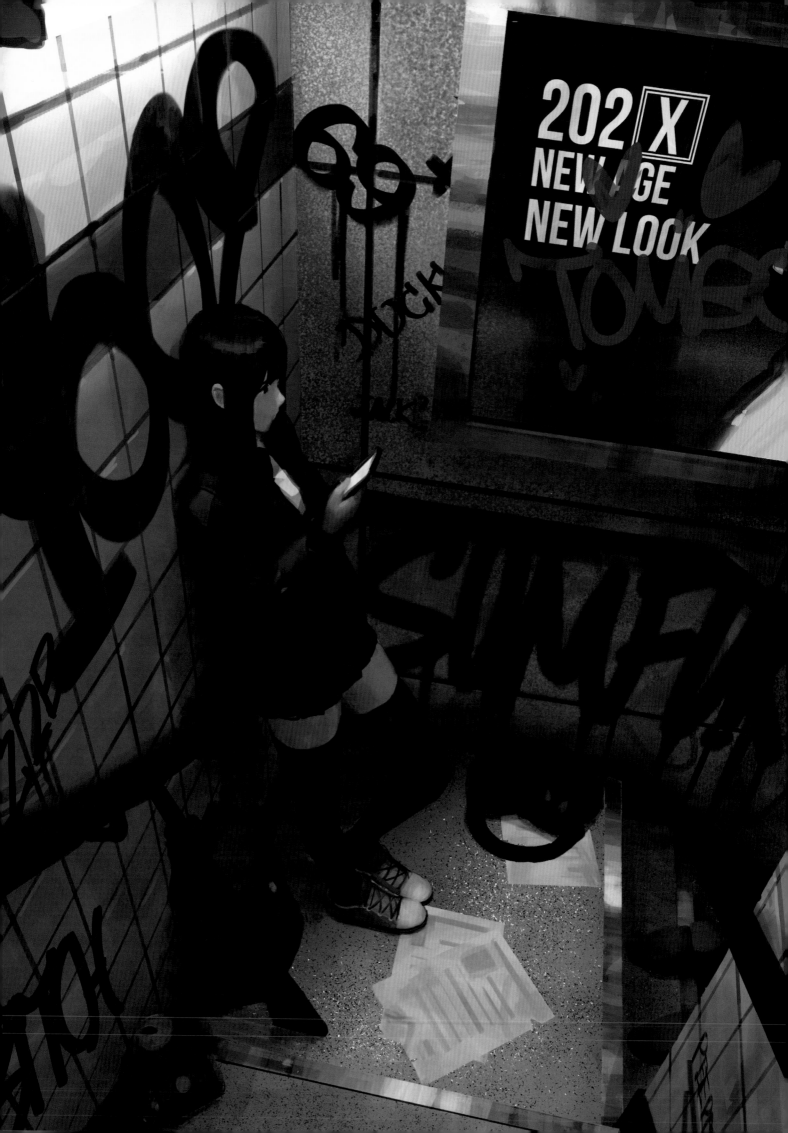

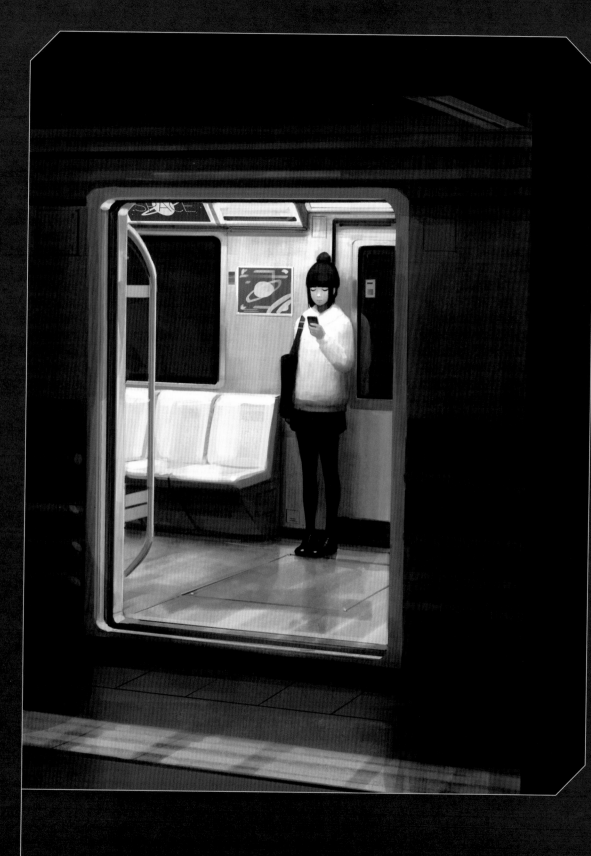

LAST TRAIN
A late-night commuter
rides the last train.

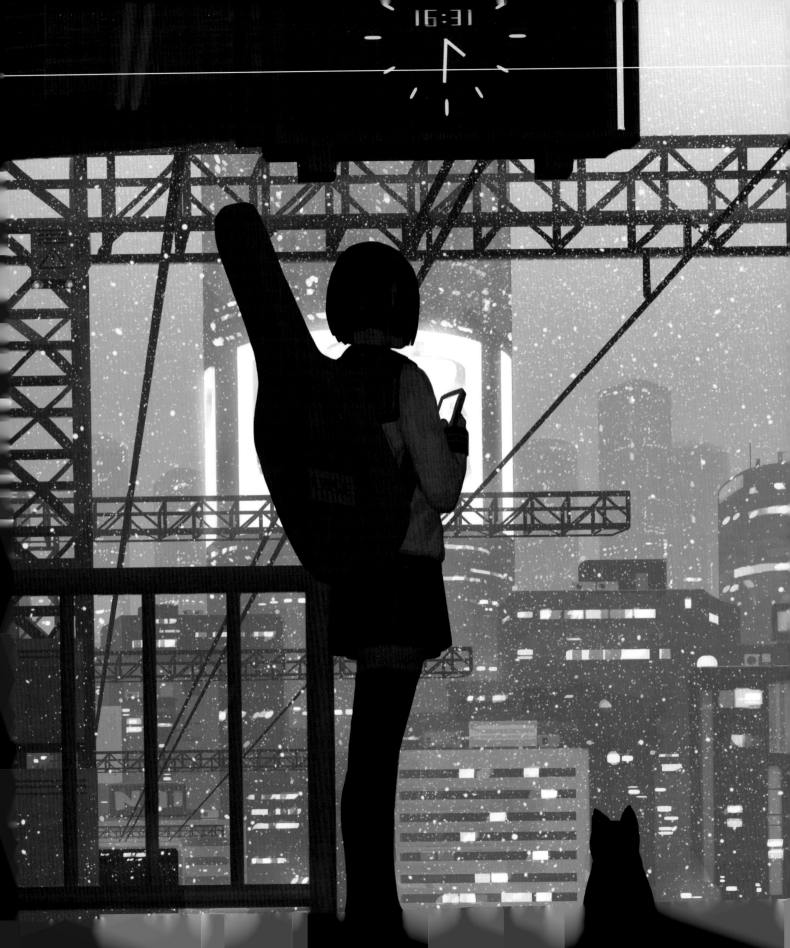

- R O U T I N E -

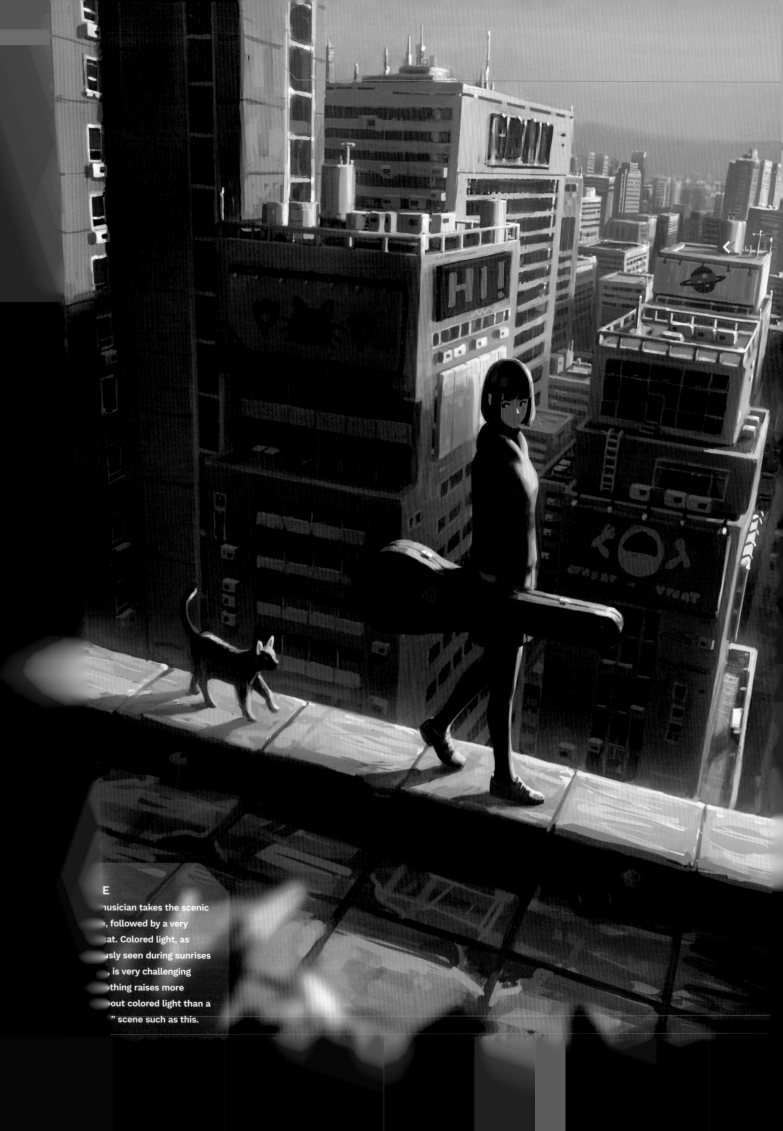

E

...musician takes the scenic

..., followed by a very

...at. Colored light, as

...usly seen during sunrises

..., is very challenging

...thing raises more

...out colored light than a

..." scene such as this.

studio

I work from my own home, and while there are pros and cons to that, so far, it's been very convenient and inexpensive. My daily workstation is quite simple. It's centered around a multipurpose PC with a regular keyboard and mouse setup. Add a small drawing tablet in front of the keyboard and I'm all set to get to work. I also have a separate tablet PC, just in case I need to display something to the side.

Work-life balance is often discussed when people work from home. It's difficult to stop work when you're really motivated and eager to keep going, and in some situations, I would say go ahead. If it's important for me to accomplish a goal (for example, to finish painting a specific thing) and I'm still feeling up to it, I'm happy to spend a couple more hours drawing. However, I stop if I start to feel unhappy or negative. Hours of problem-solving can take its toll and usually, especially if it's getting late, I find it better to call it a night and continue afresh the next day.

Another way I balance my time, is to take a break for a couple of hours each time I finish a painting. I really enjoy drawing as a hobby as well as for work, so sometimes the two merge and I find it hard to step away from a piece. That mostly works to my advantage, although the long hours spent sitting can cause problems. To remedy that, I go to the gym five times a week to do a mix of resistance and cardio training. Thankfully this has worked for me so far and I've been able to stay in fairly good health, despite the otherwise sedentary working conditions.

If I'm tired or overwhelmed, working from home quickly becomes a blessing. Whenever feasible, I find a quick nap is one of the best ways to reset and refocus. Don't be afraid to take some time to rest; it's not a waste of time if it helps you to stay focused and refreshed in the long run.

COLORED LIGHT

Colored light, naturally seen at sunsets and sunrises, colors while it illuminates every surface it touches, and figuring out what color each surface should be, is a puzzle. Does a red-brick building become more red, or closer to orange? How bright should it be compared to the blue billboard next to it? What about asphalt surfaces, how do they react? Interrogate the scene and research colored light references to ensure your drawing offers an accurate portrayal.

motivation

Ideas for drawings are much more easily found and discovered than the motivating forces behind why we draw. As much as I love drawing, after long periods of it, which is essentially continuous problem-solving, it can be exhausting. I have never considered giving it up, but it doesn't hurt to be extra motivated either.

Extremely well-drawn and masterful artworks have a huge power over me. The genre or type of art doesn't matter so much; even if the subject or mood is completely unrelated to anything I am ever likely to draw, I find the skill behind the artwork extremely motivating. I feel incredibly driven to reach a level of skill I observe in these masterpieces; that feeling alone propels me to take on difficult pieces, or to work through compositions I'm less familiar with.

When I'm not painting, most of my time is spent thinking about what to paint, but that doesn't mean I don't find time for friends, family, or activities to keep myself healthy. It's mostly recreational activities that I find I lack time for these days. Ironically, it's on sick days where I feel terrible and can't focus that I get to spend time catching up on shows and watching movies in earnest.

I maintain a fairly rigorous routine and I would never suggest that this is even close to the only way to improve. Everyone works best when they find their own speed and intensity.

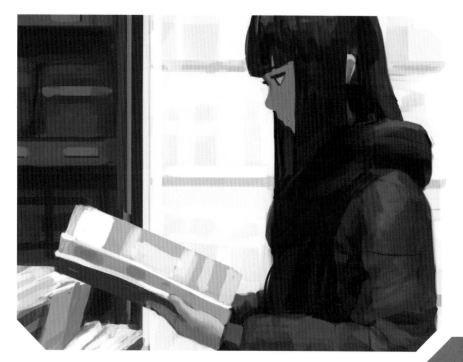

MAN, NOT MACHINE

We're all human and we shouldn't expect ourselves to work like machines. Pace yourself by focusing hard when you're able, but also taking it easy when you need to. If creating art is going to be a long-term career, it will help you greatly to find a pace you can keep up for years to come.

productivity

Staying productive stems from my passion for drawing. I find spending time working on paintings to be quite addictive. Despite that, there are also times where I'm not feeling up to it. My plan changes depending on whether I'm just feeling lethargic and lazy, or if I'm actually overwhelmed and tired.

I keep a sizeable gallery of references and sort them according to genre or application, such as whether images have been chosen for reference regarding composition, perspective, or a specific lighting setup. When I'm feeling lazy, a quick browse through my reference

library will instantly wake me up. Seeing a composition I saved a while ago and really like will immediately get me thinking about how I can use it. Browsing through interesting character designs also motivates me to think about how I can incorporate certain designs, shapes, and textures into my own work.

One trap I still fall into occasionally, however, is becoming unfocused and just browsing the internet. This typically happens when I'm working on part of a painting that I'm not very excited about, but I'm usually able to stop myself and get back on track.

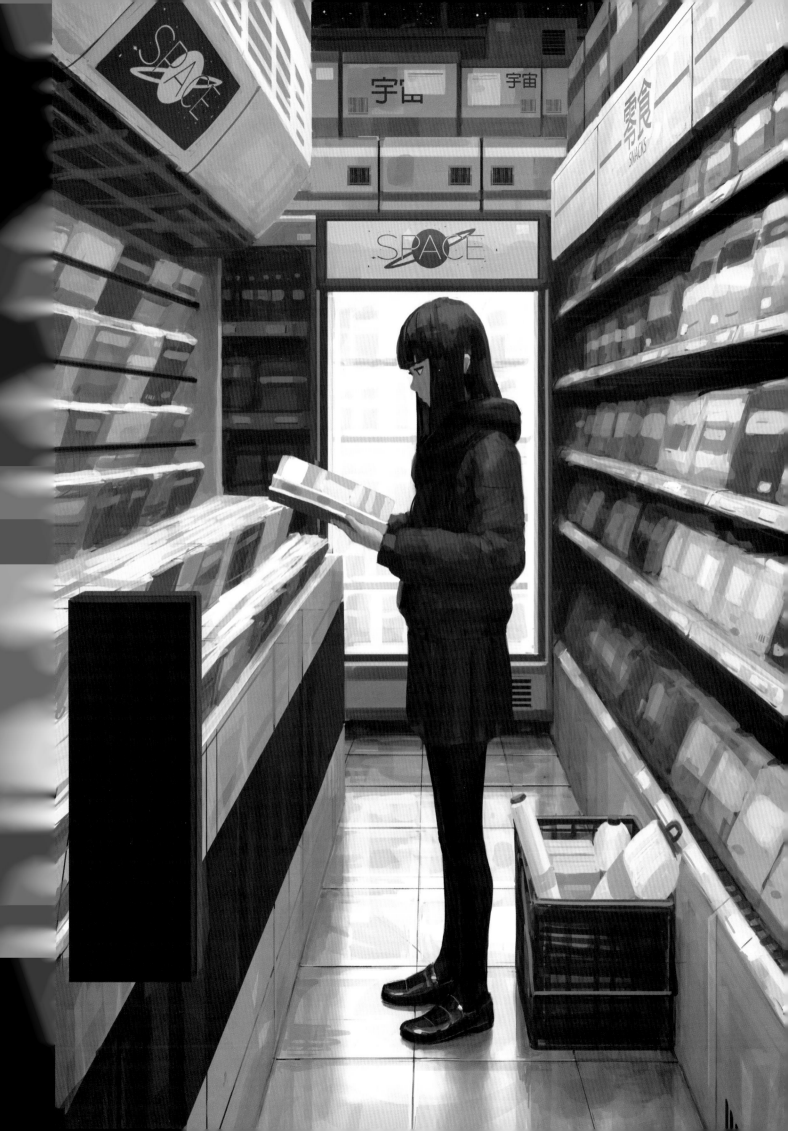

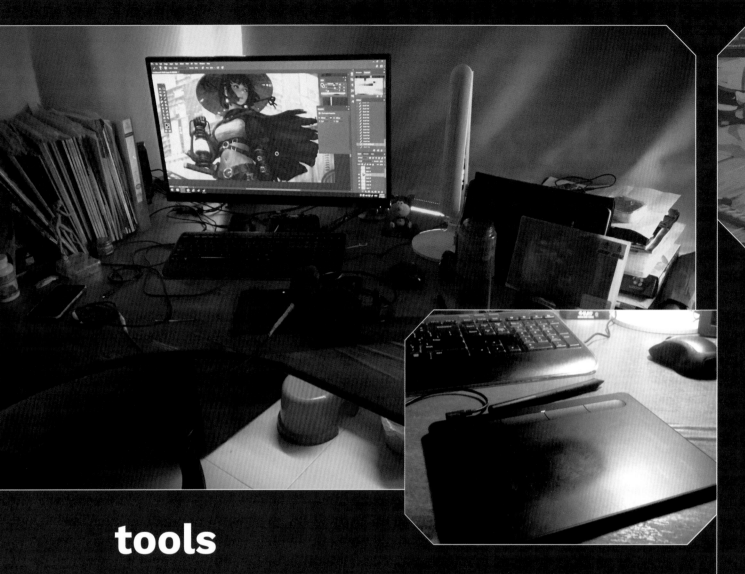

tools

Adobe Photoshop is my software of choice when it comes to digital painting. For hardware, I work on a PC with an i7-7700 CPU, with GTX1060 6GB and 16GB RAM, using a Wacom Intuos Small. For scratch disks and page files, I use an empty 256 GB SSD. I find that the amount of RAM and the speed of the SSD help a lot when it comes to making sure Photoshop runs smoothly. It's a demanding program in terms of taking up lots of memory and creating a huge temporary file on the scratch disk.

With my current workflow, I don't rely on any of the Photoshop tools heavily, besides very basic adjustment filters such as Color Balance, Hue, Saturation, Value, and Curves. For 90% of a painting, I use the default Photoshop round brush with pressure settings on. For erasing during early sketching, I use a hard eraser (as it doesn't leave any semi-transparent markings). Then later on, during the rendering process, I simply paint over the top.

Hotkeys, however, offer huge potential in streamlining digital workflow, so have fast become some of my most valuable tools. It's worth learning the hotkeys for common functions, as these can really speed up the drawing and painting process and make it much less frustrating, especially when revisiting elements in a painting.

I find it extremely useful to be able to keep your eyes on a design while simultaneously opening menus and making changes using the keyboard. For example, I often use the Warp function under Free Transform and have it mapped to Ctrl + W. This means I just need to hit the L key to start lassoing the relevant area, followed by Ctrl + W; I can then move straight into warping and editing. This allows me to work this useful function into the painting workflow without being intrusive.

Another program I find useful is Procreate on the iPad Pro for when I need to sketch on the move. Most of the time I take traveling as a chance to have a break, but if absolutely necessary, I find Procreate works very well as it contains most of the common Photoshop tools and is intuitive to use.

canvas size

A question I get asked a lot is which resolution and canvas size I paint on. A good place to start is usually 3000-4000 pixels wide or tall. Depending on the requirements of your project, you could use a lower number of pixels to keep the file size small and the painting process fast and rough, or go much higher to make sure you have the capacity to work fine details into a very wide shot.

There is no magical resolution, nor is it a big problem if you need to change resolution in the middle of a painting. It's a little inconvenient due to minor stretching and extrapolating when you scale up, but if it's necessary to add in more detail, it's usually no issue and barely visible in the completed painting anyway.

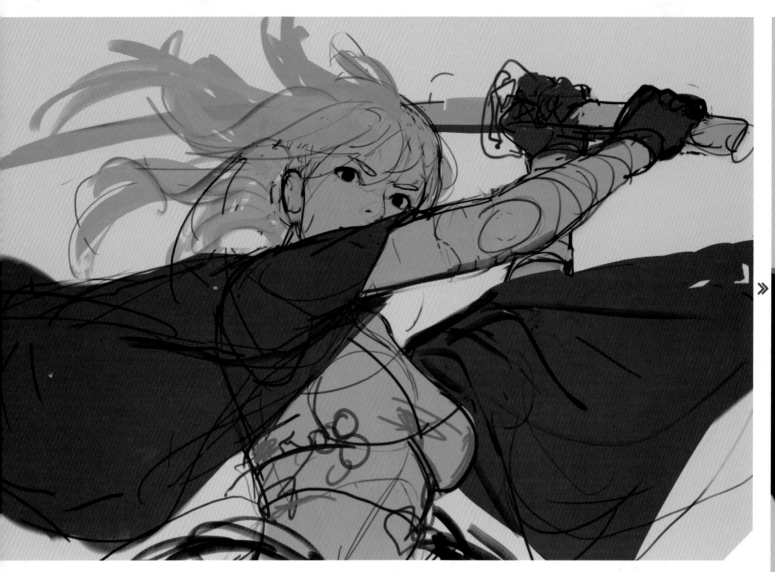

project insight: **war 2.5**

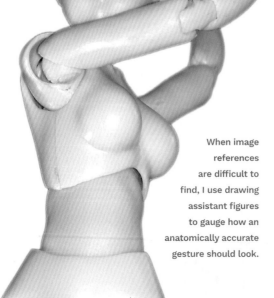

When image references are difficult to find, I use drawing assistant figures to gauge how an anatomically accurate gesture should look.

In this piece, a fierce fighter is seen preparing to strike a fatal blow. As one of the designs in a series of war-themed paintings, this piece explores a more dynamic pose and perspective to my usual designs.

When reference photos aren't available, drawing assistant figures are a great help. While developing this design, I knew that high-energy, war-themed reference material would be hard to find, especially when combined with a complex perspective, so I used a drawing figure model to recreate the pose in three dimensions. The proportions may be different, but using this type of visual reference helps a lot in getting a more accurate feel for the movement and volume in the piece.

Problems can still arise much later in the drawing process, so take every precaution you can to have the best chance of avoiding them. Taking accuracy of perspective, anatomy, and gesture into account early on in the development of a painting should help you to avoid mistakes in the overall composition.

Although I found the alternative angle a challenge, the process of deciphering the correct perspective forced me to learn to intuitively view a design from extreme angles. Capturing the energy of the gesture also required extra time and work, although I think there is room for additional finessing, overall, I like the final design very much.

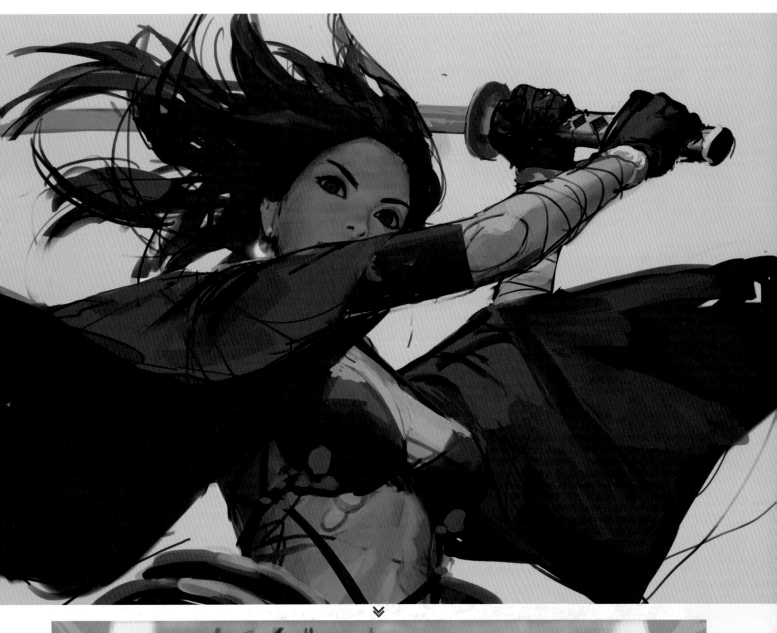

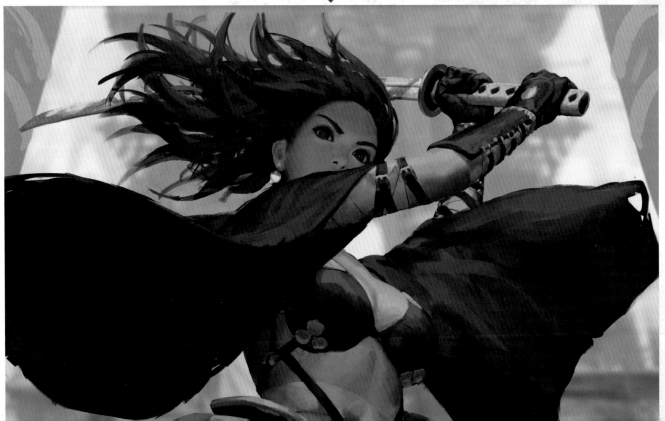

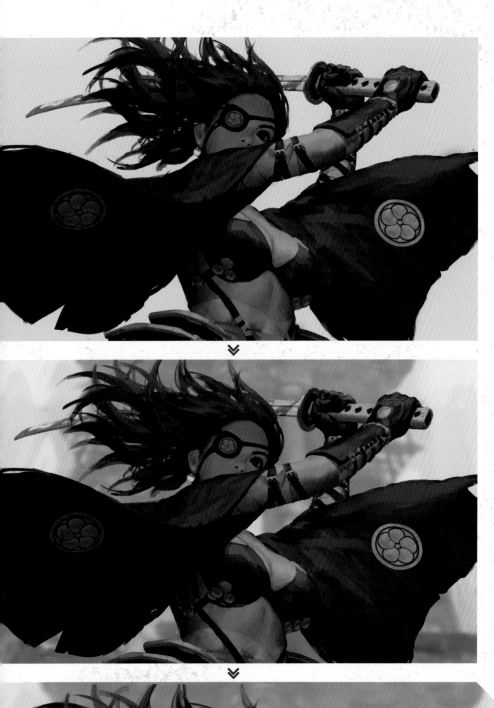

DESIGN EVOLUTION

From first sketch and ideation to final render, this design offered many challenges to overcome but resulted in a successfully dramatic and distinctly war-themed painting.

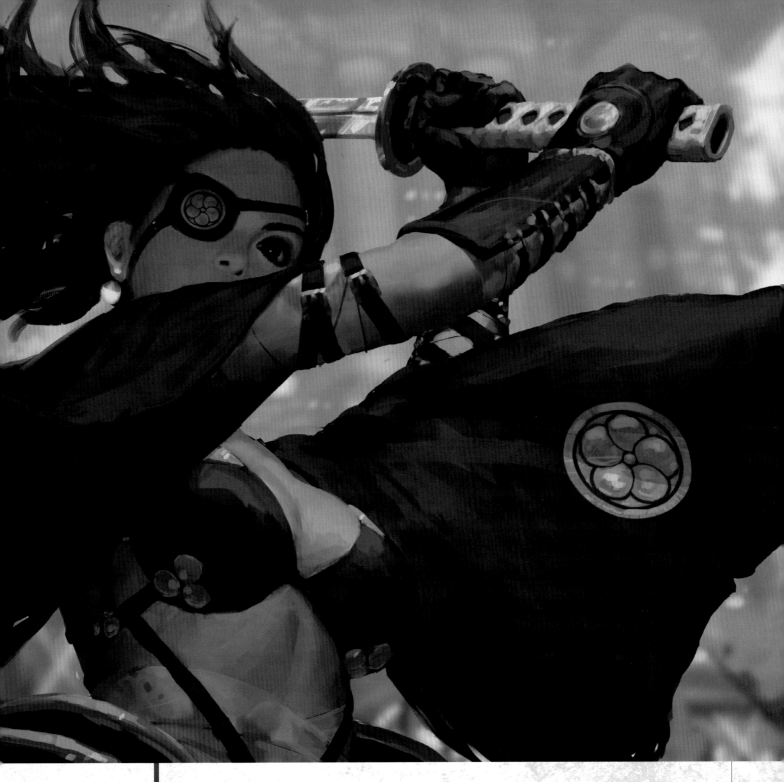

THE PROCESS OF DECIPHERING THE CORRECT PERSPECTIVE FORCED ME TO LEARN TO INTUITIVELY VIEW A DESIGN FROM EXTREME ANGLES

BLURRED BACKGROUNDS

Backgrounds can seem easy to create, especially if they are out of focus, but it's very important to make sure they have a solid design and are put together with fundamentals in mind.

building resilience and overcoming challenges

Growing as an artist isn't limited to improving skill. There is also an aspect of mental resilience that comes into it. Living in the age of the internet, we have a very powerful tool at our disposal, not only when it comes to looking up resources and storing them, but also when we want to display our own work. As versatile as being connected is, it also essentially exposes us to "everything" at once. We're able to see every kind of work, learn from it, but also be intimidated by it.

Artistic setbacks and challenges come just as fast and hard as you work, but I find that it's best to see them as just another part of an artist's lifestyle. Every time you face a new obstacle, chances are it's because you've progressed beyond where you're comfortable and a new level of problems begins to emerge.

Imagine completing a painting you thought was great, but a quick browse through your favorite art platform immediately reveals several pieces that far surpass your own abilities. It's not an uncommon encounter in today's age, and it's easy to feel bad or inadequate in the face of work that you look up to immensely. Unfortunately, I don't have a quick and easy solution to this problem. What helped me over time was to be very focused and clear in my own work and concentrate on what I wanted to achieve or improve in each piece. Over time, I was able to feel more inspired rather than dejected when looking at the work of artists whose skills far surpassed my own. Because of my goal-oriented approach, I could also see and account clearly for what others did better than me, instead of feeling overwhelmed by how amazing another artist's work was.

Alongside managing morale, it's also good practice to constantly be aware of your own progress and to take stock, especially when you notice improvement. I make sure to take note of anything I did differently when I finish a painting, and whether I feel it's an improvement on previous work.

Lastly, remember that there is always a next piece. Good or bad, the painting you are working on will inevitably be followed by another. Always try your best, and enjoy the process. Even if you make mistakes, learn from them and know your next will be better because of it.

KEEP MOVING

Don't allow yourself to become restless, and dwell on negative feelings. Either immediately take a break to do something relaxing, or if you're feeling up to it, attack your next piece and turn that lethargic energy into positive motion.

»
HOOD
A hooded stranger walks in a storm. This is one of the pieces that started my obsession with rain that lasted several years. The texture of the rain captures the space in the scene and offers depth to the design. There are plenty of issues with this older piece but I'm still happy to have it here.

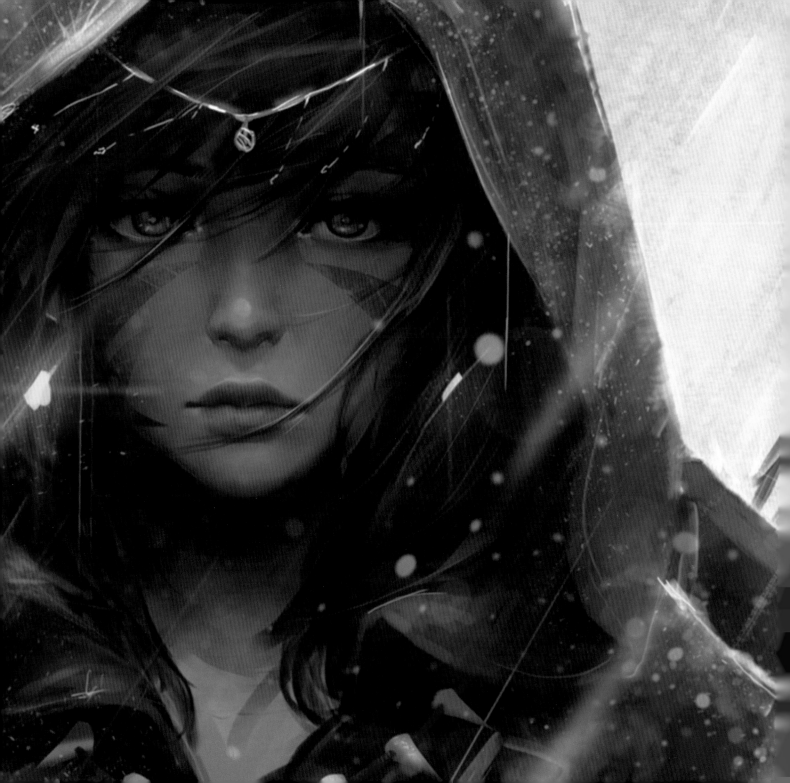

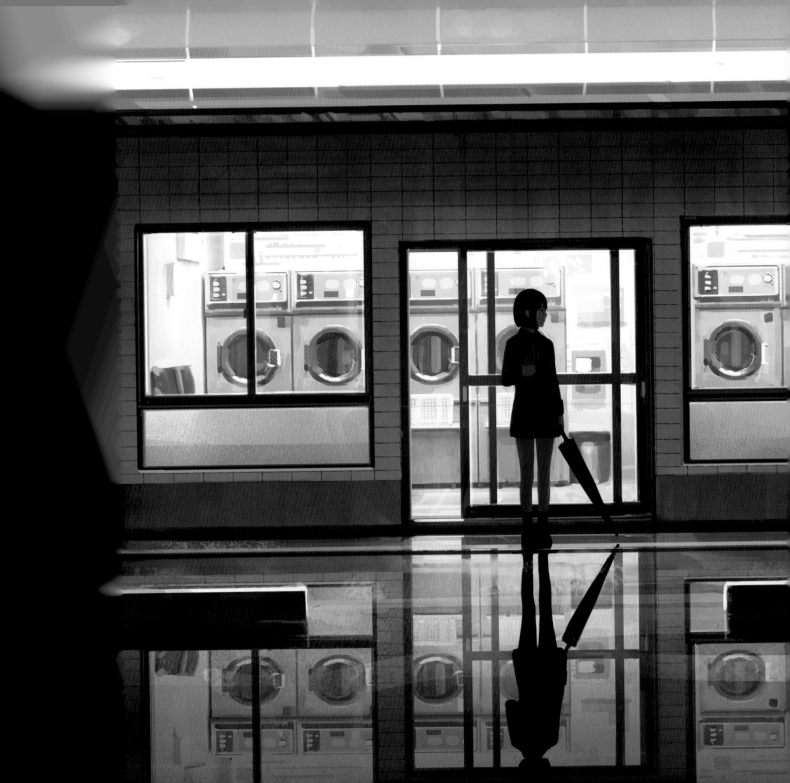

obstacles
and setbacks
practical

One of the most common issues I still face is when a painting gets stuck in the 60-70% completion stage. For example, you start with a sketch you like, paint in the key parts, but then the picture starts looking very incomplete, as if the main focus isn't interesting enough, or you've lost the focus. When I was less experienced, these problems felt like a huge setback. It's hard to feel confident when you realize all your work until that point might have been a waste and won't lead to the creation of a good piece.

Through the trial and error of overcoming this, I've found that when unsure of what to work on next in the piece, it's helpful to return to the fundamentals and focus on the central element of the image. For example, if a portrait feels incomplete, pay more attention to the character itself and make sure you get the features, proportions, and shapes down correctly. It's often when the focal point of an image feels weak that I make the decision as to whether I can make it work or not. Being able to consistently overcome this through experience and practice is a really rewarding feeling.

**LAUNDRY IN
THE WOODS**
A late-night visitor to
a remote laundrette
goes outside to check
out a strange noise.

emotional

Feeling as though your work isn't as accomplished as the work of others can affect an artist negatively. Dealing with this isn't as straightforward and it differs from artist to artist. While some naturally have a competitive mindset and are likely to get hung up on negative thoughts, others are more relaxed and find the feeling passes quickly. I used to struggle with overcoming this challenging feeling. The feeling isn't one of envy, because I understand the amount of hard work and dedication artists have undertaken to reach such a level. I feel that it's more of a concern, realizing I still have so much to learn. Being reminded of that is quite sobering. In short, when I see amazing art I worry that I may never reach that same skill level.

Over time, I've learned to turn this feeling into motivation. The more amazing and unattainable the goal appears, the more can be learned from it. Dissecting what's missing from your work allows you to convert an anxious state to a feeling of proactivity. Find areas of improvement and put that new knowledge into practice. A good way to do this is to always be working on a new piece. It doesn't necessarily have to be your next masterpiece, but it works wonders for me to always have something I'm currently working on.

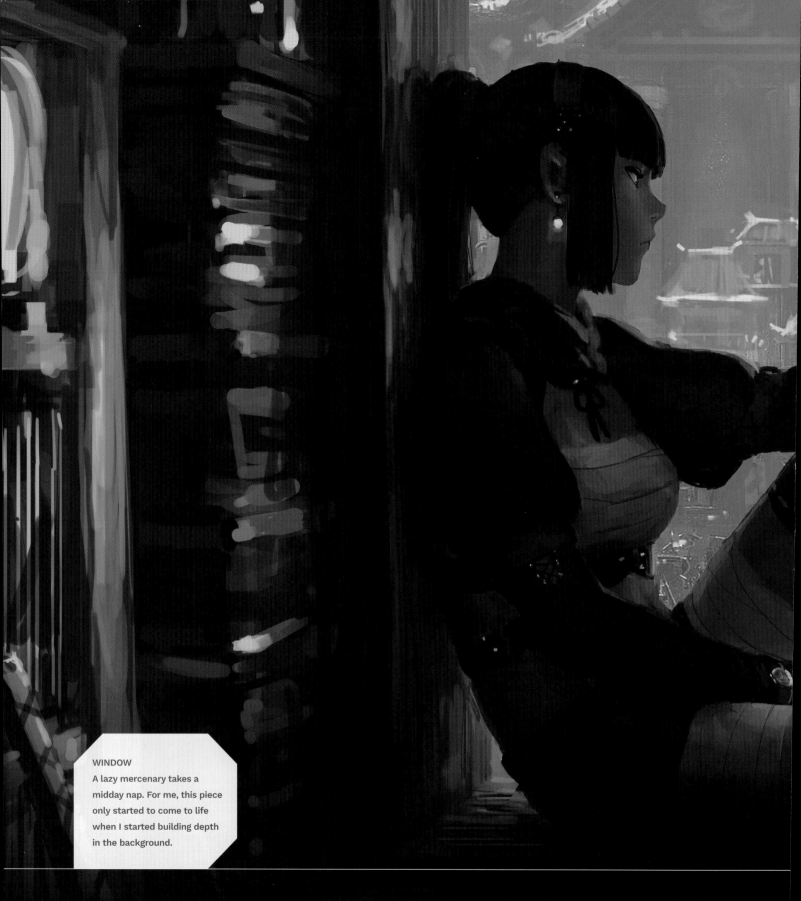

WINDOW
A lazy mercenary takes a midday nap. For me, this piece only started to come to life when I started building depth in the background.

Of course, setbacks don't just come in artistic forms. Sometimes tough things in life just happen and you have no choice but to step away from your work for a couple of days, or even weeks. It's an unpleasant feeling and it used to leave me visibly frustrated and grumpy. You've been working hard, learning so much, and have such great momentum on your side, and then suddenly you have to put it down to attend to

something. In retrospect, it's unhelpful to express your unhappiness by making your situation go less smoothly. The best way to approach it is to have a list of things you want to do on standby, so that inevitably when something comes up and you need to travel or go away for a while, at least you can use the time to catch up with things you actually want to do.

DISSECTING WHAT'S MISSING
FROM YOUR WORK ALLOWS
YOU TO CONVERT AN ANXIOUS
STATE TO A FEELING
OF PROACTIVITY

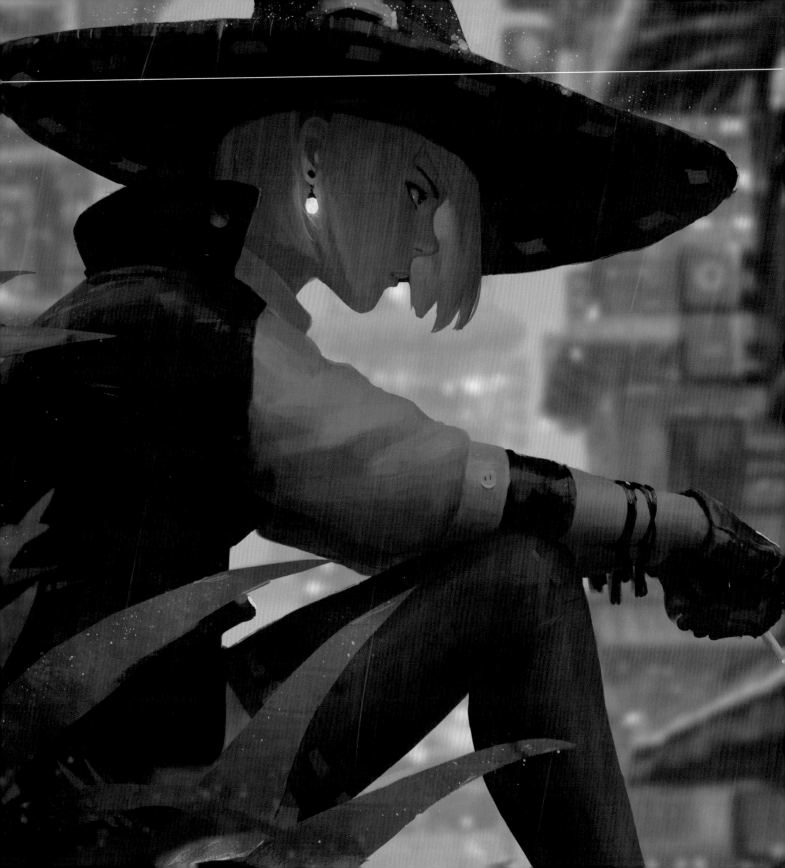

- WORKFLOW -

find the core idea

I consider whether there is anything specific I want to showcase. For example, which aspects of a character or environment should be highlighted to communicate my core idea? What could enhance this concept? Perhaps a particular type of lighting or an alternative angle?

I

approaching a new painting

During the entire painting process, which may happen over the space of a few days, I keep a reference board file open alongside the painting file. I also save multiple versions of the painting. This means I can easily access and copy and paste parts of an earlier step in the process (if I make a mistake or alter something too much), and also have an easy way to retrieve images if I need to compile some process steps. As a bonus, more saved files mean more security if anything happens during the very vulnerable process of file saving.

When creating a new piece, my workflow can be broken down into the following steps:

capture composition

I ensure, via a very quick sketch, or by looking over relevant references, that a strong composition can be achieved once painted. The composition should be balanced and implement lens distortion and perspective well. At this point, I stop and study whether there are any aspects of this idea that I have not yet considered, such as whether the sketch still works with the chosen lighting. At this point I do further research, such as browsing through my image library or searching for more references, so I can solidify the idea and find reliable visual references for difficult elements.

II

add value

Blocking in varying shades of gray, white, and black adds the first layer of paint to the sketch, and is where I start to add value to the forms. The value shows the volume of space in the scene and by the end of this step, it should be clear which elements are in front, behind, or to the side of everything else. This is often the hardest and most crucial step, as every step that follows depends heavily on its outcome. If I'm able to precisely and accurately indicate the volumes and shapes by this stage, later developments will be much easier. Challenges come in the form of difficult composition requirements, working in perspective, and making sure shape and volume line up and work well within the composition.

III

enhance the focal point

VI

The next step is to play with the relationships between elements – making sure that what needs to stand out does so. I often find that if I don't add enough detail and thought into the background environment, the image can struggle to look complete, so at this point, I work on the secondary elements in the scene.

During this time, I also begin to polish the overall design and add in finer details to the main focus, which is usually the character. With colors and values largely blocked in, it's easy to add little details, such as folds or buckles, as they can be simply painted in in context.

color

IV

I add color to the most essential areas, starting with the skin tone if characters are involved, or to the image as a whole if there is a prevailing color (for example, strong sunset lighting). Using a new layer set to Soft Light or Multiply usually comes in very handy, as entire colors can be adjusted at once with smart select tools on the respective layer. One of the key requirements in this step is to make sure everything that should have color is colored in, even if just roughly. I find it much easier to assess the painting as a closer representation of its finished state when all colored elements are present. For example, a rusty iron beam should have brownish-red splotches, red cloth should be red, and metals should take their respective colors.

If there are colored light sources in addition to the main scene light, now is also the time to add them in and make sure they fit well, without throwing off the weight of the whole composition.

affect with effects

VII

Post-processing effects come at this stage, such as blur, foreground and background particles, and color bleeding. It's still a good idea to keep an eye on the painting as a whole, as too many effects can alter fundamentals of the design, such as focus and composition. I also continue to paint over any areas I think need attention.

texture

V

At this stage, the majority of the painting is complete, so it becomes easier and much more enjoyable. I develop textures to distinguish materials from one another. Minor edits to shapes are also not out of the question, especially as elements change during the refining process. Sometimes major changes are also required at this point, which can be time-consuming – a reason for the need to be rigorous in the previous steps.

finalize

VIII

After polishing the details, I leave the piece overnight and take a fresh look at it the next morning. Sometimes I might feel like continuing to work on the piece, editing and adding more elements for another couple of hours. Once complete, I save the Photoshop PSD file as well as a separate JPEG version, for ease when posting online.

following intuition

I can't say how unique my workflow is, or if there's anything I and only I do, because most of my creative process comes quite intuitively to me. However, my understanding is that everyone works very differently for the most part. Some people immediately jump into coloring and block colors in the moment they finish their sketch. Some even sketch directly in color. The most important thing is to make sure you are comfortable with the process and are confident that it works for you.

I am always working on and reinforcing my fundamental skillset, but I mostly use a method of painting that relies heavily on achieving value and volume. By working in grayscale for the foundational part of the painting, I can direct my focus towards making sure I am able to depict the scene accurately in its dimensionality. Only once I have achieved that do I move on to working in color.

There are positives and negatives to every method. For example, using my usual method, I can sometimes struggle to fully populate the composition with color, which slows the process down hugely, especially if I am creating more colorful pieces. And when starting with coloring, for example, I have difficulties figuring out the overall shapes and volume within a design. Either way, I think it's best that artists try out different methods to find out which fits best with their workflow and which they enjoy most. It's completely natural for processes to adapt and change over time. And it is important not to get too fixated on the exact steps and to instead understand what needs to be achieved at each stage of the painting.

LATE
A city dweller basks in the glow of countless lights, beaming from a city that never sleeps. Depth of field is a fun cinematic trick to play with when the composition allows. Especially when bright light sources are involved, the blur of the lens can create a rather magical effect, almost making every light ten times brighter than it should be. I think the best setups however, also complete the field by featuring something out of focus in the foreground, closer to the viewer.

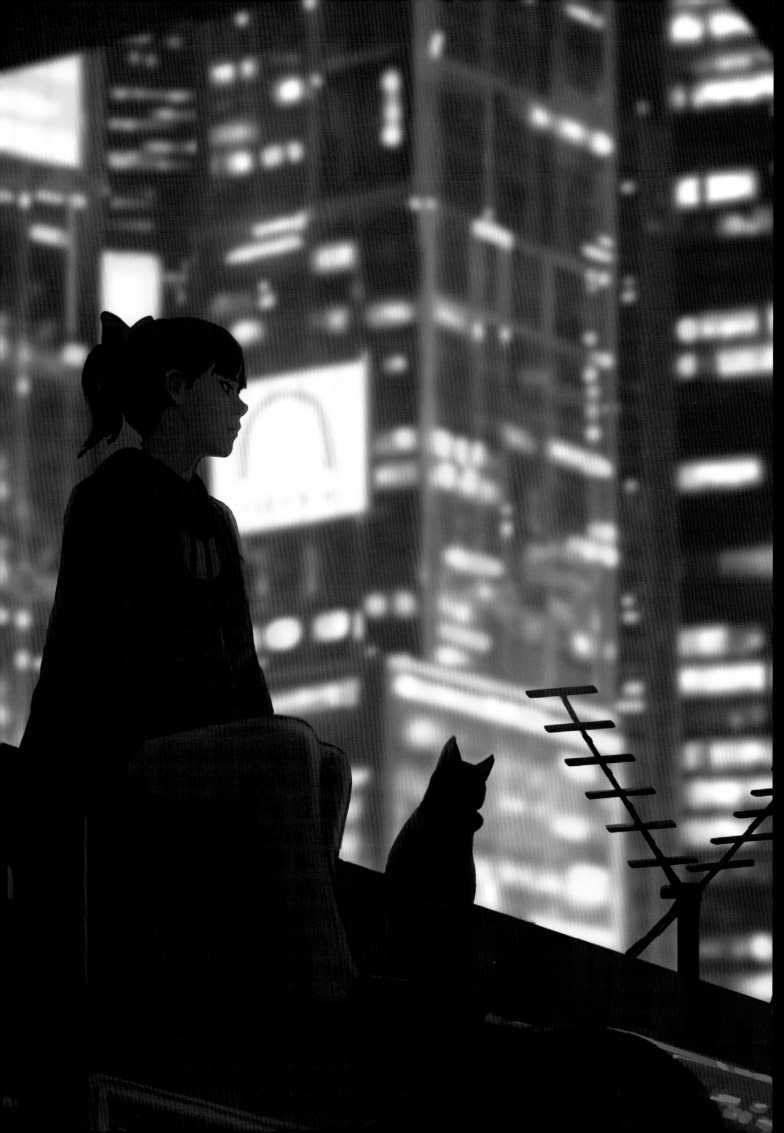

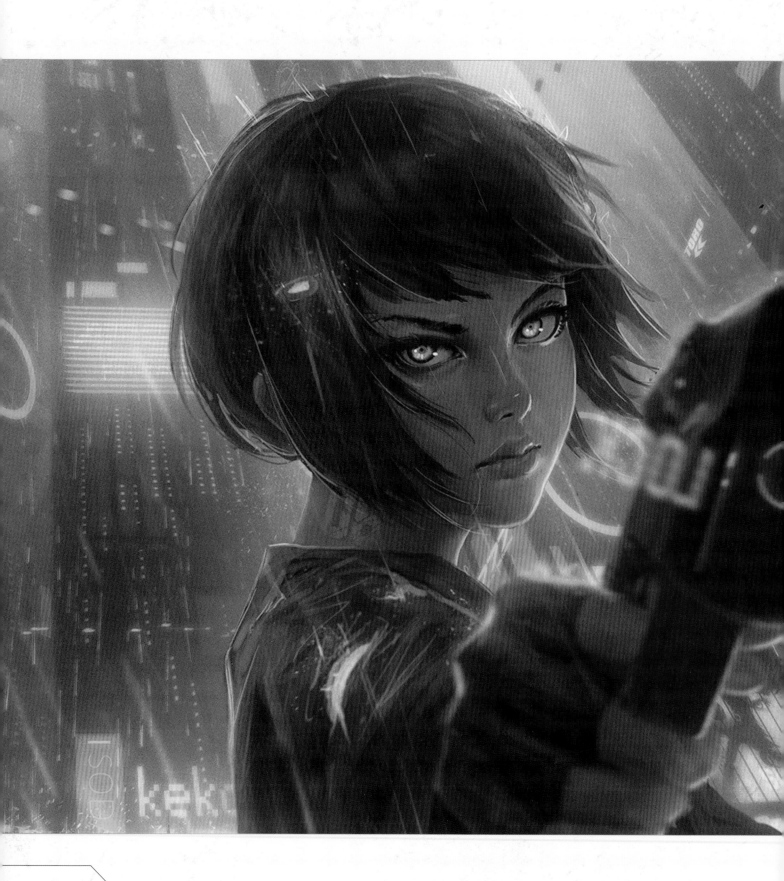

expectations and communication

I avoid having too many expectations of others when it comes to my work. It's awesome if a piece is well liked and introduces a lot of new people to my work, but constantly expecting it to happen can lead to a lot of disappointment and negativity surrounding your art. You must accept that audience engagement is one element you can't ensure and that not every work will break a record. Instead, focus your concern on your own engagement and excitement for your art. Even renowned masters have artworks that speak more to their audience and some that speak more to themselves or other artists.

NOT EVERY WORK WILL BREAK A RECORD ... FOCUS YOUR CONCERN ON YOUR OWN ENGAGEMENT AND EXCITEMENT FOR YOUR ART

The key to staying healthy with regards to expectations is simply to try to create a piece that you are happy with. If that sounds like an excuse to reduce your efforts, it's not. I often find it much easier to finish a piece if I only think about satisfying the audience. I've been posting my work online for long enough now to have a idea of what my audience enjoys seeing and what they have a harder time engaging with. Strangely enough, it ends up being much harder to meet all of my own requirements for a piece than to follow a checklist of elements that people usually respond well to.

Another topic that has seen much discussion is creating fan art. Some artists primarily draw artworks based on others' intellectual property and find a lot of their traffic comes from creating seasonal art of popular culture, such as TV shows or films. I believe it's a valid way to pursue art; after all, they contribute a unique touch to a well-liked concept – I certainly enjoy looking at fan art of characters I know well.

However, I tend to avoid creating fan art as I don't often find myself passionate about TV shows or characters enough to immediately create art based on them. I also find it restricting to draw someone else's concept, and am always conscious that it is possible to misinterpret it horribly and end up making something that goes against the author's original vision. The times I have created fan art, especially as I have become a more experienced artist, are all situations where I felt I had an original reinvention that was worth sharing. I personally feel more of a sense of urgency to practice and build my own visual library and hone my skillset, rather than imitate what already exists.

project insight: concert

A singer gives it her all in a busy shopping plaza. A low angle proved to be a useful tool in this composition. It gives the main character the biggest presence, as everyone looks physically smaller because they're further back in the scene. A strong centerpiece often brings opportunity to have a bit more fun with secondary features: in this case, a big shopping mall, a couple of bright billboards, and some heads turned in the crowd.

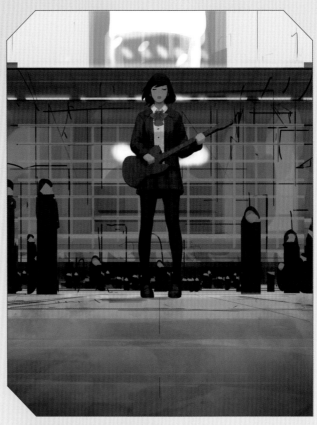

Once the focal point and low angle were decided upon, the design was quickly blocked in.

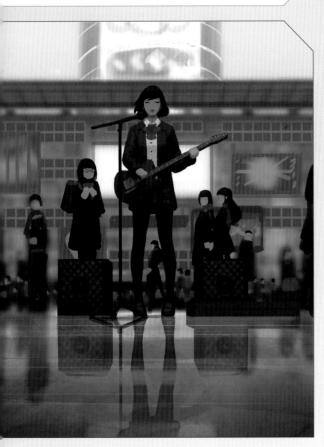

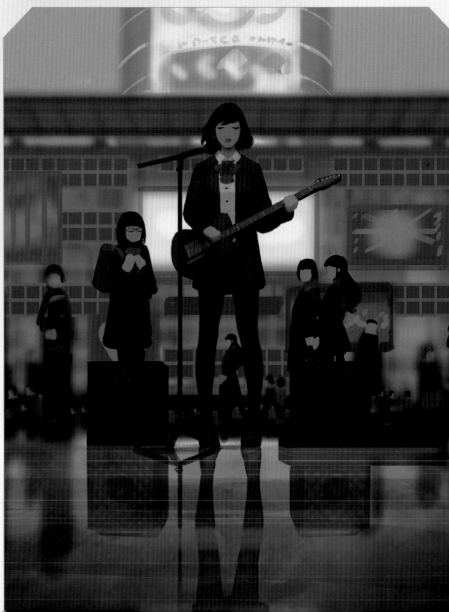

Color, even a limited palette, brings a touch of life and realism to the piece.

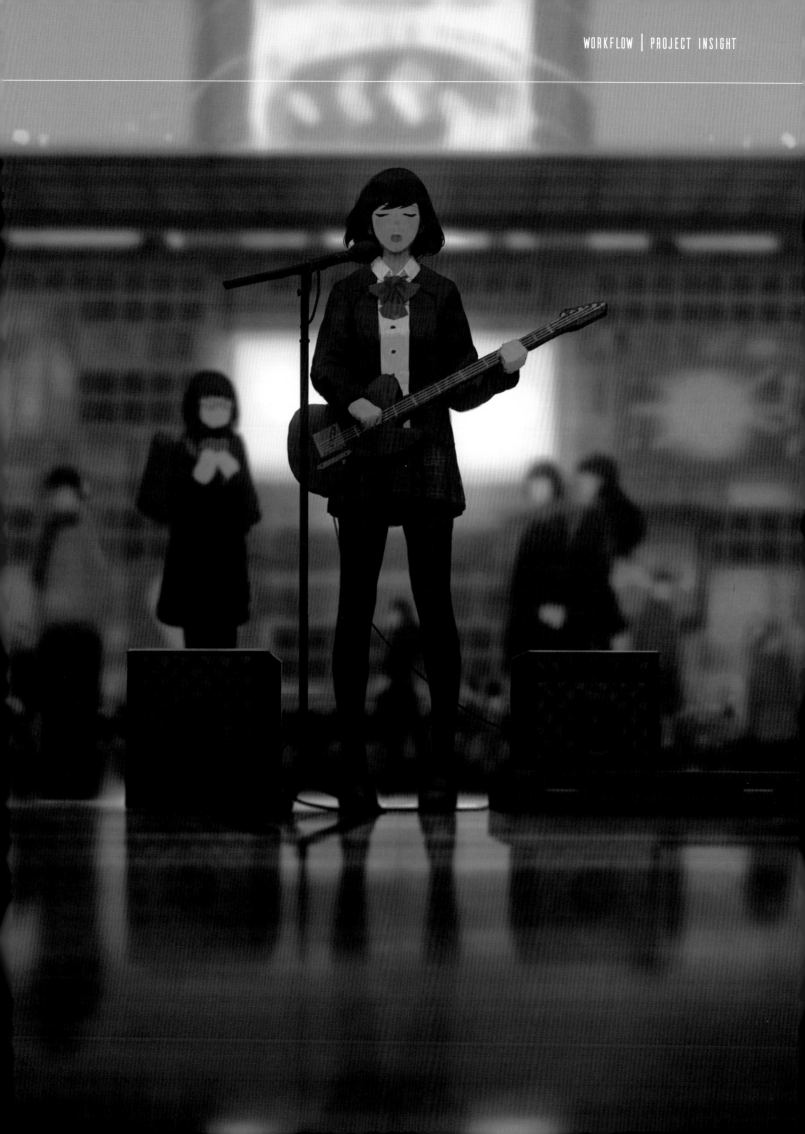

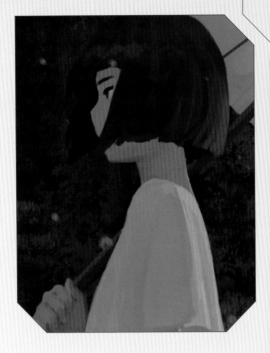

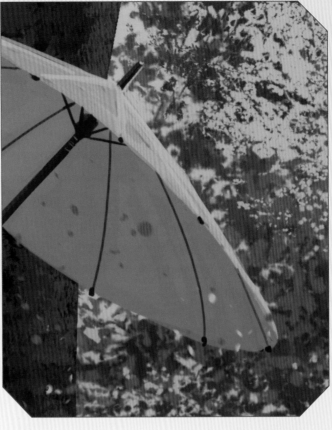

color and light

As far as colors go, I would call myself a novice. I feel I'm proficient in coloring my pieces such that they work on a foundational level, but I'm still far from being able to plan complex color schemes in advance and execute them perfectly. Color can evoke very specific emotions in very specific combinations and that can be a real challenge to understand and use to your advantage.

Color is one aspect of design that I aim to improve in over the future. Color is an extremely powerful tool that can do a lot for a painting. It doesn't just add a touch of realism; it can go beyond and transport the viewer into the world of the painting.

I feel I have made some progress in understanding the more technical side of color. Just as in real life, multiple lighting sources (including natural ones) can vary in color. I find it very helpful to use color in that context to define surfaces more clearly. For example, if I paint all upward-facing light to be a little warm, and all downward sources to be a little cold, it increases the contrast significantly and can

serve huge purpose in a composition. Similarly, there are certain colors we are very familiar with in daily life, including the light touch of blue in the midday's shadows and the strong reds and violets we sometimes witness at sunset. These are universal in indicating the time of day and can become very helpful to build atmosphere in suitable pieces.

In these situations, color becomes incredibly useful in making sure the viewer understands the lighting, and even the time of day. For example, a weak downcast gray light from above would indicate a cloudy or hazy day, while a similar light but blue would indicate evening, early morning, or very cold weather.

RED LEAVES

A lost girl meets a white rabbit in a blood-red forest. This piece gave me a really fun chance to play around with textures and colors. I usually keep to more conservative palettes, but I'm glad I gave this red and white combination a try.

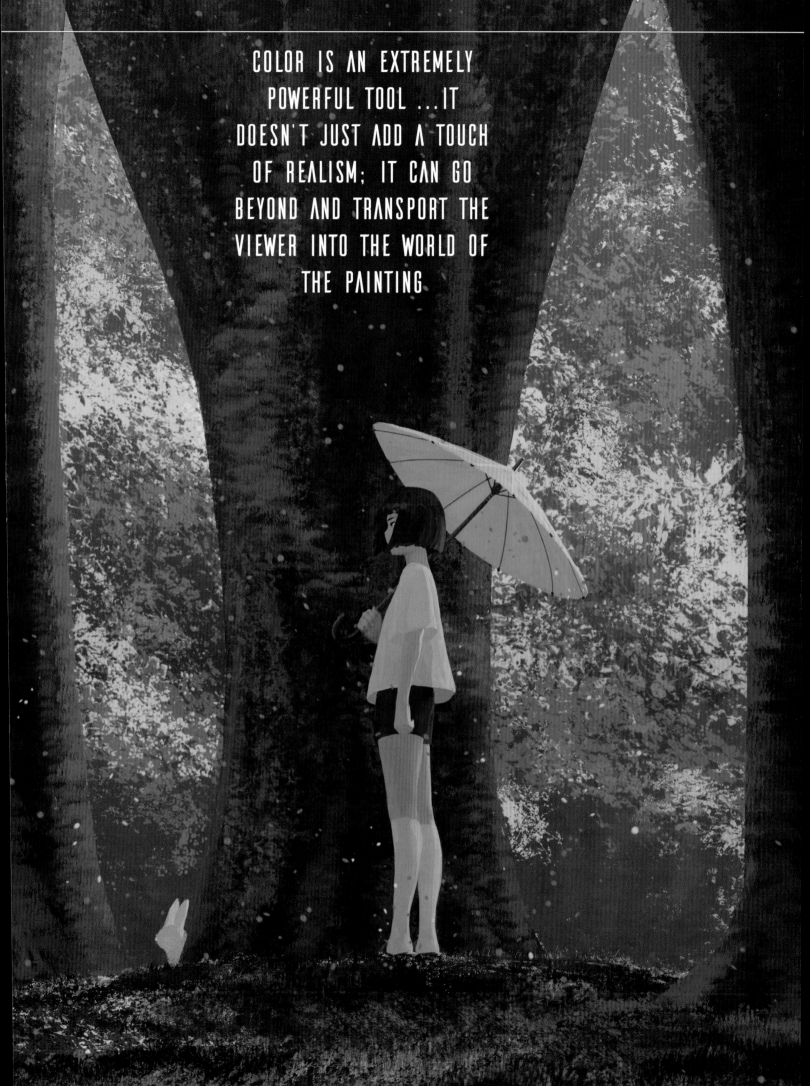

COLOR IS AN EXTREMELY POWERFUL TOOL ...IT DOESN'T JUST ADD A TOUCH OF REALISM; IT CAN GO BEYOND AND TRANSPORT THE VIEWER INTO THE WORLD OF THE PAINTING

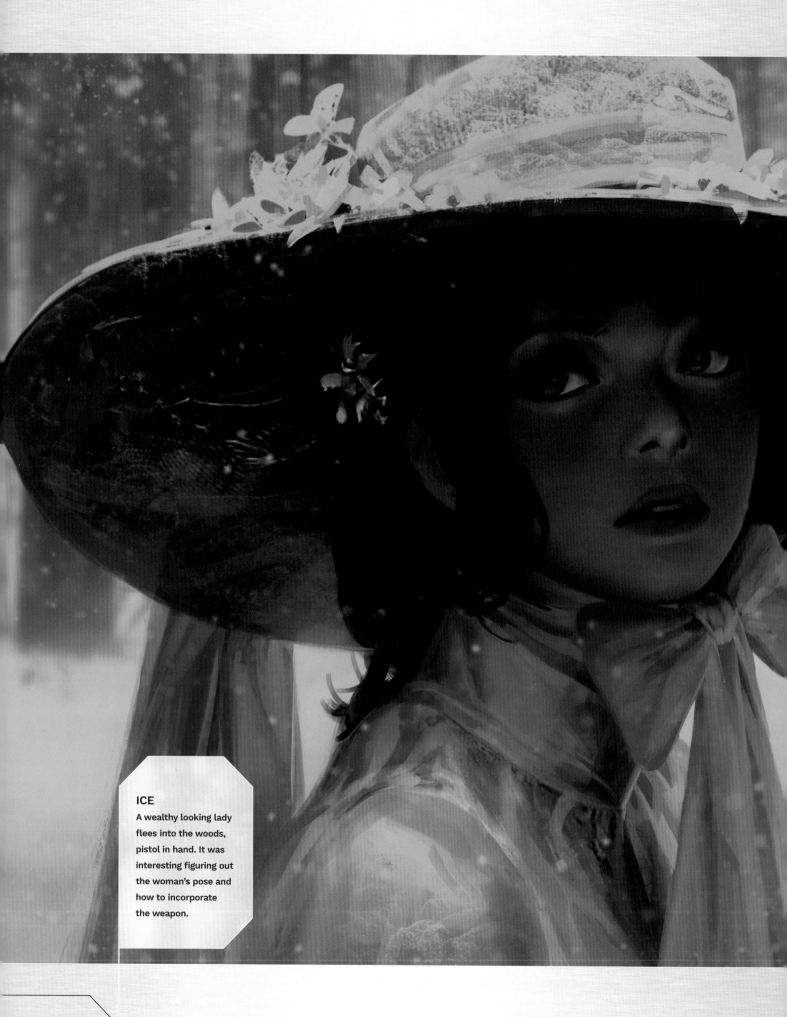

ICE

A wealthy looking lady flees into the woods, pistol in hand. It was interesting figuring out the woman's pose and how to incorporate the weapon.

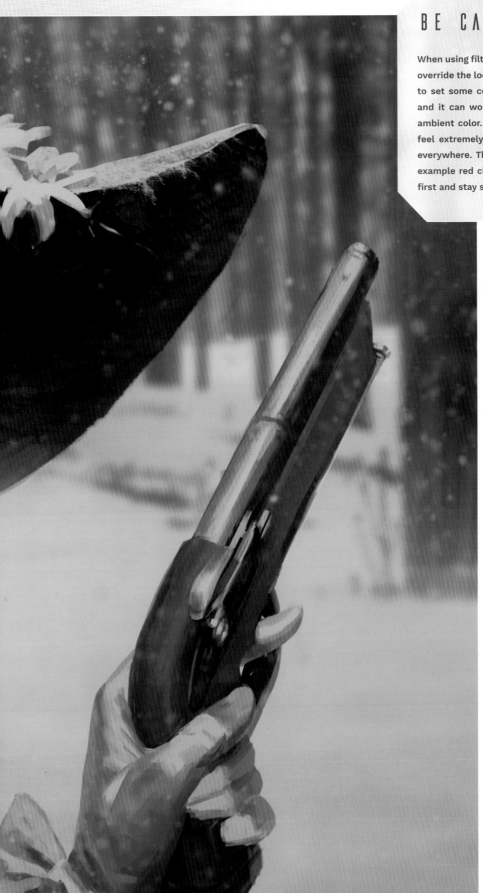

BE CAREFUL WITH FILTERS

When using filters for early coloring, be very careful that you don't override the local colors in a piece. It's tempting to overlay a filter to set some colors for your shadows, midtones, and highlights, and it can work quite well in pieces which have a very strong ambient color. However, if you're not careful, the piece can still feel extremely monochrome despite there being colored pixels everywhere. The key is to make sure that colored elements, for example red cloth, brown leather, or green grass, are colored in first and stay sufficiently saturated as ambient color is added.

Another place colors can shine is in character and set design. While I do generally enjoy darker costumes and clothing for my characters, I still find that there needs to be at least one or two additional accent or highlight colors to make the design work. For that purpose, we can get creative with color beyond just having fabrics or apparel being dyed a certain hue. Rust, dirt, or environmental debris can add color to characters and environments greatly, while dyes and colored metals can help add a local color to important parts of the painting.

In my personal work, I prioritize using color to help the world feel more real, as I find the transition between grayscale and color extremely important to how immersive a certain work feels. I often prefer muted colors to very vibrant ones, but I think that's something I definitely want to master and add to my arsenal in the future. I have seen many amazing pieces which use very vibrant color palettes to great effect, which motivates me to start learning how to apply them better. As with many other aspects in drawing, I would rather have a fuller perspective on the subject at hand and then decide on what to do with that knowledge, than get stuck doing only one thing because that's all I know.

subject matter

A common goal I have for a lot of my work is to create a believable scene for which the viewer can suspend their disbelief. Being able to create artwork that interests people in a fantasy world is an incredibly worthwhile venture. Much of what I draw is derived from my interest and excitement surrounding a subject and my desire to share it with a like-minded audience.

With that in mind, I often aim to create superficially mundane but thematically interesting visuals in my work. For example, many of my characters simply exist and interact with the world around them in a very casual way. I think this makes them feel a little closer to real life than if they were always performing some kind of flamboyant pose or action. In that case, I also try to subdue the presence of the unusual environment, not framing it as front and center compositionally, but allowing it to exist in the background as it would in real life. Rather than forcing elements of the world upon the viewer, I find it a bit more believable to allow the setting, and its effects on the character, to speak for itself.

I also find it incredibly enjoyable to capture dynamic moments. The appeal, however, is completely different for me in those pieces, as I allow myself to indulge in exaggerating elements of the design and composition, abandoning the quietness of my other works. While I have found a comfort zone with my workflow, I am also keen to experiment and push my work in order to explore new ideas I had not considered before. It's exciting and awe-inspiring to know that there's so much more out there to discover and wonder at. Just the thought of being able to encapsulate a tiny taste of that in my own work is plenty motivation to keep me drawing for hours on end.

MESSENGER

A mystic speaks to a magical butterfly bringing tidings of war. Creating the background for this piece was the highlight of the process. Depicting the focal character interacting with a butterfly while a huge character waits in the background, gives the design an immersive quality. Playing around with scale can produce quick and interesting results.

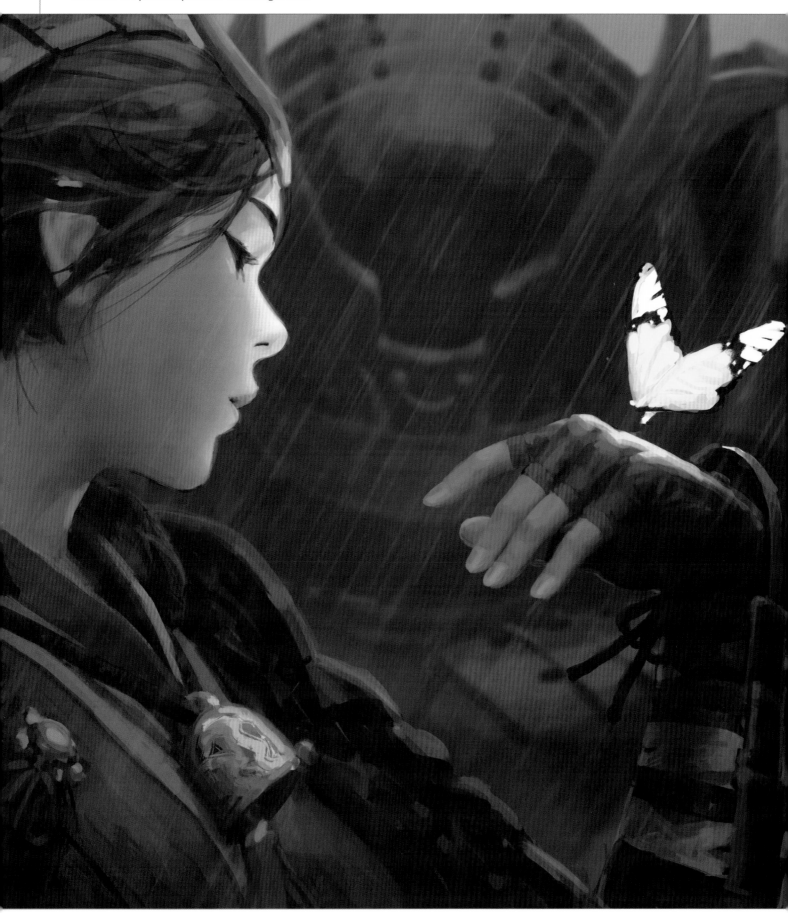

project insight:
violinist

A musician presents a rooftop performance for the birds. Thanks to the collection of cinematic poses that I rediscovered while browsing through my reference folder, this piece was very enjoyable to develop. Low angles are always interesting and sometimes challenging to portray because of how much material can fit into the foreground and background without obstructing the main focus.

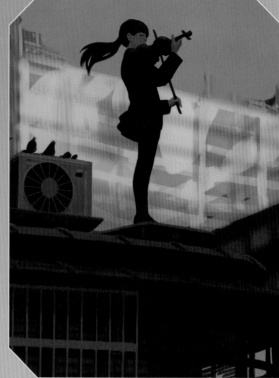

The final color palette for this design was only decided once the overall composition and values were added. It could have gone in many different directions, but I decided to use the high contrast of a golden-hour setting.

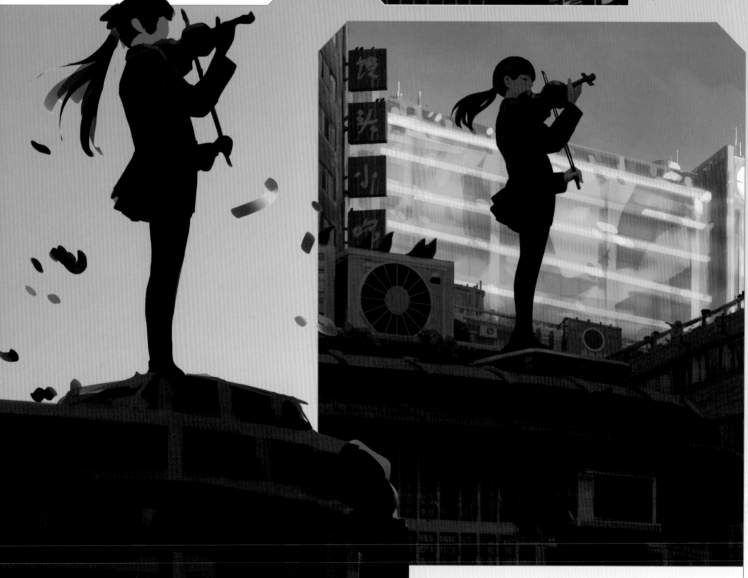

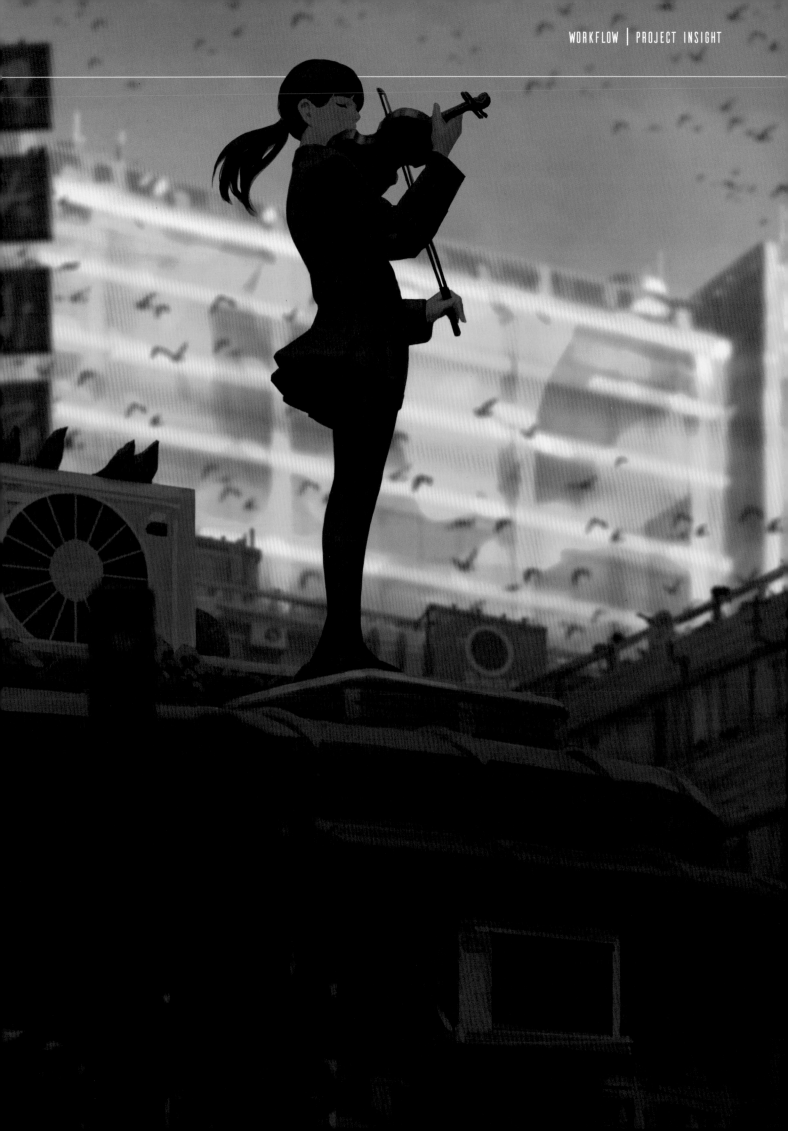

narrative

I believe that every painting needs a narrative. Not only does telling a story make the artwork more interesting, it's also a chance for the artist to inject their personality into a piece. Do you enjoy portraying sinister, dark scenes? Or maybe you prefer using warm colors to present calming or soothing stories? Over time, an artist's personality really shines through their work; if you've seen enough of their art, you can almost tell what kind of stories they prefer. Narrative can also act as one of the factors that keeps people engaged and waiting for your next piece of work.

When it comes to delivering a story, a painting is one of the more challenging mediums to work with. You only get a single frame to let the viewer know why they should be interested, and everything starts with the first impression. The immediacy of social media and internet browsing means that an artist needs to work hard to grab and keep a viewer's attention from just a thumbnail image. This means that even zoomed out, the viewer should be able to tell at a glance what's happening in an image. Only if they can identify a vague narrative might they be interested enough to investigate and take a closer look. This doesn't just apply to getting more views. A good painting should be able to execute its message at all levels of "zoom." In industry work, these principles also apply to concepts and designs, as well full paintings.

The process of adding narrative starts right at the beginning when we decide how our subject and elements interact with the composition. What is happening in the scene? Is it obvious to the viewer? Does the composition complement the story, or does it go against it? Are the colors suitable to suggest such a scene? There are many questions that go into making sure we start from a strong position and know clearly what the goals of the piece are. A good narrative goes hand in hand with strong fundamentals. There are certain compositions and angles that are so powerful that they can compensate for minor errors, for example, in the perspective or pose. However, in order to be able to consistently inject narrative successfully into your work, it's important to use strong fundamentals as a springboard.

FOG

A mysterious roaming mercenary crosses a rice paddy, looking for the next town. This is the second piece I have created that has been set in a swamp. This time I aimed to include all my usual favorite fantasy elements and I'm very pleased with the resulting image.

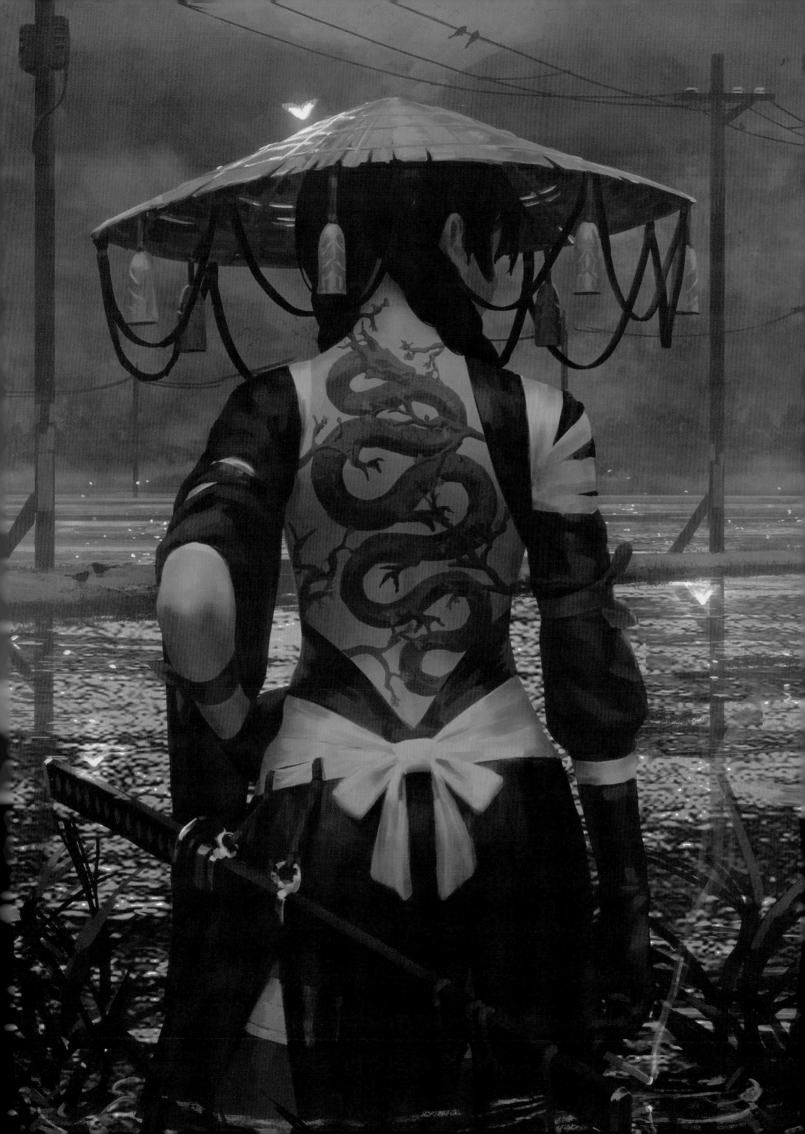

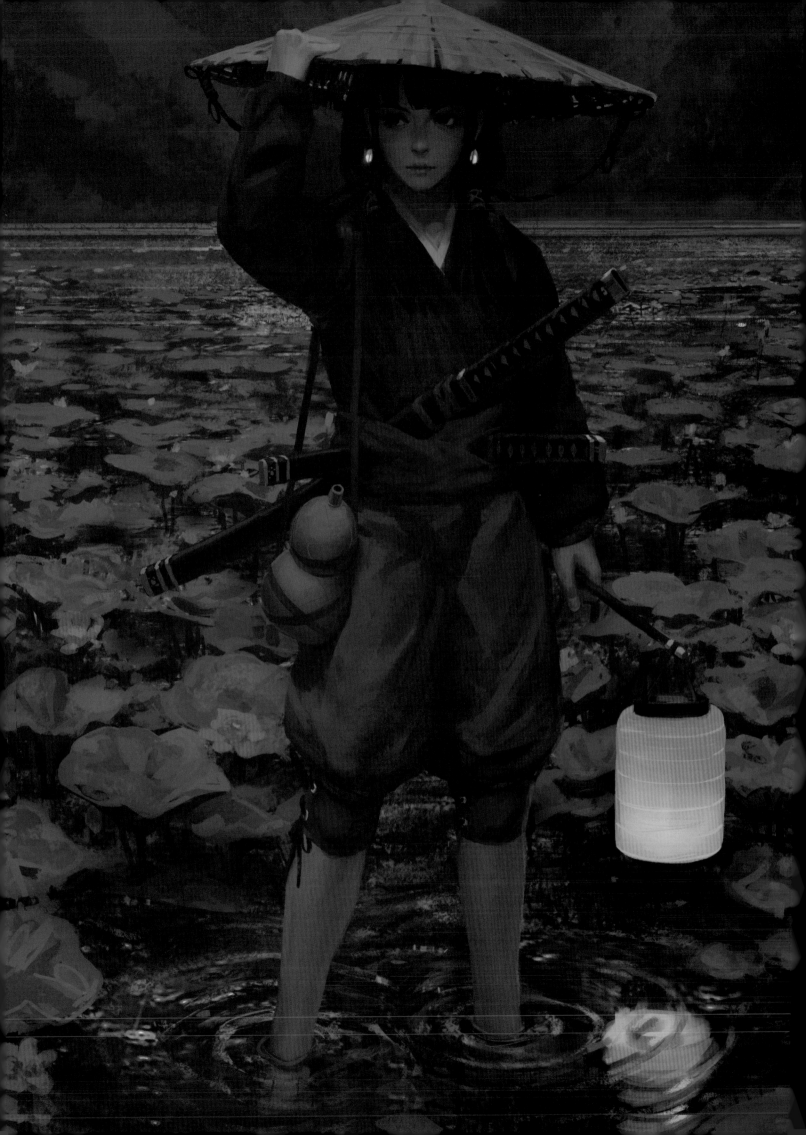

THE PRODUCT OF BEING YOU IS SOMETHING THAT OTHERS CAN'T EVER TAKE AWAY

Sometimes there will be compositions that are perfect for the intended story, but the requirements for actually painting the piece may be rigorous. For example, the main focus may be brightly lit and therefore require precise knowledge of its form; the perspective and camera focal length may distort parts of the image in frame, making it very difficult to visualize things in three-dimensional space. Compositions such as these demand much from the artist.

Other times we may just be in the mood for creating work within our comfort zone – themes that we are familiar with, and characters we enjoy drawing. It can be a very good opportunity to invest time in our strengths. For example, if someone is really skilled at depicting sunset lighting and coming up with compositions that use it, their comfort-zone paintings of dusk scenes could be a great chance to build more depth into their narrative. Over time, they may accumulate a range of work that resonates with them and their audiences, presenting a great opportunity to produce a collection.

However, I think it's still ok to relax in your comfort zone. Not every piece has to display everything you can do. Sometimes a piece can flow easily, and that itself may encourage new thought processes and uncover new things about your workflow and storytelling – skills that a challenging piece may not allow you enough energy for.

Ultimately, I believe the possibilities are endless as to what unique pieces artists can create, especially after factoring in how everyone has a different way of telling a story. I find it very motivating to know that if you spend time developing yourself and your art, there's always something incredibly special waiting to be found. The product of being you is something that others can't ever take away from you.

LOTUS
An explorer with her trusty lantern that always shines, even on the gloomiest of days. Overall, I feel that this design works well, but the pose could be a little more dynamic.

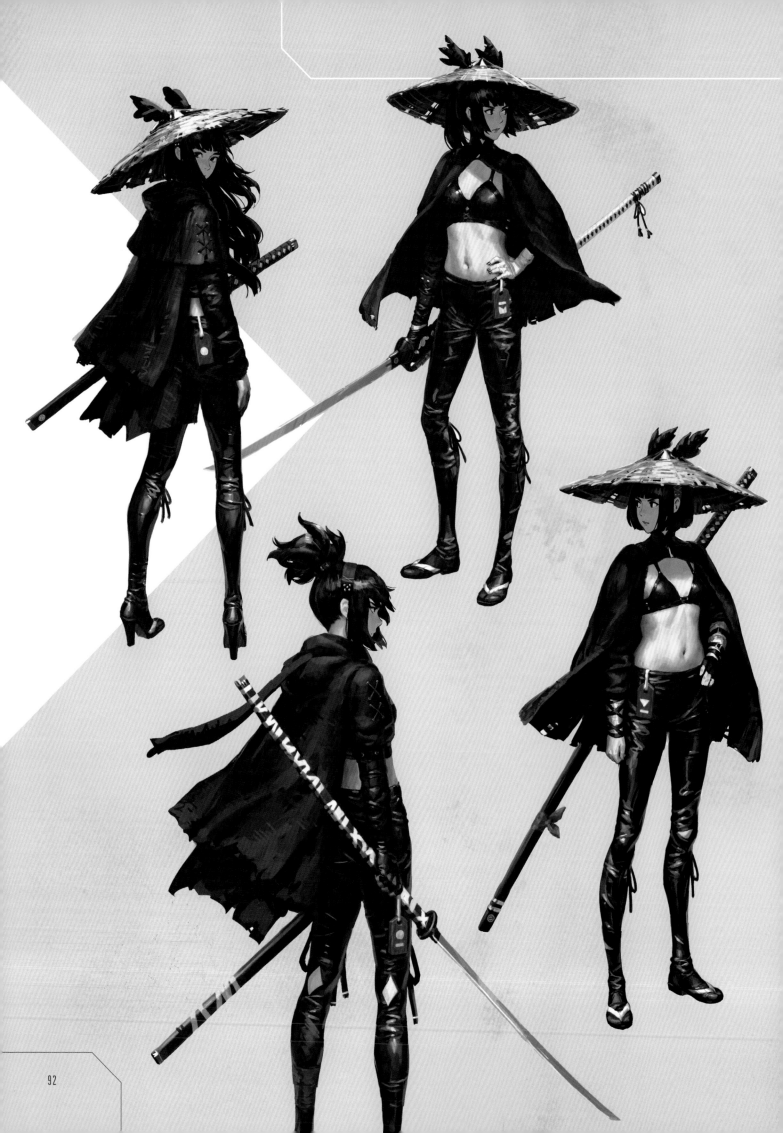

characters

I've not yet created any named, consistent characters for my work. Part of the reason is that I like to reserve the flexibility to keep changing the characters' appearances based on the piece. Another reason is that I still don't think I have solidified the universe in which to place them. Designing characters and settings is something I do quite often for external client work, but strangely enough have not yet done for myself. Putting time into designing a few characters that I can name and keep coming back to is something I plan to start doing however.

That said, there are a few elements that I like to add to my characters, making them into a kind of meta-character. One thing that is immediately recognizable is the dark clothing. Dark colors help to keep clothing and other parts of the body slightly less attention-grabbing and allow the face to stand out. As we humans are drawn to the faces of other humans, the face becomes a natural focal point in artwork, making it a key element of the overall design.

Another reason I enjoy using dark colors is that it is often easier to paint dark colors roughly, and it's more forgiving of small mistakes, allowing me to save a little time and stress unnecessarily finessing non-focal areas of the painting. A character with a dark clothing silhouette is also easier to incorporate into darker environments and backgrounds. It really helps in quickly establishing depth and making the character pop off the page, as often lighter colored elements can accidentally blend into darker parts of the background. Darker silhouettes also provide me with opportunities to play with lots of dynamic shapes, which can improve a composition. However, I mainly just enjoy the general aesthetic of dark clothing, which is why it's so common throughout my work.

Another element that could be seen as a mark of my particular style is the glowing orange earrings and orbs that appear in my work. They started simply as a way to make the image look a bit brighter. Having entire patches of dark colors on the canvas can confuse the viewer as to whether the setting is actually dark, or if the image is just underexposed. The little highlight is a good way to introduce some saturation to the image without it being overly weighty on the overall design.

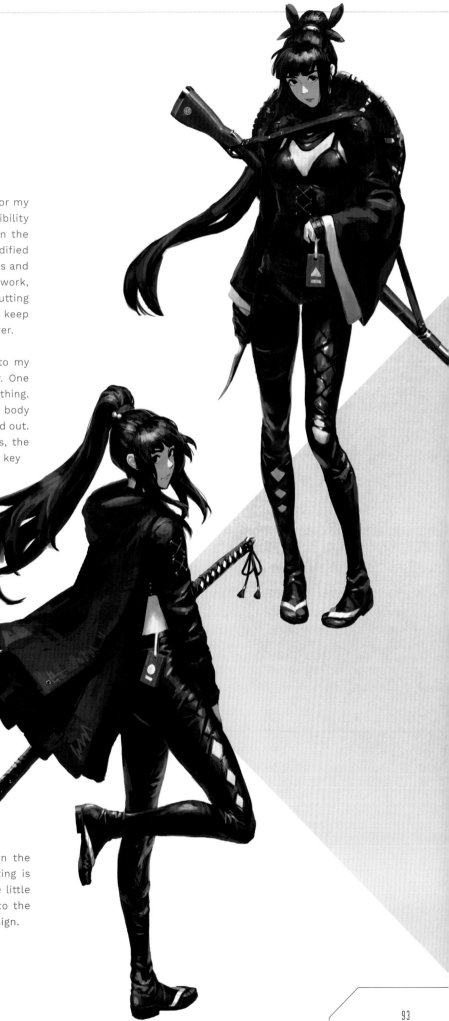

project insight:
inspector

A stern and uncompromising detective overlooks a crime scene. The story for this piece only emerged towards the end of the creation process. Only after adding the red accents as a color highlight did I begin to think that the badge might have a purpose, possibly identifying the bearer as someone of rank, such as an inspector.

The design of the character and her attire evolved over the course of the design development. The addition of the glowing earring introduces bold contrast and eye-catching detail.

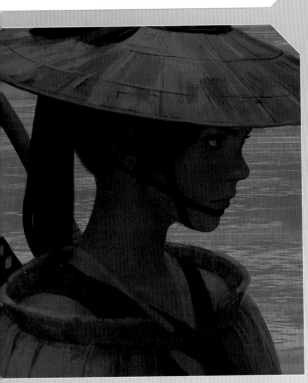

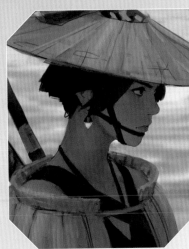

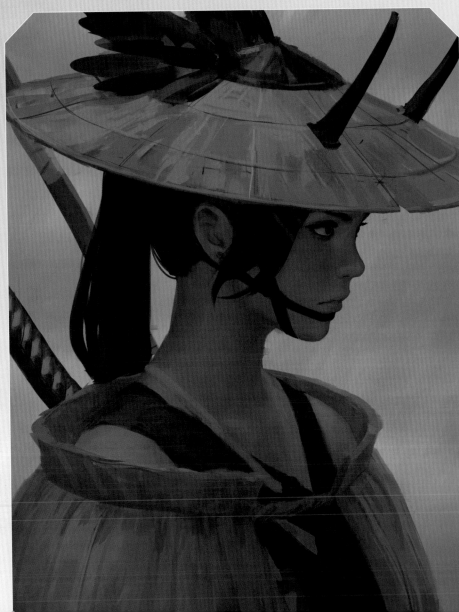

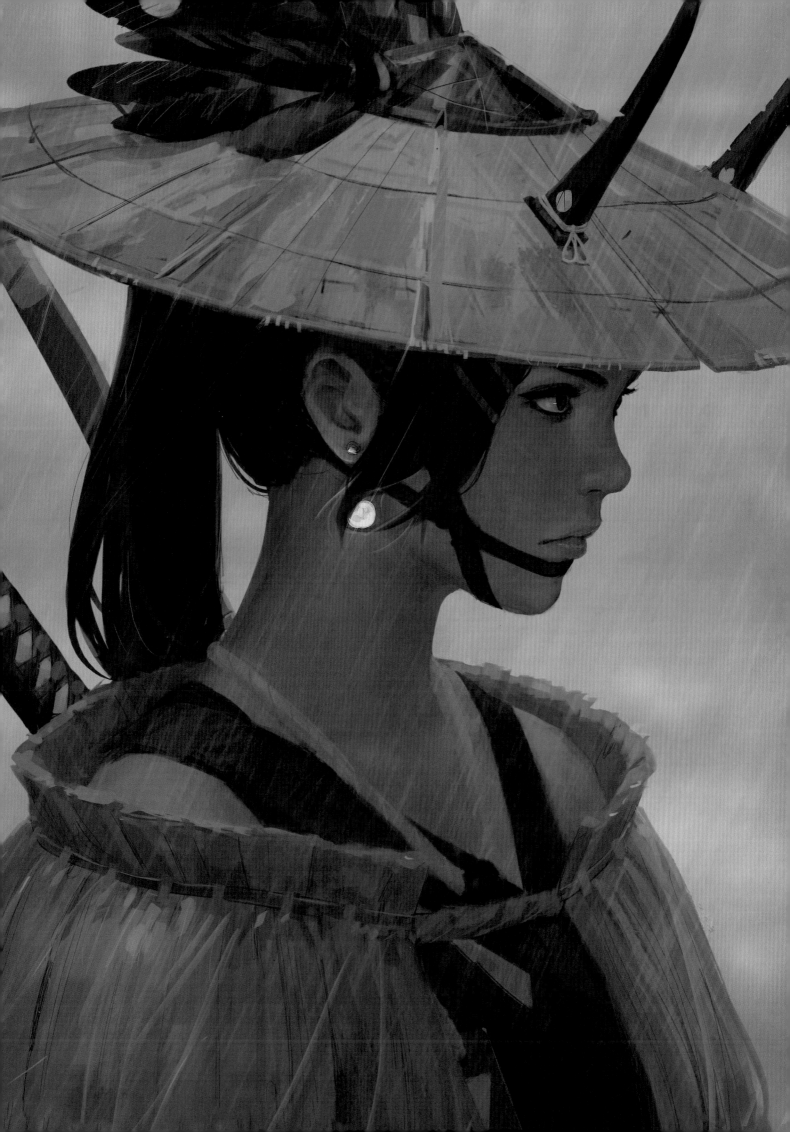

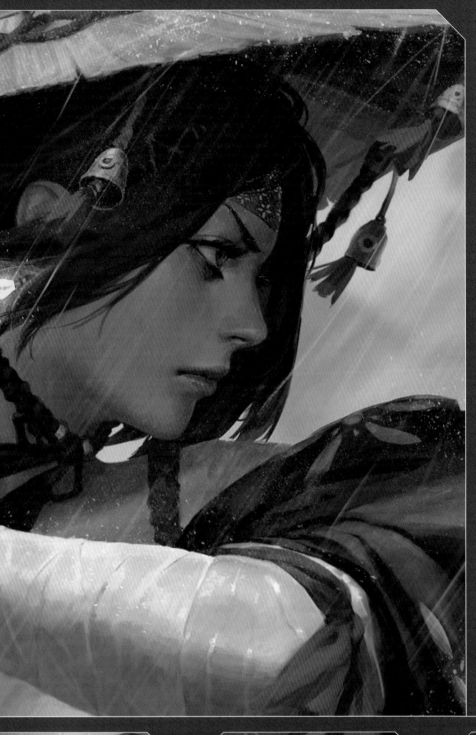

GALLERY | FANTASY

The biggest moments of joy come when designs and characters are complete and effectively communicate the fantastical narratives I have in my mind. Knowing that these pieces have attracted an international audience is one of the greatest forms of validation I have had as an artist and motivates me to continue to create original pieces.

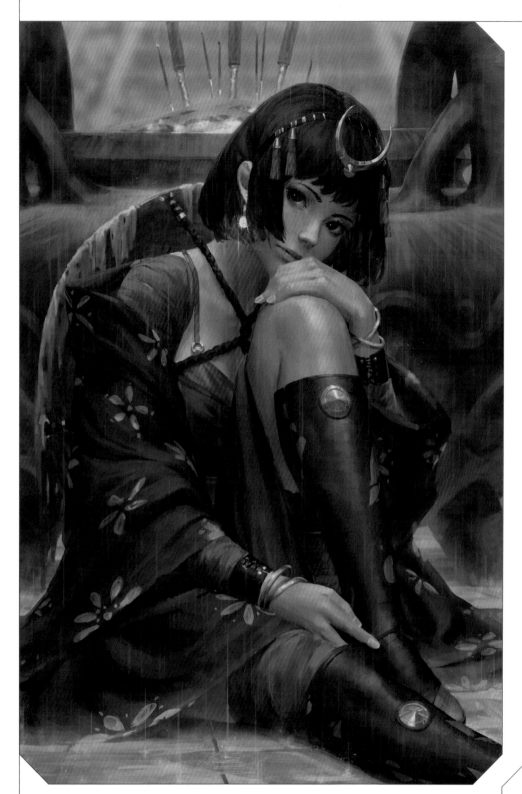

MYSTIC

A shrine maiden takes a break in the rain. I very much enjoyed creating this design. The character's colorful wrappings add a welcome burst of color to the otherwise yellowish-green color scheme. It's a little strange to think she would just sit out in the rain, but who knows what she's thinking?

MASK

A warrior dons her mask, in anticipation of battle. This was another very fun piece to build. Using reference photos, I decided upon the pose early on in the design process, but found everything else a huge challenge to deal with, especially achieving the accurate perspective and foreshortening on highly decorative pieces of armor.

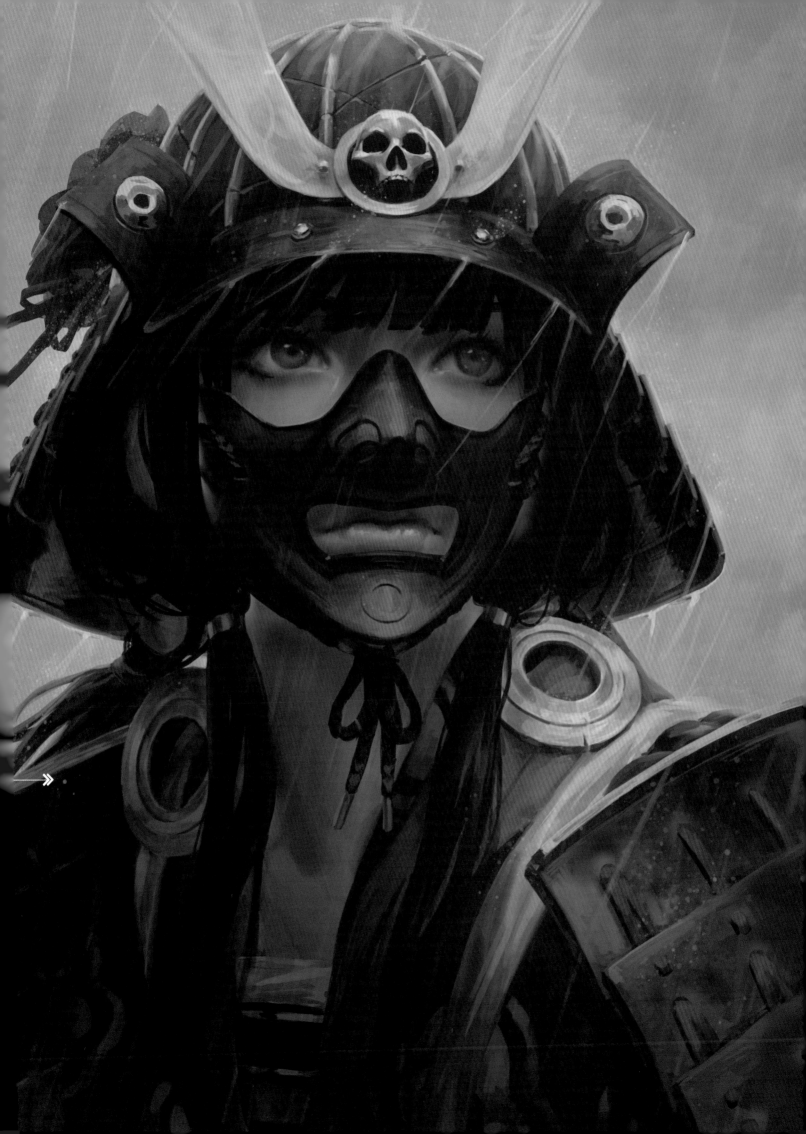

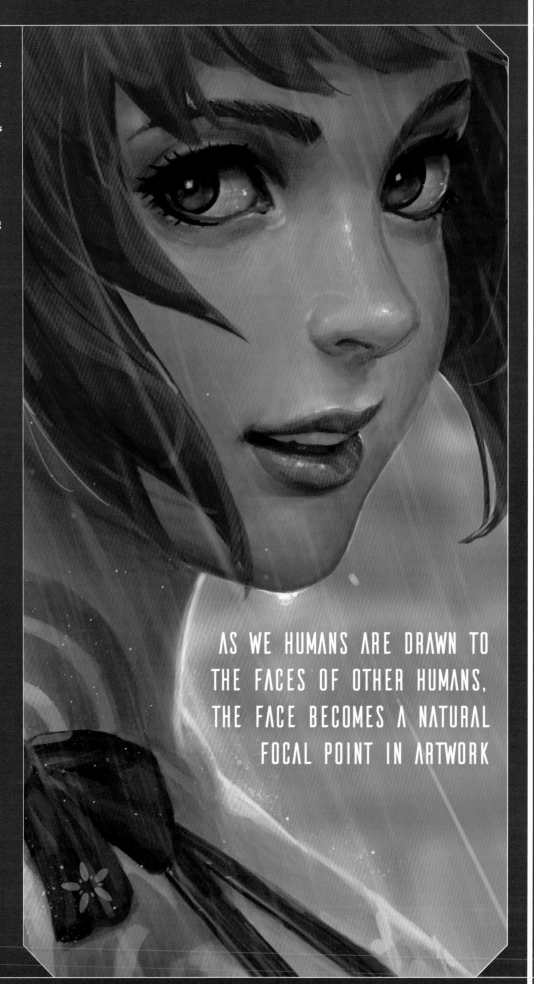

SWIRLS

A tattooed mercenary goes for a casual stroll through the town square. Using patterns and textures, especially in great detail, is a skill I'm still developing. They can add so much interest to existing elements and open up composition and narrative options. However, applying surface pattern designs at a believable, detailed level can be time-consuming, not to mention designing the original motifs in the first place.

AS WE HUMANS ARE DRAWN TO THE FACES OF OTHER HUMANS, THE FACE BECOMES A NATURAL FOCAL POINT IN ARTWORK

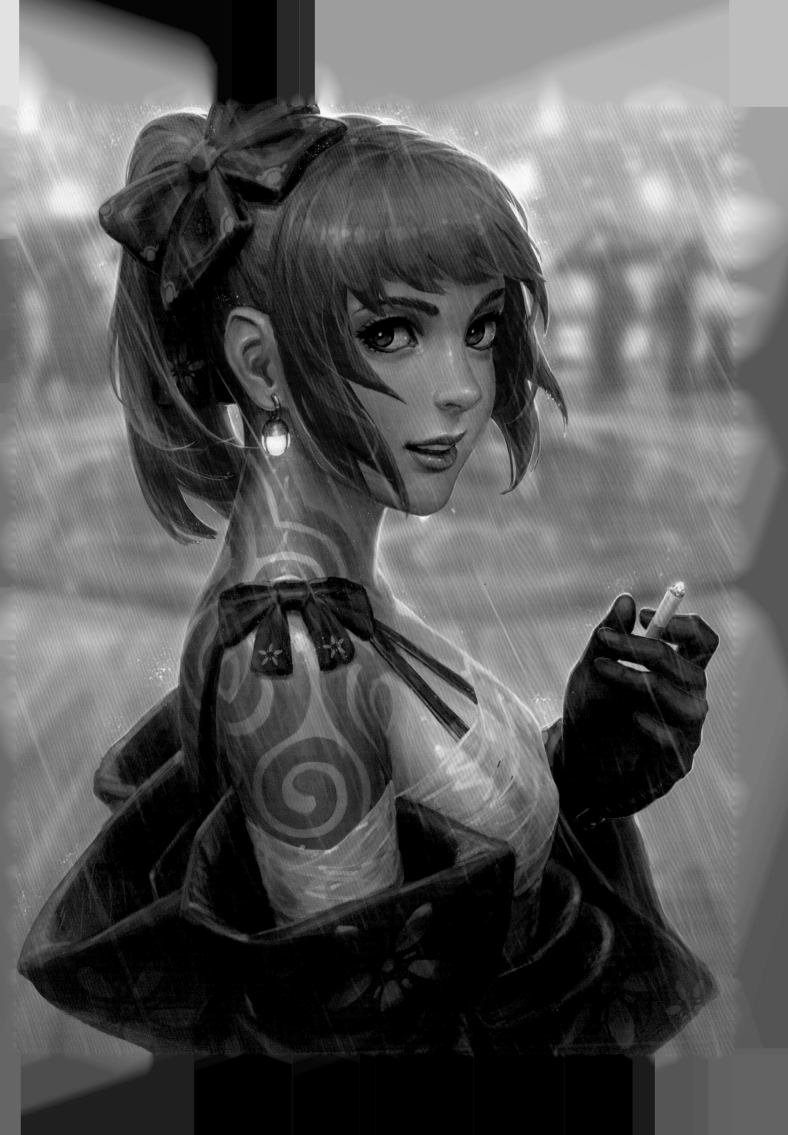

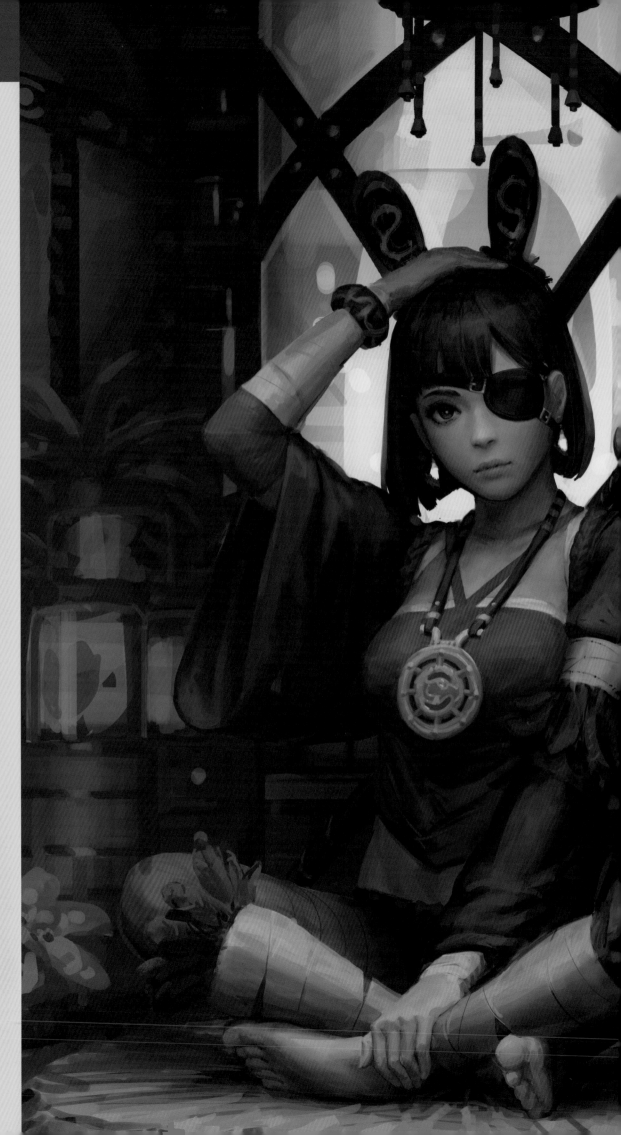

TRINKETS

This worker has a summer job running a gift shop. A quaint little store selling lots of trinkets was the initial core idea behind my design. I deviated from my original concept however, and produced a more character-centric piece. I've not given up on building a more convincing quirky shop, so this will certainly be a piece to revisit in future.

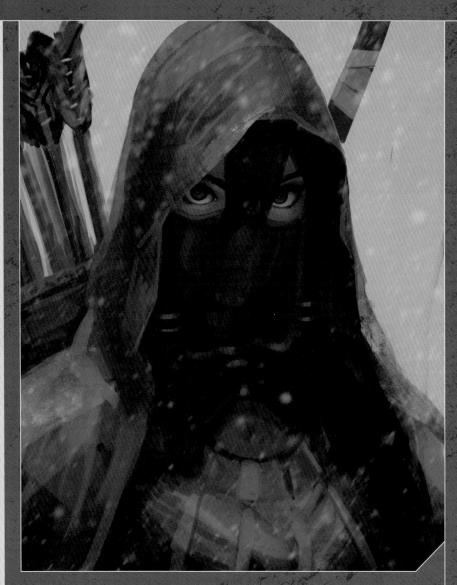

HOOD
A well-traveled hunter crosses a bleak snowscape. This piece is a second attempt at creating a hooded character. This time I used loose brush strokes and heavy shapes, leaving much to the viewer's imagination.

ENVIRONMENTAL DEBRIS CAN ADD COLOR TO CHARACTERS AND ENVIRONMENTS GREATLY, WHILE DYES AND COLORED METALS CAN HELP ADD A LOCAL COLOR

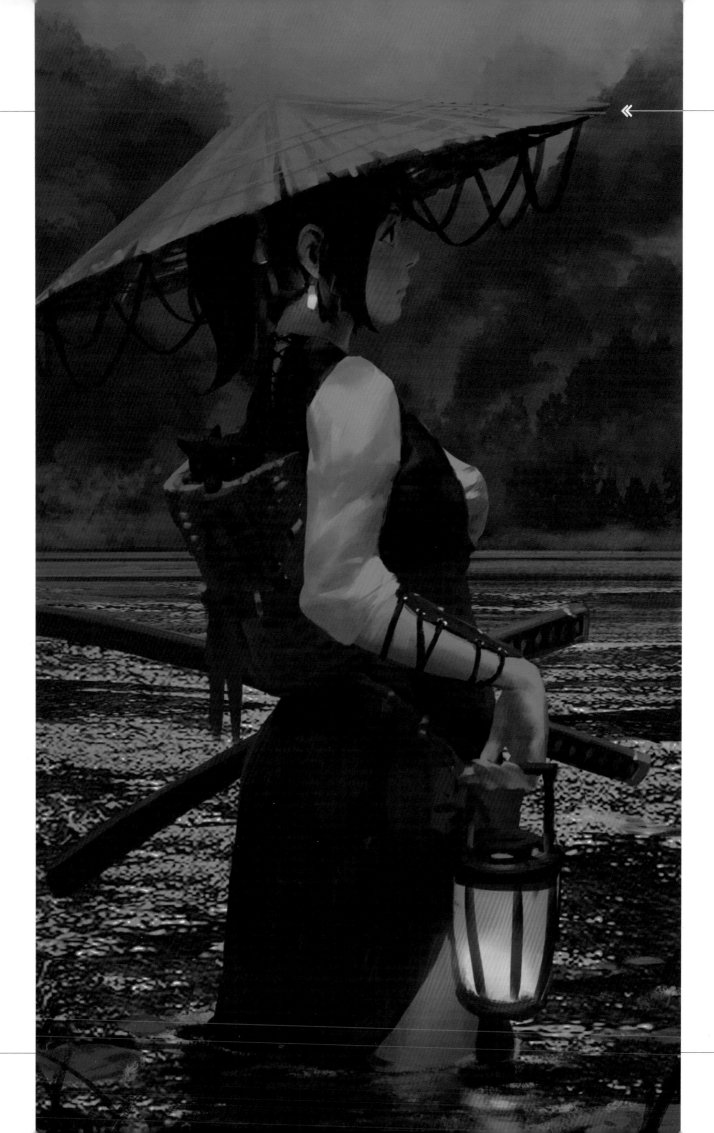

SWAMP

A traveler carries a basket of lost kittens across a large swamp. My initial plan was to simply draw a quick study of a pose and angle I hadn't studied before. After playing with the silhouette and composition, I eventually ended up with this design. The grungy swamp environment helped to set the dark mood I was looking for.

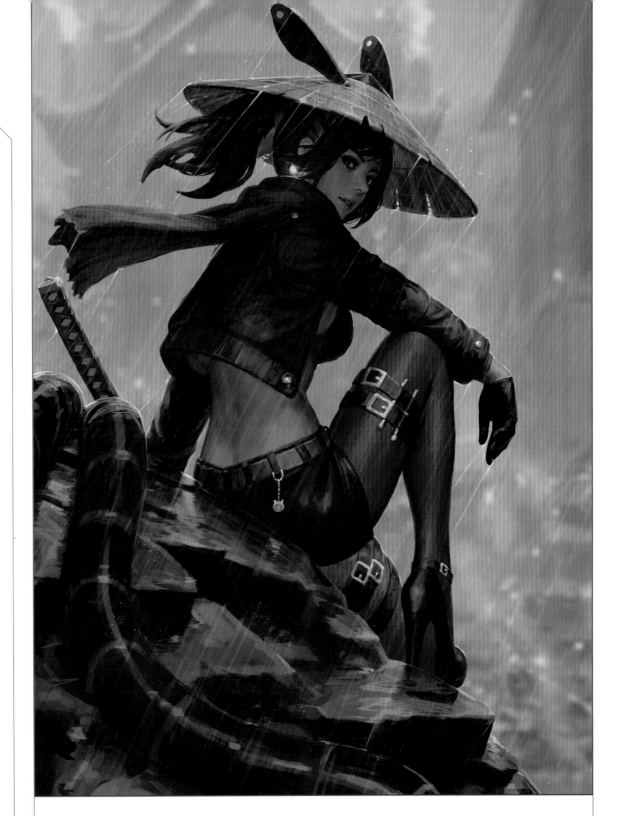

WINDY

A strangely fashionable traveler perches on a cliff high above the town. Here, I started to blur the lines between real and fantasy. The character in this piece is seen with more stylish real-life attire, such as a leather biker jacket and high-heeled shoes. In this case, I think it's a little bit too far on the modern side but I still like the color scheme overall and it does make for an interesting look.

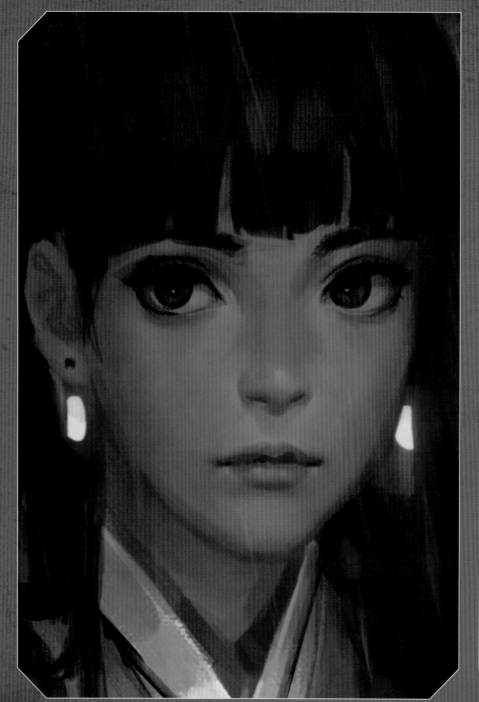

AUTUMN

A traveling mercenary stops
for a rest on an overgrown
rooftop. This was a tough piece
for me to create as I found
it very difficult to create the
surroundings. I decided upon
an easy and more colorful
solution of adding leaves in
varying shades of red. The only
thing I would change if I were
to repaint this piece would be
to show more interaction with
the cat.

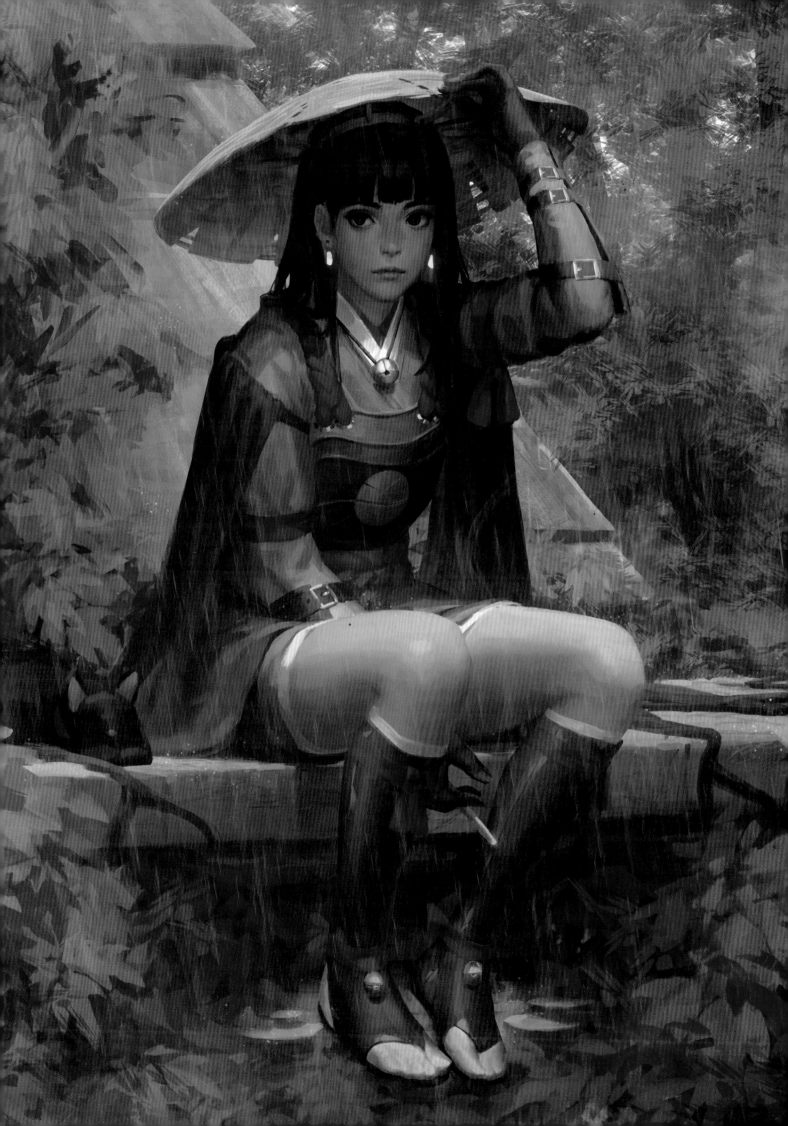

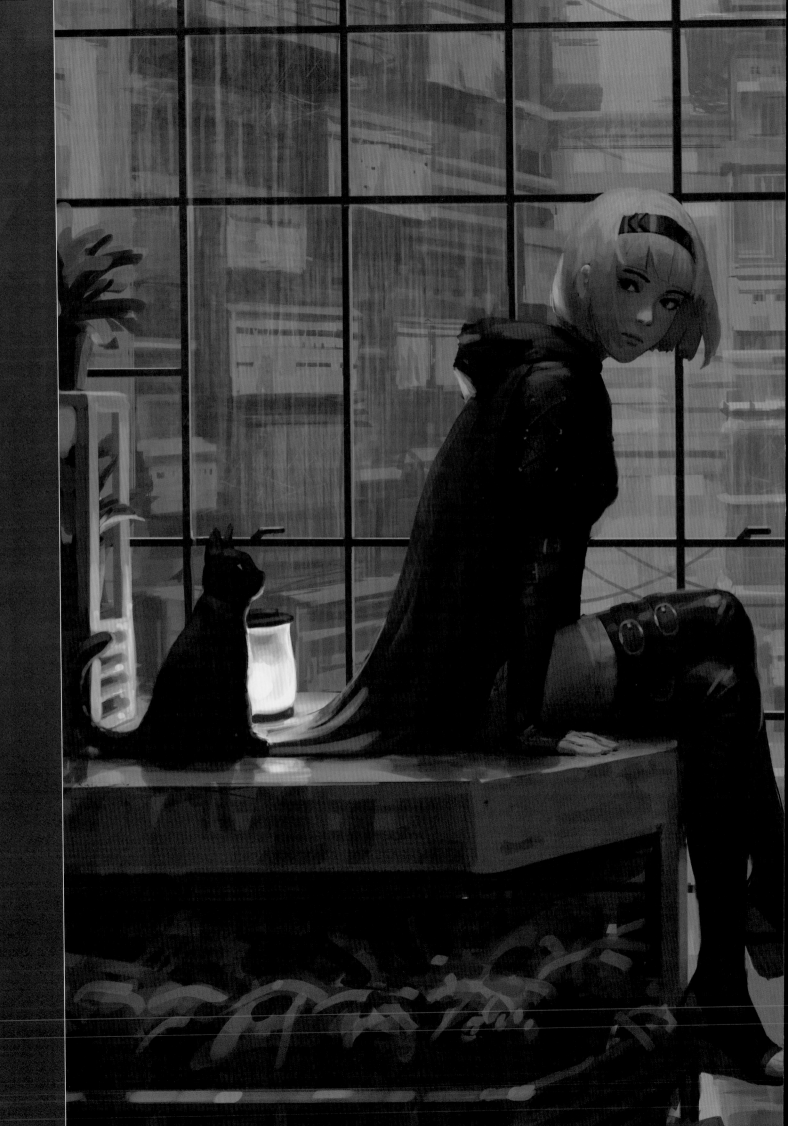

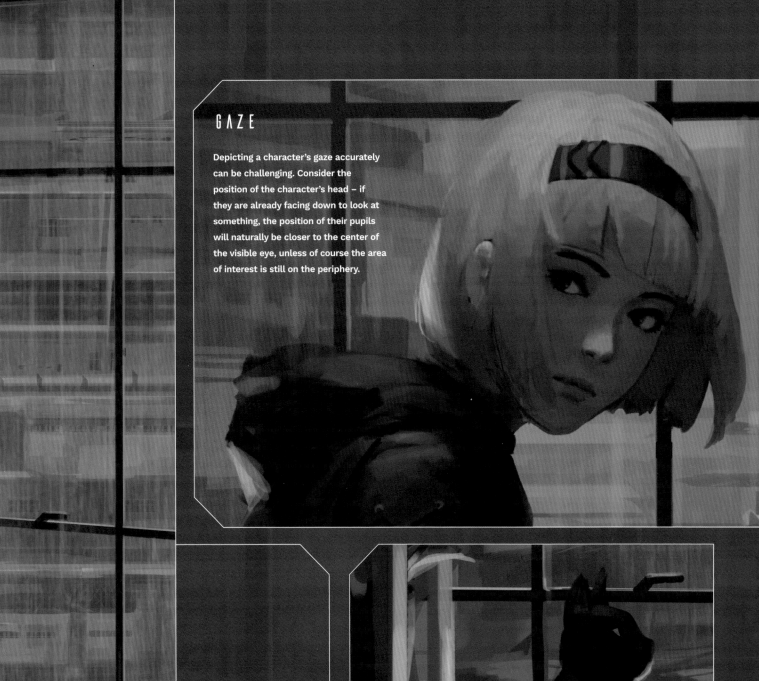

GAZE

Depicting a character's gaze accurately can be challenging. Consider the position of the character's head – if they are already facing down to look at something, the position of their pupils will naturally be closer to the center of the visible eye, unless of course the area of interest is still on the periphery.

GREENHOUSE

A white-haired traveler takes a rest stop in a greenhouse, rousing the suspicions of a local cat. This piece was made shortly after *Autumn*. In this design, the character is interacting with the cat, acknowledging its presence. The expression lends an intriguing vibe to the piece and makes the viewer question how the duo ended up here.

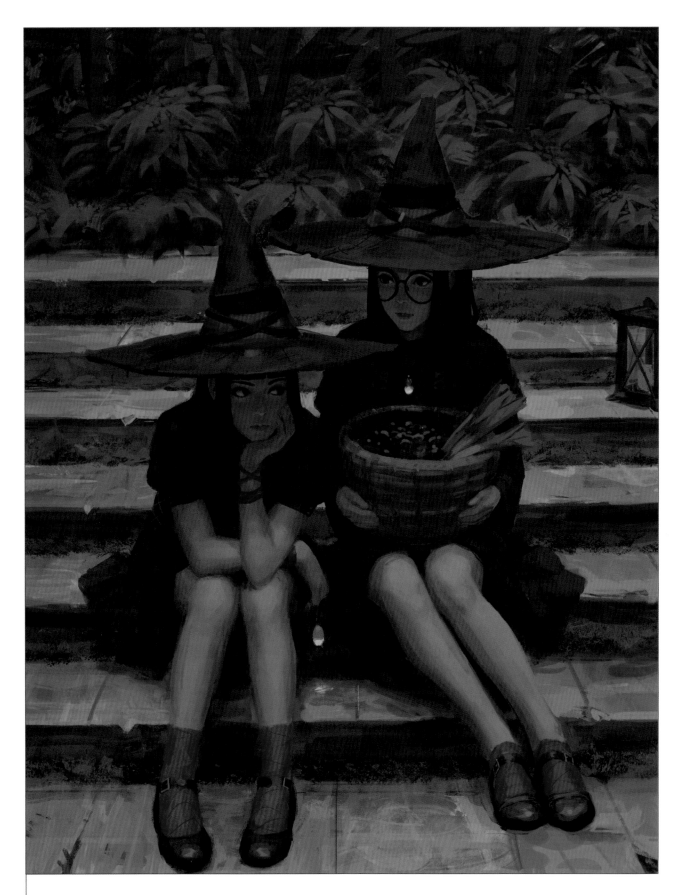

WITCHES

A couple of young witches-in-training sit and have a talk about how best to split their forage. This was one of my first attempts to put two similar characters together in a scene. Although the thumbnail captures the concept well, there is definitely lots to improve upon with regards to the characters and expressions. However, even though it's not perfect, this design motivates me to attempt more complex scenes like this.

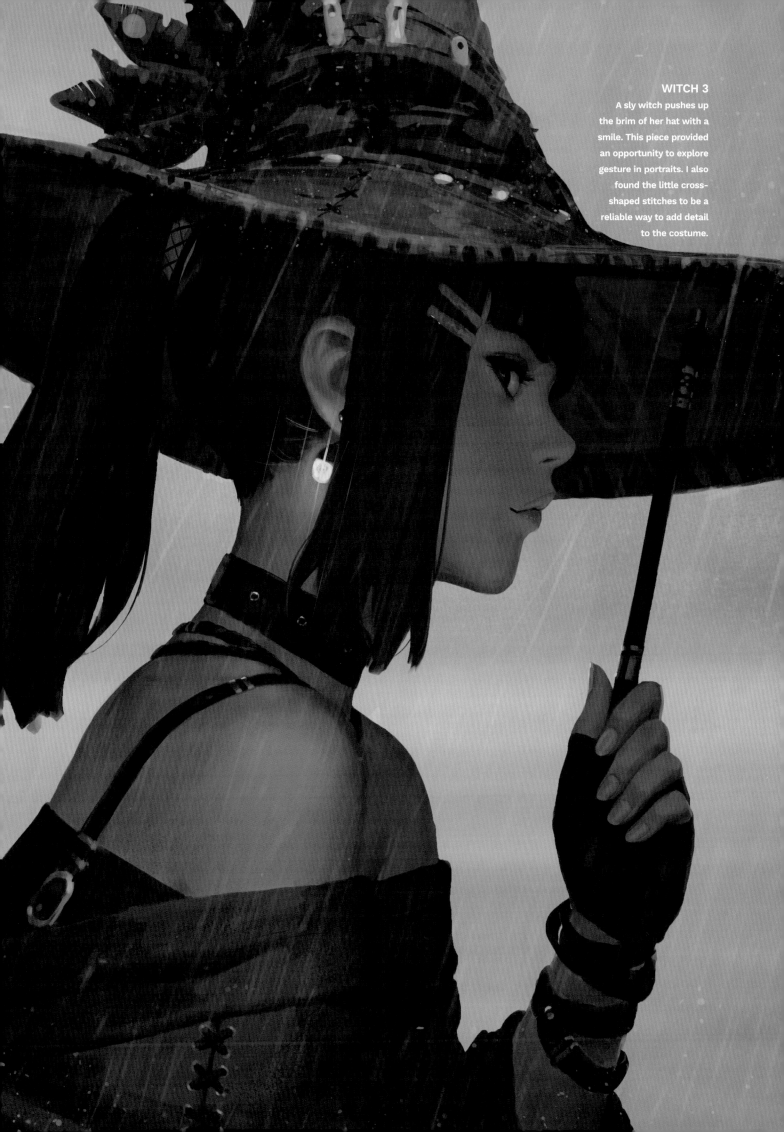

WITCH 3
A sly witch pushes up the brim of her hat with a smile. This piece provided an opportunity to explore gesture in portraits. I also found the little cross-shaped stitches to be a reliable way to add detail to the costume.

WOLF

An angry warrior and her wolf encounter a dangerous opponent. Here, I wanted to focus on depicting a fierce wolf, so the human character plays more of a support role. Their expressions came together well in the end, with parallel intensity and ferocity reflected in both characters.

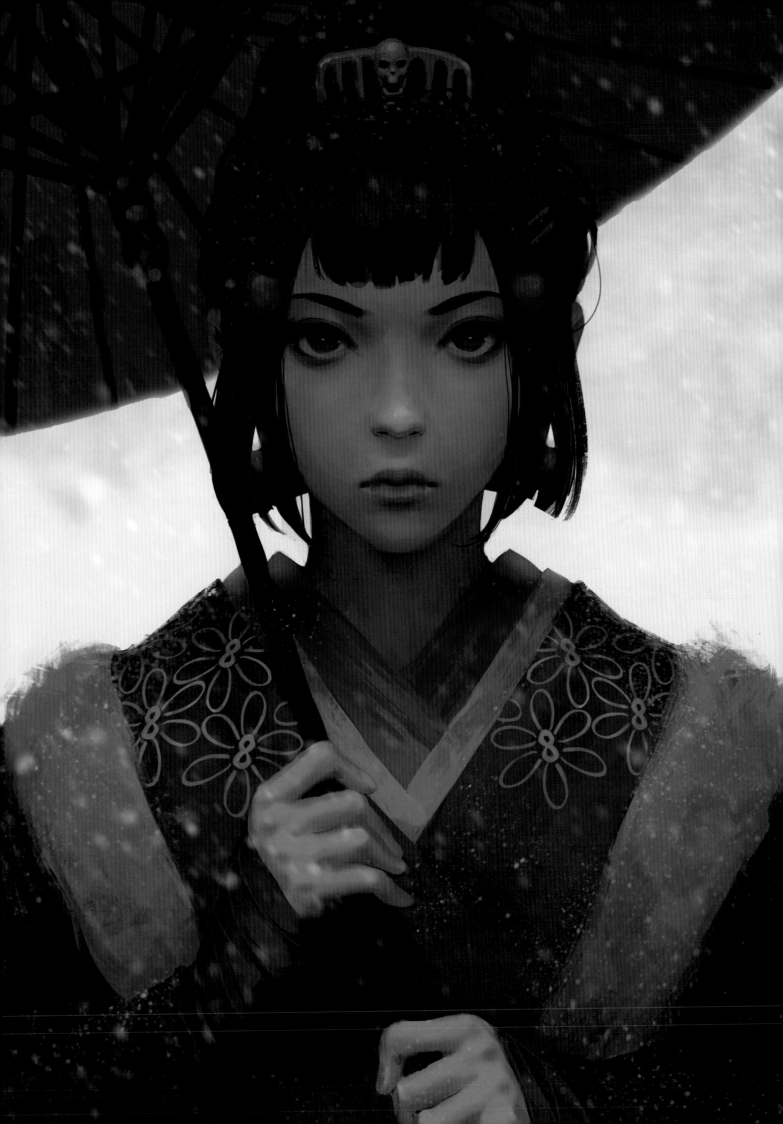

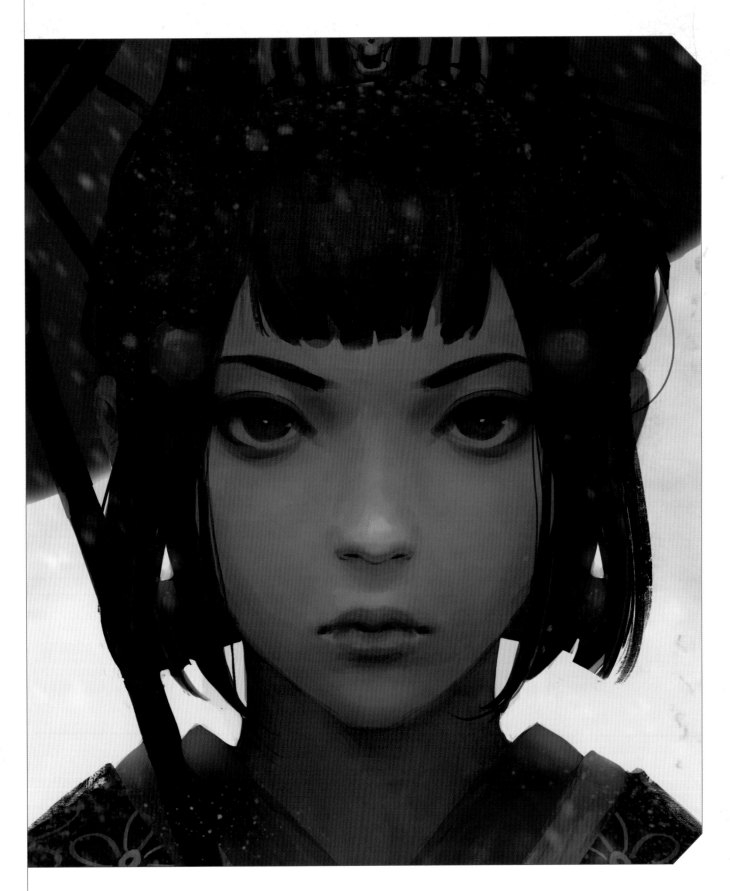

PARASOL

A geisha-like woman with a delicately powdered face blends quietly into the snowy landscape. Straight-on portraits are a staple of initial drawings, but I find them incredibly difficult to perfect. So many easy ways to imply depth and create layering are lost thanks to the fact that it is a largely symmetrical, flat view of the subject. However, it is, in a sense, a good exercise for finding and presenting useful asymmetry in creative ways.

IF YOU SPEND TIME
DEVELOPING YOURSELF
AND YOUR ART, THERE'S
ALWAYS SOMETHING
INCREDIBLY SPECIAL
WAITING TO BE FOUND

BLOOD

Dressed in white, an oddly clean woman presides over a scene of carnage. This was a really fun but challenging experiment dealing with a more complex scene. Arranging elements to compose the scene was the most difficult part. While making sure that the composition is balanced overall, I also had to pay a lot of attention to detail. Having chosen a more neutral lighting for this composition, gaps in my knowledge could have been easily reflected here. One of the things I feel I could have improved is the refinement around the character – I possibly could have drawn in additional objects to fill the scene better.

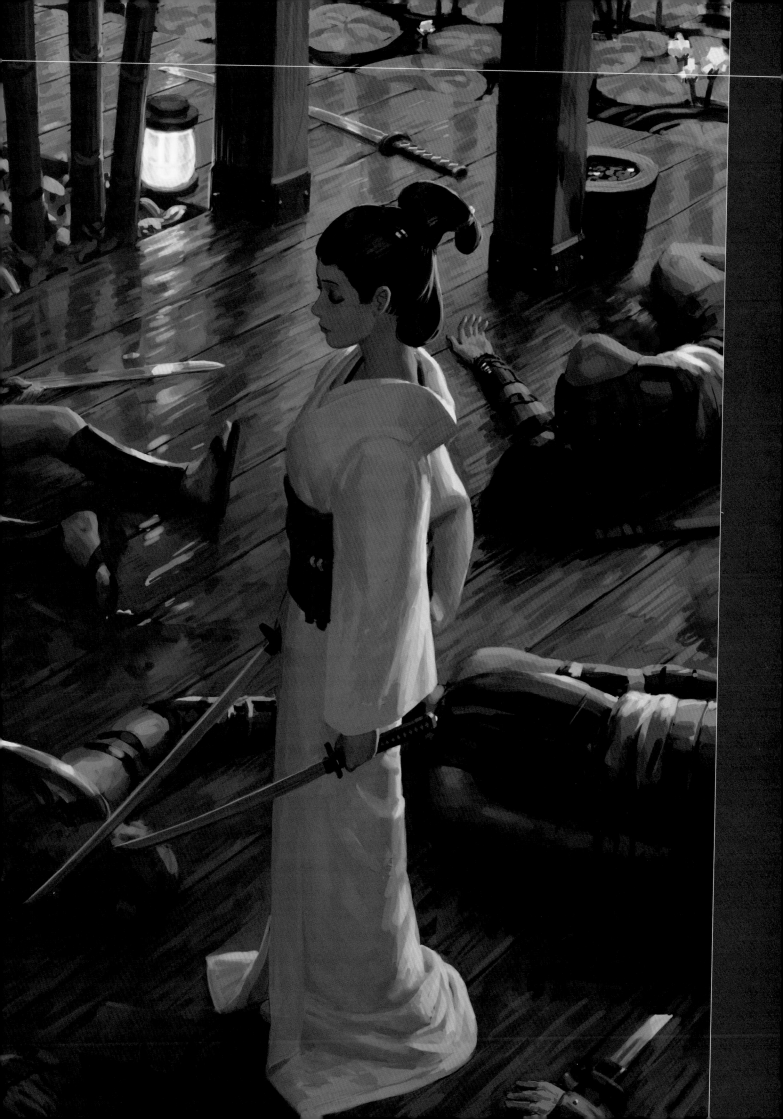

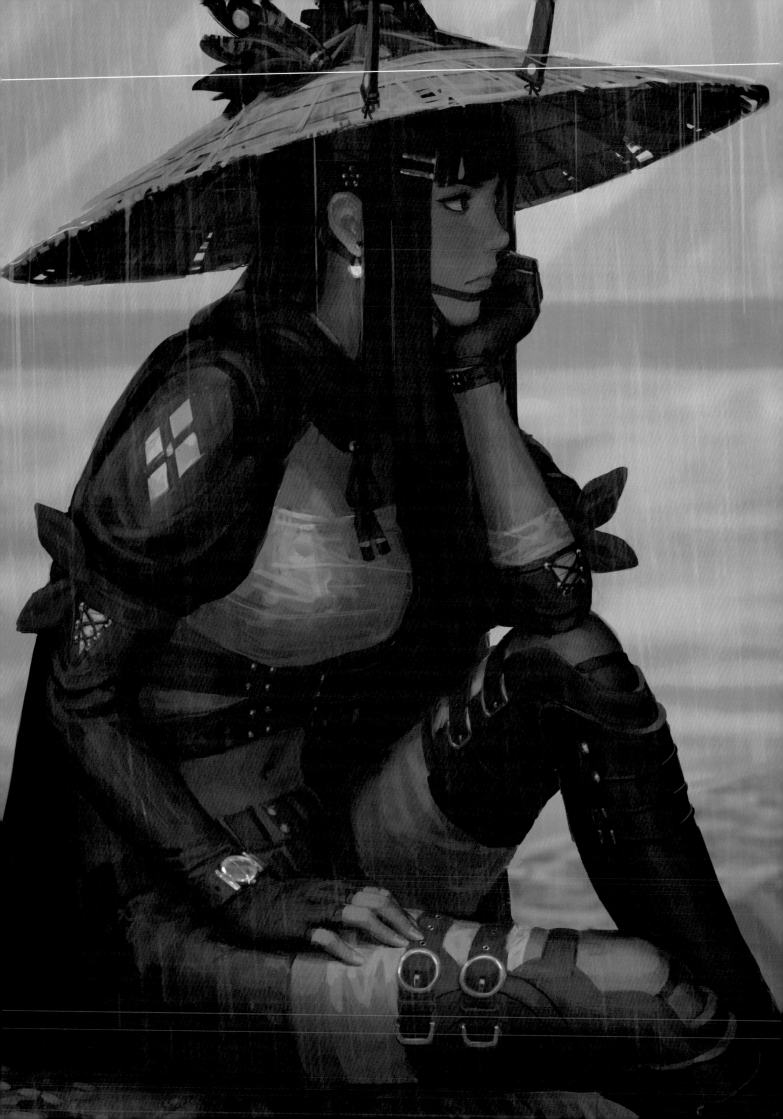

- PROJECT DISSECTION -

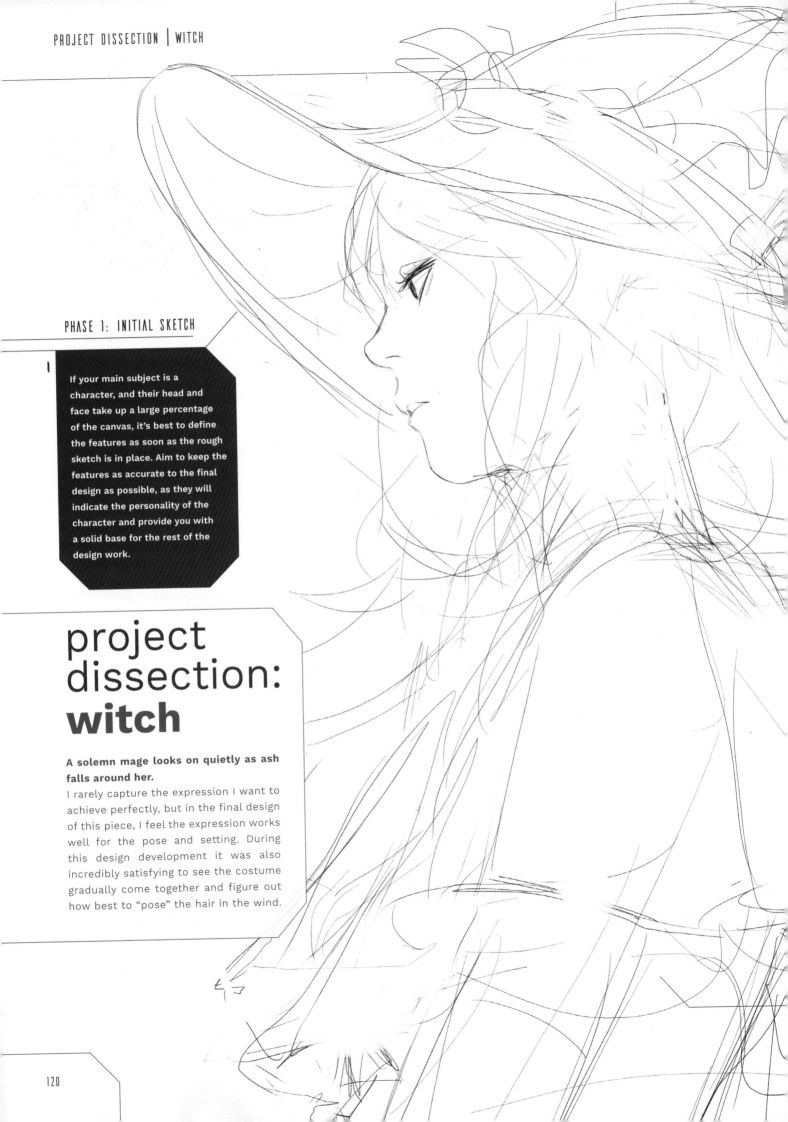

PHASE 1: INITIAL SKETCH

If your main subject is a character, and their head and face take up a large percentage of the canvas, it's best to define the features as soon as the rough sketch is in place. Aim to keep the features as accurate to the final design as possible, as they will indicate the personality of the character and provide you with a solid base for the rest of the design work.

project dissection: **witch**

A solemn mage looks on quietly as ash falls around her.

I rarely capture the expression I want to achieve perfectly, but in the final design of this piece, I feel the expression works well for the pose and setting. During this design development it was also incredibly satisfying to see the costume gradually come together and figure out how best to "pose" the hair in the wind.

It takes many years of practice to sketch cleanly and presentably. However, if you intend to finish the piece as a painting, especially in the digital medium, the sketch phase is just that – a phase. Instead of worrying about creating the perfect sketch, I focus on experimenting with rough lines which are quick to erase and edit.

The initial sketch is first and foremost for your own eyes and understanding. As I sketch, I take time to think about key lines, especially those that indicate important features, such as a line that separates the arm from the torso, or a line that defines the silhouette of the character.

PHASE 2: VALUE

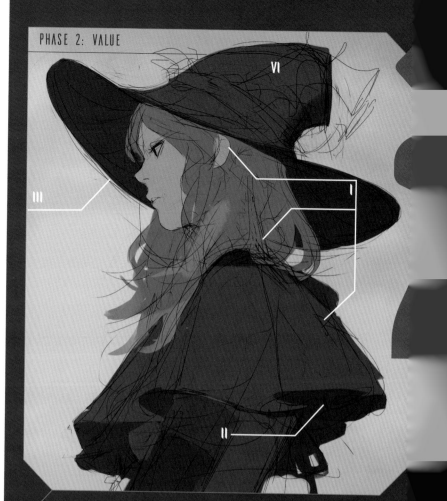

Next, I fill in the sketch with values, usually using the Lasso tool and a hard brush or fill tool. In this case, skin, hair, and clothing all receive a separate "base value." This step is extremely time efficient for what it does; it allows me to immediately tell if the different tones can synergize well.

The layout of light and shadow will help greatly in defining your subject's 3D presence. Here, simply darkening the underside of the cloak indicates how the clothes interact with the torso. This is also the time to think about lighting. For example, having a shadow cast by the hat over the shoulders hints at its size and implies the dominant light source.

At this stage, you have all the visual information to start making adjustments to the overall composition. Try to ensure that the focal point of the piece is positioned well and easily read. When in doubt, the rule of thirds is a good place to begin. Also consider zooming out to ensure the thumbnail is readable, and flip your canvas horizontally to check from a new

perspective for anything out of place. The navigator window in Photoshop is a useful tool for this process as it keeps a live thumbnail of the image.

Sometimes elements of a design deviate from your initial sketch. For example, at this point the complex ha shapes I had in mind originally are difficul to incoporate, so I decide instead to keep it simple.

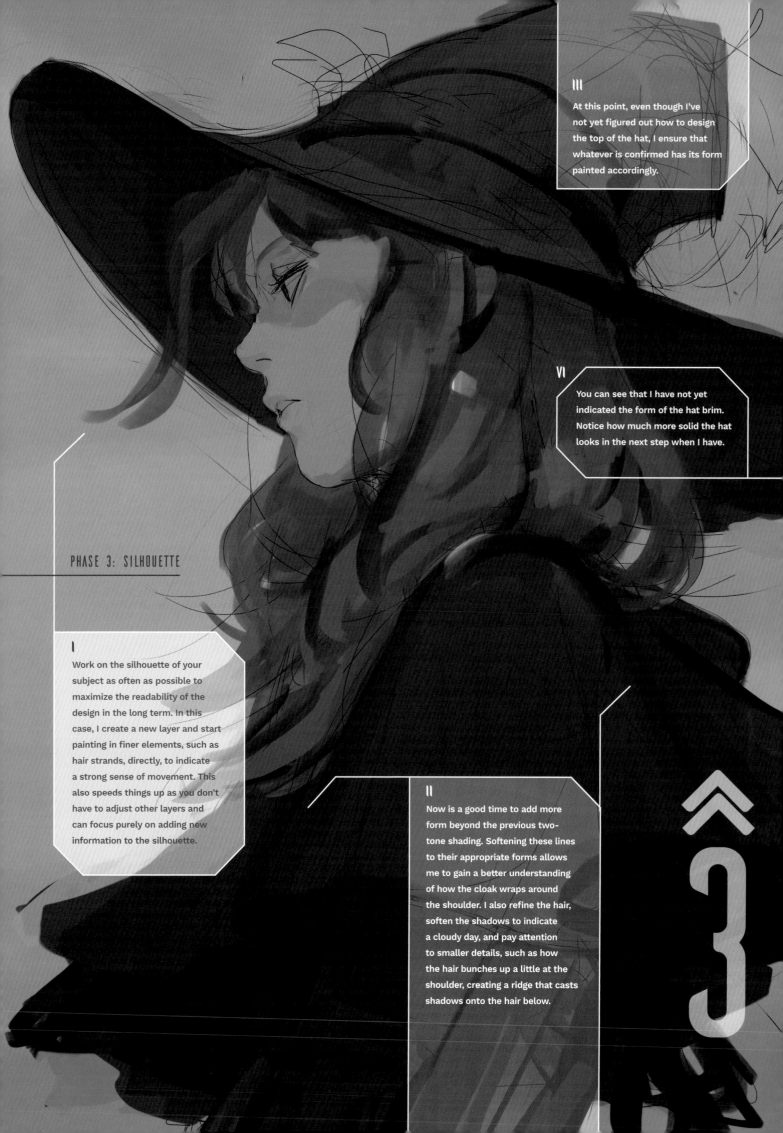

III

At this point, even though I've not yet figured out how to design the top of the hat, I ensure that whatever is confirmed has its form painted accordingly.

VI

You can see that I have not yet indicated the form of the hat brim. Notice how much more solid the hat looks in the next step when I have.

PHASE 3: SILHOUETTE

I

Work on the silhouette of your subject as often as possible to maximize the readability of the design in the long term. In this case, I create a new layer and start painting in finer elements, such as hair strands, directly, to indicate a strong sense of movement. This also speeds things up as you don't have to adjust other layers and can focus purely on adding new information to the silhouette.

II

Now is a good time to add more form beyond the previous two-tone shading. Softening these lines to their appropriate forms allows me to gain a better understanding of how the cloak wraps around the shoulder. I also refine the hair, soften the shadows to indicate a cloudy day, and pay attention to smaller details, such as how the hair bunches up a little at the shoulder, creating a ridge that casts shadows onto the hair below.

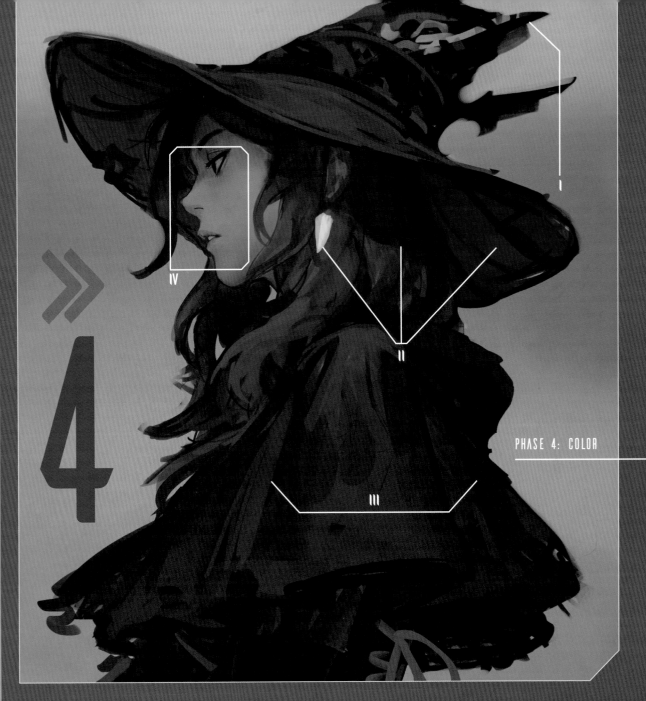

>> 4

I I decide upon a design for the top of the hat that I like very much. The chosen sharper hat adds complexity to the silhouette. Painting loosely, but with a visual in mind, is a quick and effective process to try out a number of ideas that you think could work. The roughness often lends a level of intricacy to the area that can fill in for details, allowing you to roughly assess how all the elements fit together in the meantime.

II Next, I assign color to to separate elements, just like value, color assigning builds a design quickly. I create a Soft Light layer and fill areas with their designated colors. I use brown for the hair, orange for the earring, and a deep red for the underside of the hat to add extra emphasis and detail in order to frame the focal point: the face.

III The form of the cloak changes a little here as I find that straighter, stronger lines of action suit the composition better than the initial floaty and curvy lines. I also roughly paint in highlights to indicate how the shoulder exists in space – a little further away from the head and neck than previously shown.

IV I always start coloring faces with two tones on the Soft Light layer, one for the skin and one for the lips. It's a very simple setup, but it works well enough to create a solid base.

IV

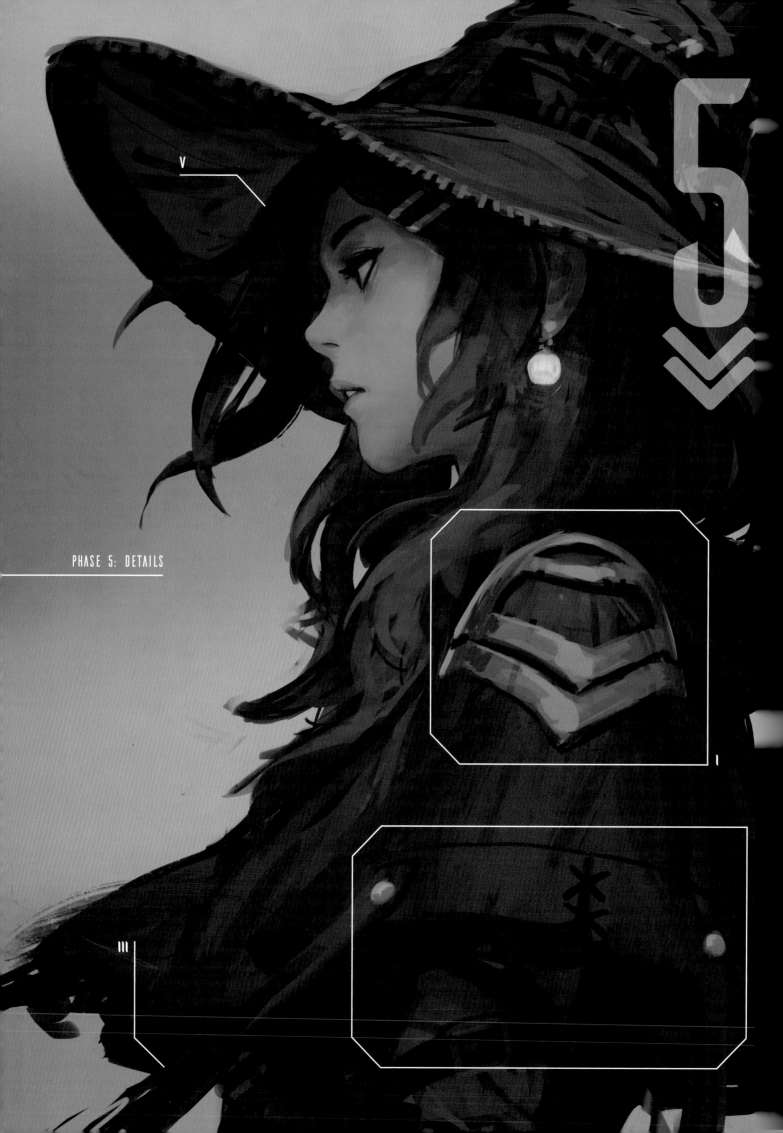

PHASE 5: DETAILS

IV

I Keep a lookout for opportunities to add extra elements to areas of interest. When building a character from scratch, it's easy to end up with designs that are a little too sparse. The gold shoulder ornament and buttons shown here add an new material, color, and realistic complexity to the character.

II Areas of the image that are further away from the focal point also need some level of detail. They serve to add embellishment and believability to the overall image, without being overtly attention-grabbing. Here, I add wrappings, straps and buckles, a few stitches, and a couple of gold buttons, while making sure to manage their values and contrast to avoid drawing too much attention.

III If the silhouette feels a little too simple in certain areas, feel free to make significant changes. Adding these loose straps helps in indicating movement while enriching the silhouette in areas that lack interest.

IV I arrive at the final shape and details of the hat. A few relatively stiff feathers that stand up in the wind add great balance to the composition. They pull the viewer's gaze up and right, while many other elements pull the eye down and left. Overall, they help in settling the balance point close to the face area, the intended focus.

V To emphasize elements of a character, you can stray from reality a little and experiment with different color or value techniques. Here, I add a slightly unrealistic glow to the underside of her hat to visually separate the hair from the hat and improving the readability of the silhouette.

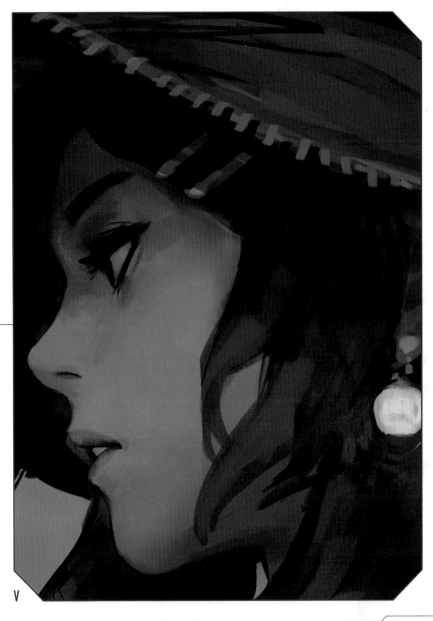

V

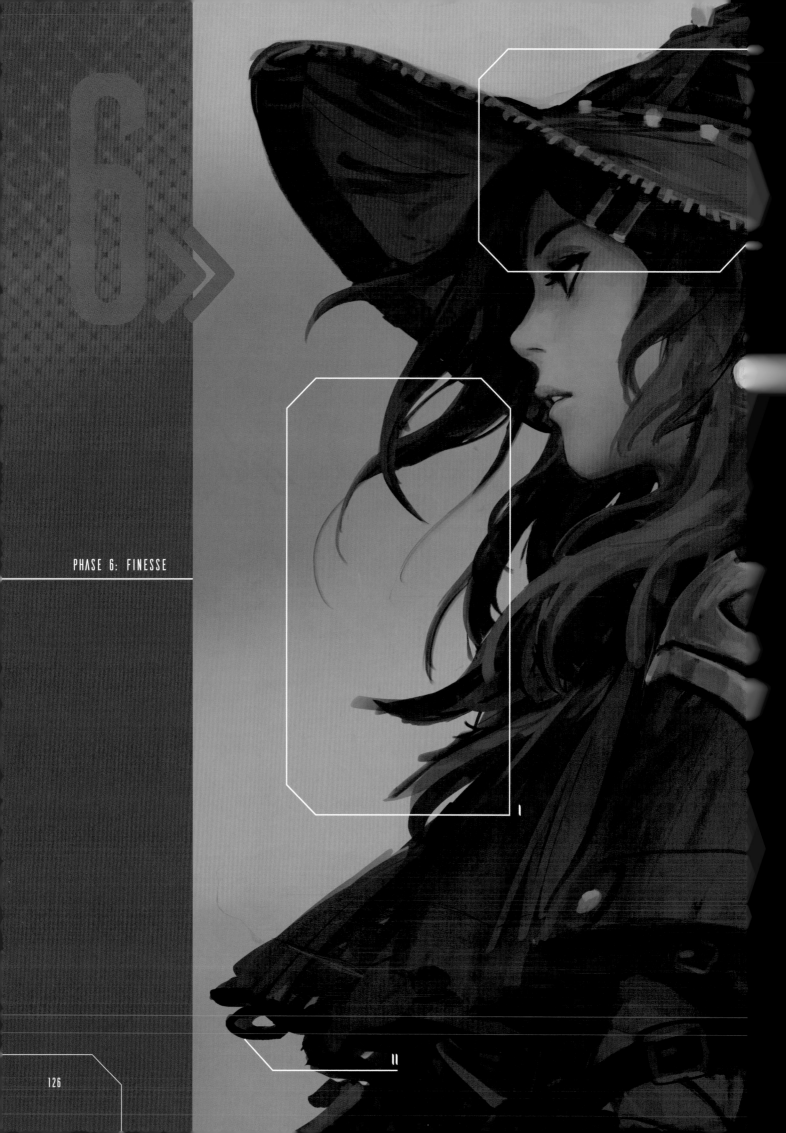

PHASE 6: FINESSE

BEFORE ADDING FURTHER DETAILS, IT IS IMPORTANT TO CHECK IF THEY WILL HAVE THE INTENDED PRESENCE

I Now is the time to begin finessing the image. More intricate materials, such as hair and fur, require extra attention. In this case, showing a variety of strand sizes and finishing with a few thin strands visually implies that the level of detail extends down to the individual hair, without actually having to draw hundreds of strands manually. This helps to create a strong silhouette for fine details, as they can become lost in a composition.

II In order to reflect the low-angle perspective of this composition, I correct the cloak a little to reveal more of the underside, especially in the region closest to the front of the frame. I also remove the straps as they weigh a little too heavily on the composition towards the left.

III Before adding further details, it is important to check if they will have the intended presence. In this case, I want the details to be visible even in thumbnail size, so I use lighter colors to contrast against the darker hues. Remember that even small details need to have accomplished forms so that they may be accurately read. For example, I give the hair clips volume and reflected highlights that are true to reality.

IV Larger elements need a bit more attention to feel sufficiently detailed. Here, adding a different volume, drawing in finer forms, and inserting interesting lines within the shoulder piece serves that purpose and makes the design as a whole feel more complete.

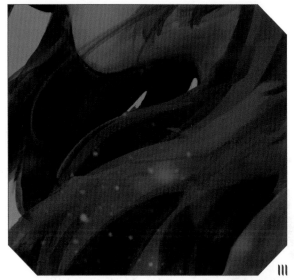

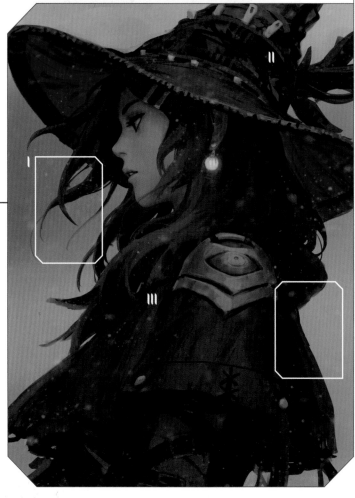

PHASE 7: FINISH

I Once the drawing is mostly complete, I add environmental effects to infuse volume into entire scene. A potential weakness of character portrait pieces is the lack of extra elements in the composition that can reinforce the volume and indicate how everything belongs within the universe in the frame. In this case, I use falling snow to add depth.

II A value check on the entire design is useful. In my pieces, I aim to distribute values to be slightly weighted in a certain range, with a small percentage of the canvas including both extreme ends of the scale. The Histogram tool in Photoshop is incredibly useful for identifying potential problems, especially if the lighting doesn't appear correct.

III Mixing up the sizes of particles you use is extremely important as one of the biggest indicators of depth is the varying scale of otherwise identical objects. Here, I apply a couple of pixels' worth of blur to the largest particles, a little less to the medium particles, and none to the smallest ones to create a strong illusion of multiple layers and depths in the image.

BELIEVABLE DEPTH

Depth can be difficult to indicate, as reference images rarely perfectly capture realistic depth. Instead, you can create illusions by stacking and overlapping elements to essentially make depth very obvious, aiding the believability of the whole drawing.

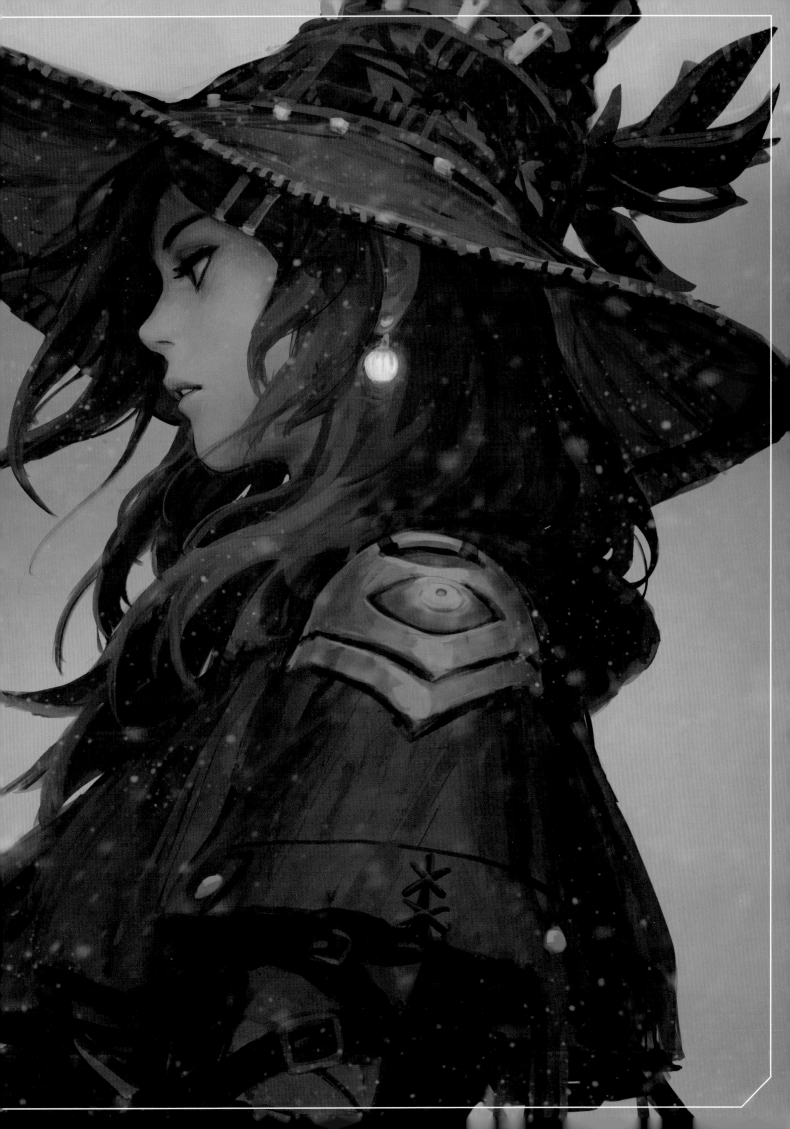

PHASE 1: COMPOSITIONAL CONSIDERATIONS

I

Starting a new piece can be difficult if you don't have a plan. It's easy to get lost in one part of the painting and forget to consider how the piece should come together overall. This is why my usual workflow is to immediately move on to roughing out the rest of the piece as soon as the focal point is sketched out. Keeping it very rough is not only a time saver, but also allows for a lot of flexibility in your imagination as you assess the composition.

II

Don't be afraid to block in shadows, even early on in the sketch stage. Doing so can help you flesh out the shape and structure of what you are drawing, and also assist you in checking if the lighting looks visually correct.

III

To make the scene in the canvas feel like it has believable volume, you need to feature enough elements that direct the viewer. In this case, I add a few shapes leading up from the ground to the focal point. This not only helps to reinforce an accurate perspective, making depth more obvious, but also leads the eye of the viewer from a lower interest area to the focal point.

A MORE DYNAMIC SILHOUETTE IS IMMEDIATELY RECOGNIZABLE, EVEN AT A THUMBNAIL LEVEL OF ZOOM, AND CAN PROMPT VIEWERS TO TAKE A CLOSER LOOK

IV

When drawing characters, I find that adding any kind of gesture helps to make the piece more interesting. A more dynamic silhouette is immediately recognizable, even at a thumbnail level of zoom, and can prompt viewers to take a closer look.

V

Drawing in imaginary contour lines can be very useful if you need a bit more confidence in approaching a tough angle. They are also great for aligning organic shapes to the perspective grid, which is helpful in keeping everything in the scene accurate with respect to other elements.

project dissection:
woods

A masked musician's notes pierce the silence of the dead forest.
This piece started off with a sketch of the pose and not much else. I enjoy the exploration aspect of drawing very much – figuring out how best to set up each element of the scene to complement the central character.

VI

Placing a "horizon line" is absolutely essential in almost every piece with a "ground surface" involved. Anything in the scene that has a surface parallel or related to the ground needs to take reference from this line. For example, when drawing a normal bedroom, the implication is that the floor of the room is the "ground surface" and everything within the room that rests parallel on the floor is also aligned to said surface. This means that when you draw all of these objects, including the floor, from any angle, they have a common axis which translates to a single, parallel-to-ground line of potential vanishing points, also known as the "horizon line."

It is key to note is that the "camera," or your cone of view, does not necessarily center on this line. The line is only there to guide everything in the scene that is relevant to the ground surface, which in this scene is conveniently everything, thanks to gravity.

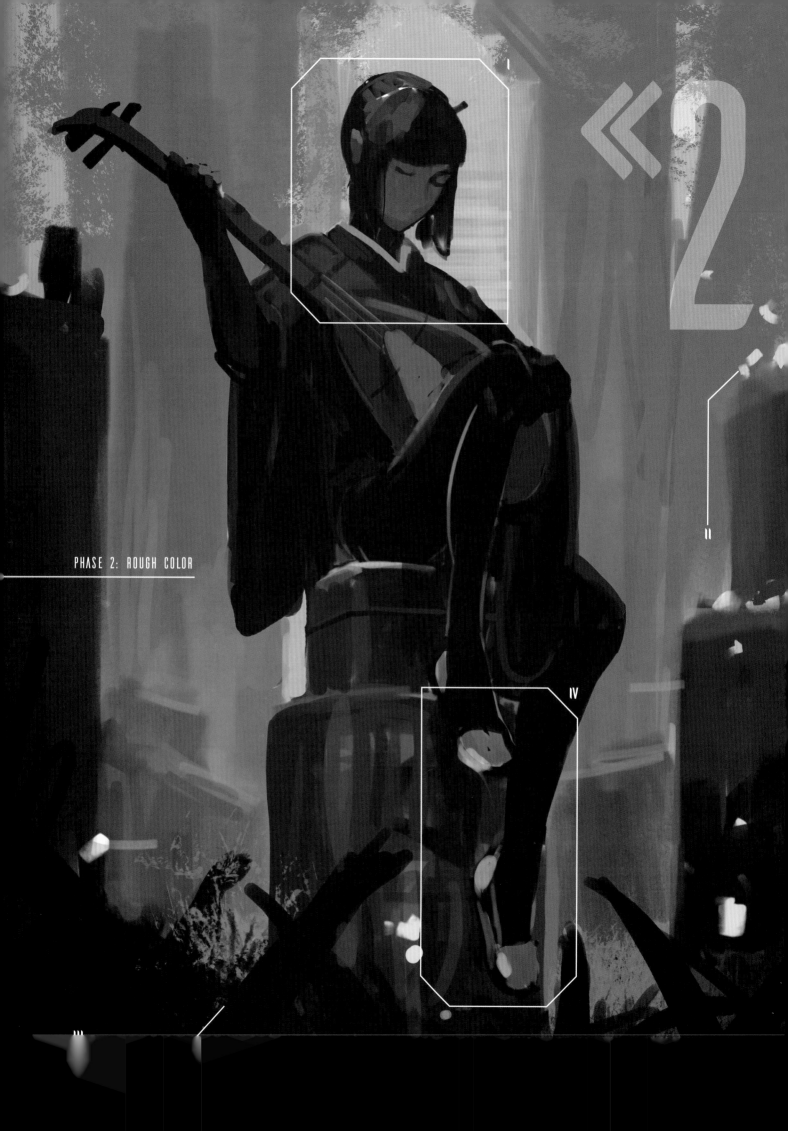

PHASE 2: ROUGH COLOR

One of my first priorities when progressing to the next stage is to paint in the face roughly. Being a focal point in the piece, I find it very helpful to make sure it is developed early. This also prevents situations where you spend a lot of time on the rest of the scene, only to come back and realize the face and head area don't match the composition, in terms of lighting for example.

II The challenge with darker scenes is that color becomes naturally suppressed most of the time, given how our eyes work. Especially in the absence of a strong light source, such as moonlight, we don't have many ways to inject color into the scene. One solution I found is to use accent lights to add both color and depth.

III The foreground was a big challenge in this scene. At this stage, you can probably tell the perspective was a little mismatched. The rest of the scene implies that the view point is from a little higher than ground level but the grass creates an illusion that it is from below. This is something I aim to fix at a later stage.

IV When adding in light sources, it can be daunting to paint in their effect on the scene boldy and decisively, as they can change the composition significantly. Often, I softly cast a little bit of light on a scene, but in this case, I push the lighting further, which works well to highlight more of the character.

WHEN ADDING IN LIGHT SOURCES, IT CAN BE DAUNTING TO PAINT IN THEIR EFFECT ON THE SCENE BOLDLY AND DECISIVELY

PHASE 3: STRUCTURAL FIXES

I Having noticed a problem with the perspective, I rework the ground area to align it with the character and the rest of the scene. Structural and perspective problems can be a make or break issue for any piece, but once they are dealt with, it becomes much easier to move forward. Here, the addition of stone tablets adds an interesting variety of shapes to the lower region of the composition, while helping to correct the perspective issue.

II Hair, accessories, or headwear can be great tools to modify the otherwise fairly simple silhouette of a character's head and help make things a little more varied and engaging. Placing accent lights near the head also keeps the area connected to the rest of the composition. Our gaze naturally bounces back and forth between high contrast areas (the accents in this case), so having highlights near the focal area ensures it doesn't lose out in terms of viewer attention.

III Adding depth often involves layering elements to add density in the z-axis

(pointing into the screen). This illusion makes it possible to believe there is space in the scene, even in areas that aren't visible. One element that is not usually drawn, is air. It's a great tool to use when you want to define a volume, but is unfortunately mostly transparent. However, thanks to the dark and moody setting, using fog becomes a viable and thematically fitting option here.

IV Early on in the scene-building process, it's important to focus on the broad shapes and surfaces. For example, notice that the stone tablets on the ground only have two different tones – black and gray. This serves the simple but crucial purpose of defining how each tablet is positioned, by making use of the lighting from above to split all the surfaces into those either upward- or side-facing.

V In a piece with a gray color palette, subtle color differences are necessary to distinguish materials from each other. In this design, the character's wooden musical instrument takes on a reddish-brown hue as compared to the bluish clothing.

RELATIVE VALUES

Make sure values are correct relative to each other at every stage of the drawing. You can add in color later, but only works there is a good value base to work on to. The image as a whole can be a little on the dark or bright side during the process, but key mistakes such as shadows superseding direct light in value must be avoided with care.

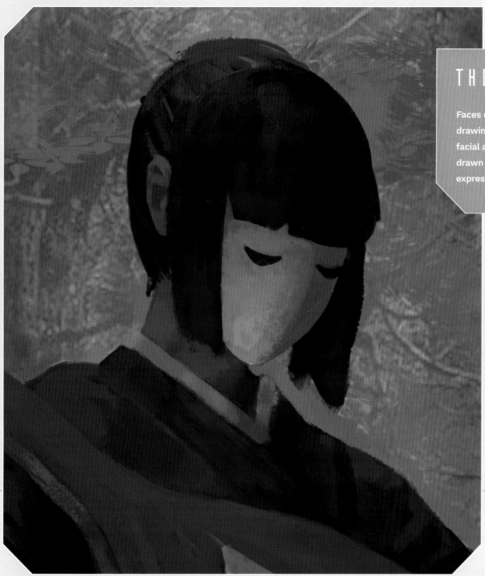

THE FACE

Faces can be very important points of focus in a drawing. When the face is hidden, pay attention to facial apparel or coverings in its place. Humans are drawn to faces and will often look even closer if an expression is not immediately discernible.

PHASE 4: EXPERIMENTATION

I Experimenting in the middle of the rendering process always feels a little uncomfortable as it means putting aside a lot of earlier work to try to find a better solution. In this case, I try trading in all the scattered highlights for a large, much more visible lantern. The compositional presence works well in terms of adding a secondary focal point to the image.

II Instead of spending time texturing every single element, focusing that effort on highlighted areas is a much more effective use of your time. Leave shadows a little smoother and untextured to help to make the scene more believable, as it is difficult to discern texture in real-life dark situations and settings.

III To take the piece in a more ethereal direction, I conceal the character's face with a mask. Thanks to the new,

stronger light source, I define the form and texture of the mask quite easily.

IV Aside from the mask, other parts of the character's body which have downward-facing surfaces also reflect the orange light. I really like the overall effect; having the character lit from below adds an effective eerie feeling.

V When detailing objects, work from large to small. Before adding tiny bumps and cracks, think about larger changes you can make. In this case, I chip the corner on some of the very cube-like tablets, making them look a bit more damaged and worn. Additionally, I make the sharp edges on the tablets rougher to add to the realism.

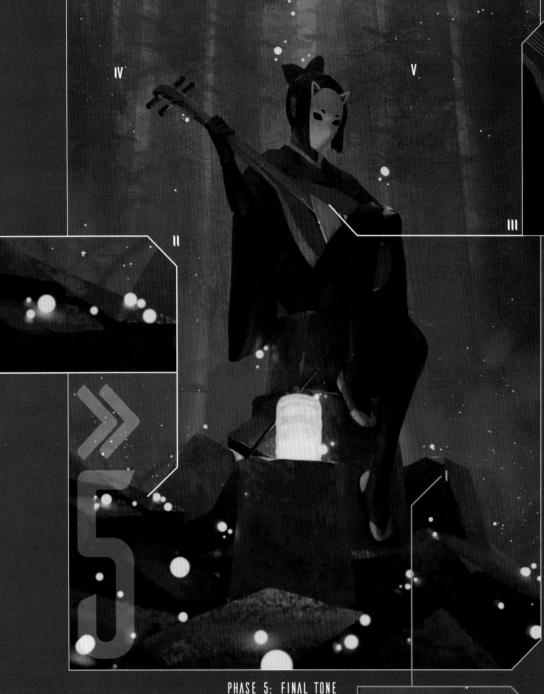

PHASE 5: FINAL TONE

You can access these useful color adjustment layers using the button at the bottom of the Layers tab.

I While my initial intention for the piece was to have an overall cool ambience punctuated by warm highlights, playing with a few tools, including Color Balance and Selective Color, convinces me that a warm ambient tone would work better. The warm color temperature of the fog implies that these glowing orbs are all over the forest, hence creating a dominantly warm, upward lighting. I reserve a cooler, slightly purple shade for skyward-facing surfaces that aren't exposed to the orbs.

II Simply using a soft brush, I add a little glow to the surfaces close to the orbs, instantly allowing the viewer to understand where in space each of them is. This strongly reinforces the structural presence of the painting in the viewer's mind.

III I use a small, hard brush to add detailing to highlights easily. Within well-lit areas, the texture and detailing should be harder and sharper. Painting the highlights with a very small brush also creates an illusion that the piece is more finely detailed than it is.

IV When using particles such as these glowing orbs, it's often a beneficial compositional consideration to dot in tiny versions to imply that they are also present in the distance. Be careful not to let small versions feature in front of elements in the foreground, as that could create confusion regarding the scale and break the illusion of depth.

V The background is covered with painted trees and branches. This removes the very high fidelity and harshly contrasting details that can often be seen when using a digital collage technique otherwise known as photobashing.

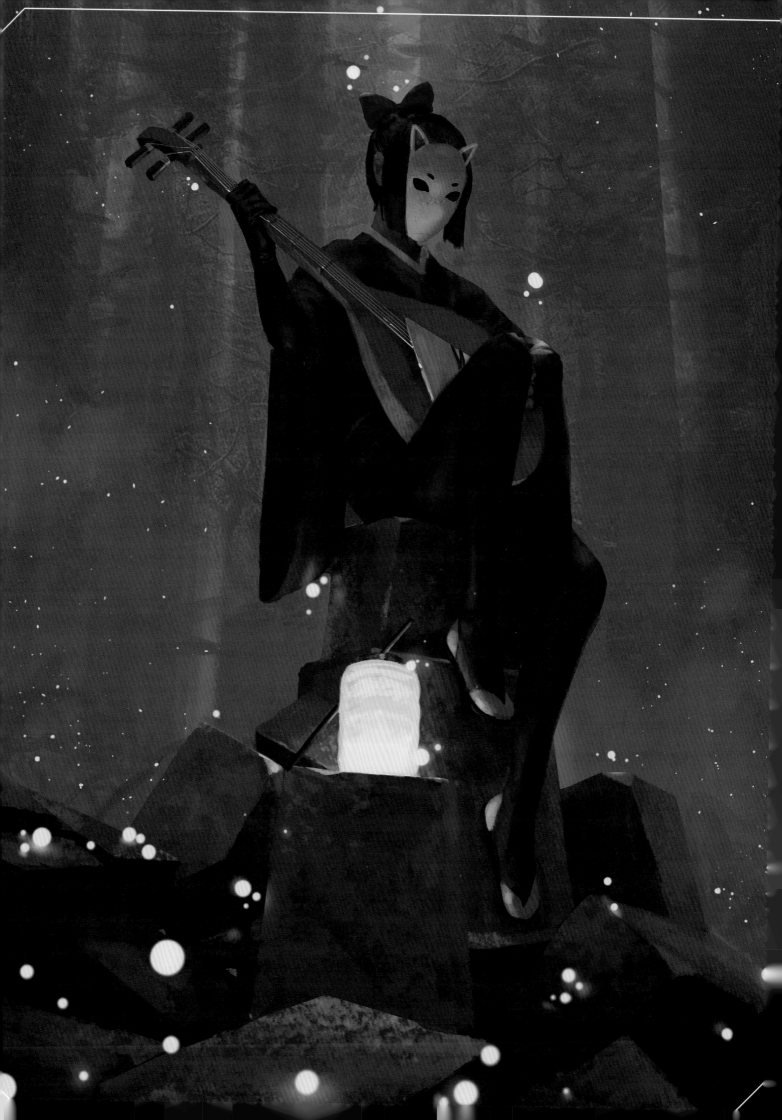

project dissection: **plant shop**

A girl strolls through her local florist shop, guided by the customer service cat.

This piece was created in support of the charity art campaign, *Earth Draw*, set up by 3dtotal in association with reforestation charities. I really enjoyed working with a nature theme. I wanted to make the shop look slightly wild and overgrown, especially in the foreground to help frame the main characters. Being diligent with perspective and making sure design elements are true to life helps the futuristic setting feel more believable.

PERSPECTIVE GRIDS

There are so many ways to create perspective grids; you can draw them yourself and save them as brushes, draw them in when you need them, or use path tools, to name just a few. However, I discovered a great plugin called Perspective Tools v2 by Sergey Kritskiy and I think it can serve every perspective grid need perfectly.

PHASE 1: GROUNDWORK

I When an image involves constructing a complex scene with organic shapes, I find it easier to begin with simple boxes. The boxes provide a sense of scale and allow you to work out perspective easily and quickly. Using this format, I am able to find a suitable composition that features the main character prominently.

II The simple rectangular boxes offer the opportunity to plan levels of complexity around the scene quickly. While they can't demonstrate exactly how the composition will look at the end of the process, they can be used to indicate how an area of the canvas works with different levels of complexity. In this case, I find that keeping the peripherals of the image a little cluttered and more diverse fits well with my chosen concept.

III Setting up a perspective grid helps to keep things clean and accurate, especially in scenes such as this where so many of the elements share parallel edges and are aligned squarely. Simply line up corresponding edges with the guide and confidently add more elements.

IV Whenever the composition or setting allows, it's optimal to use both foreground and background elements to help frame the focal point or direct attention towards it. In this design, adding shelves in the foreground serves multiple purposes at once. It not only reinforces the shop theme, it also adds a sense of space to the piece.

V My urban-themed drawings often center around this young girl character and over time I've made observations regarding how to make her more interesting. Firstly, it's very important that her body language reads clearly and decisively. The most engaging gestures are those where she is captured during an action, such as walking, or picking something up. If she's stationary, I find it much harder to make it work unless that pose fits perfectly with the scene. In this piece, she is seen walking through a strange, dark shop full of plants as something in the freezer catches her eye, hopefully offering intrigue for the viewer.

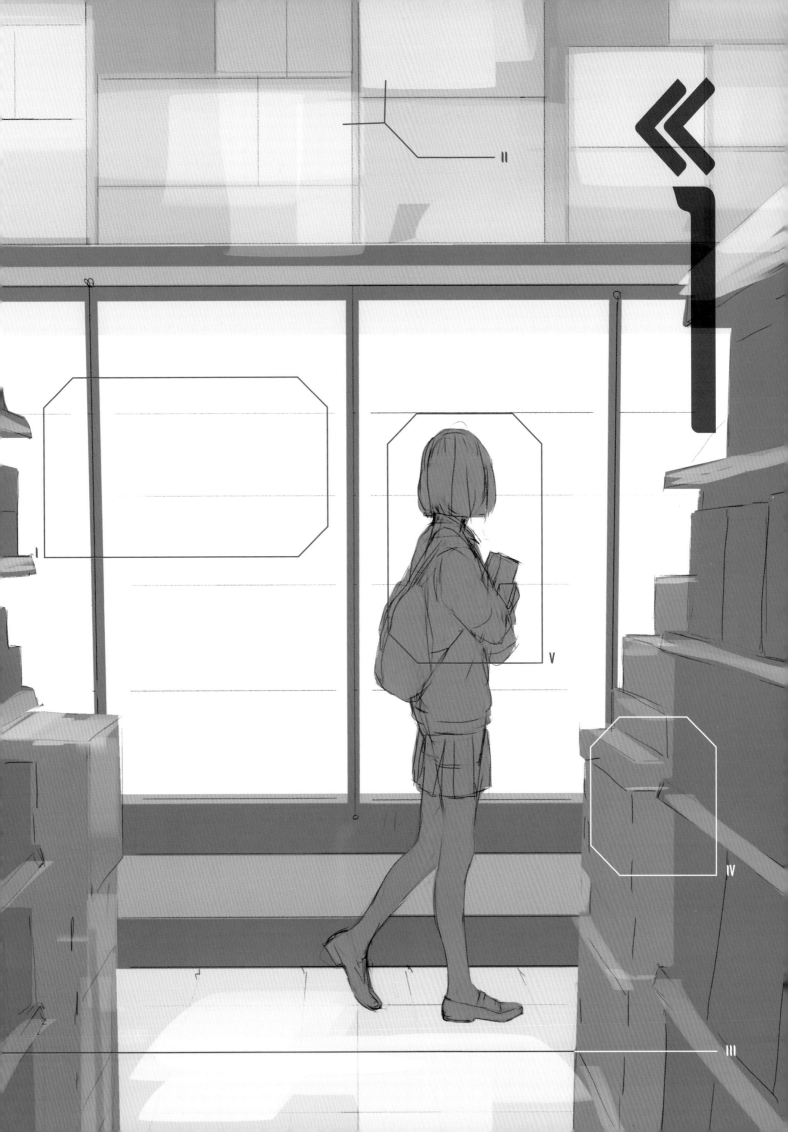

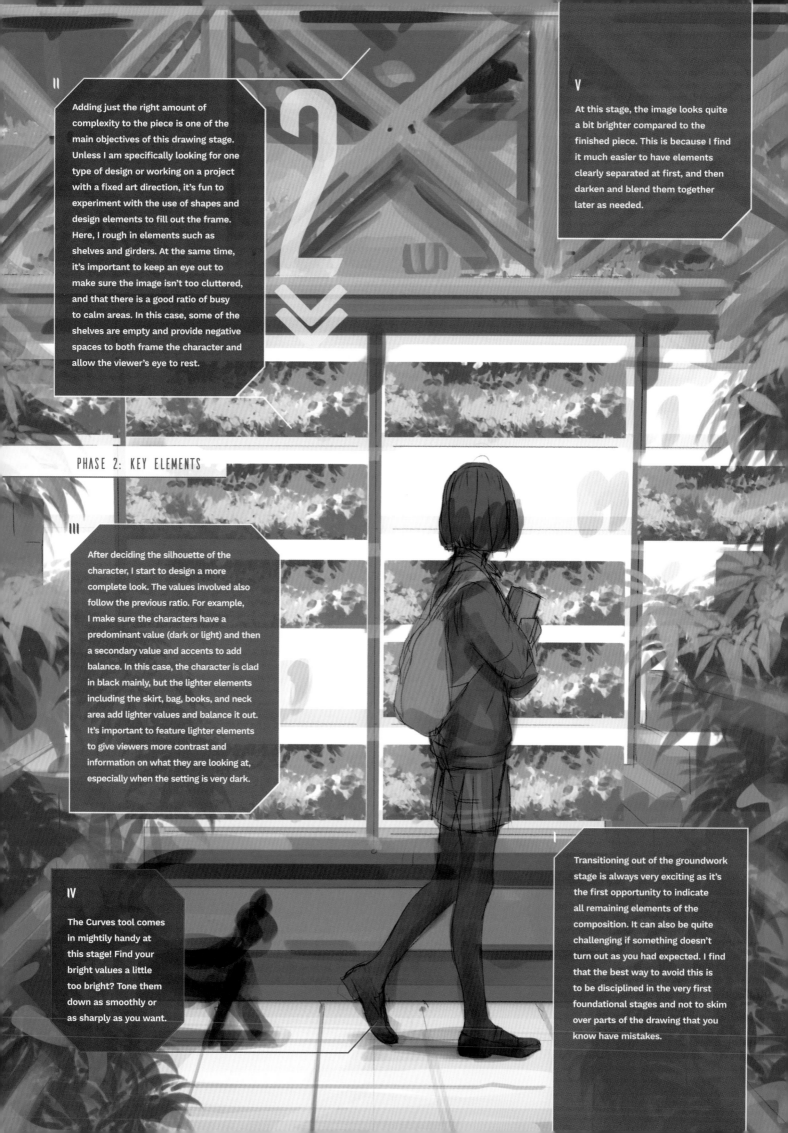

II

Adding just the right amount of complexity to the piece is one of the main objectives of this drawing stage. Unless I am specifically looking for one type of design or working on a project with a fixed art direction, it's fun to experiment with the use of shapes and design elements to fill out the frame. Here, I rough in elements such as shelves and girders. At the same time, it's important to keep an eye out to make sure the image isn't too cluttered, and that there is a good ratio of busy to calm areas. In this case, some of the shelves are empty and provide negative spaces to both frame the character and allow the viewer's eye to rest.

V

At this stage, the image looks quite a bit brighter compared to the finished piece. This is because I find it much easier to have elements clearly separated at first, and then darken and blend them together later as needed.

PHASE 2: KEY ELEMENTS

III

After deciding the silhouette of the character, I start to design a more complete look. The values involved also follow the previous ratio. For example, I make sure the characters have a predominant value (dark or light) and then a secondary value and accents to add balance. In this case, the character is clad in black mainly, but the lighter elements including the skirt, bag, books, and neck area add lighter values and balance it out. It's important to feature lighter elements to give viewers more contrast and information on what they are looking at, especially when the setting is very dark.

IV

The Curves tool comes in mightily handy at this stage! Find your bright values a little too bright? Tone them down as smoothly or as sharply as you want.

Transitioning out of the groundwork stage is always very exciting as it's the first opportunity to indicate all remaining elements of the composition. It can also be quite challenging if something doesn't turn out as you had expected. I find that the best way to avoid this is to be disciplined in the very first foundational stages and not to skim over parts of the drawing that you know have mistakes.

VALUE

Remember the ratios of value from the earlier stages, as they are really useful guides in deciding how you are going to manage the lighting setup.

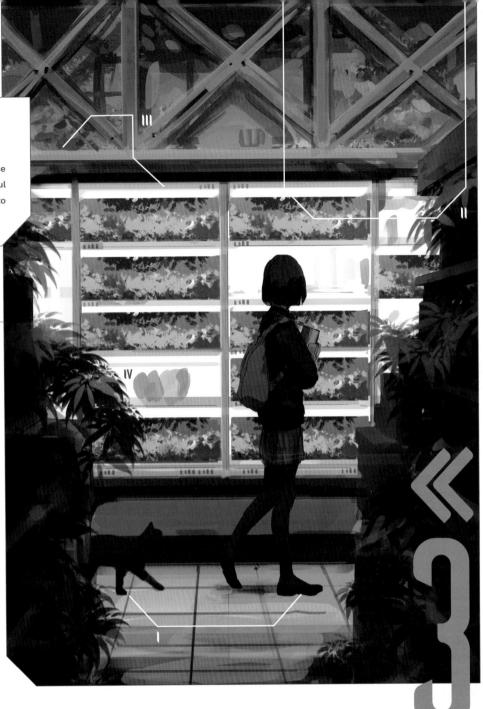

PHASE 3: CLEAN-UP

I After adding the cat in the previous step, I begin the clean-up of both characters. Areas in light or high contrast need to be detailed realistically. In this case, I make sure the characters are placed accurately on the ground plane.

II As colors are added, it's useful to give some discernible differentiation between the elements, even if the palette of the piece stays in a relatively compact range on the hue wheel. In this case, the yellowish cardboard boxes, slightly bluish shelves, and green plants add a pleasing variation. Just in the way that I prefer to work with value early on, I also find it easier to start off with colors a little on the bright side and then blend them smoothly as the piece progresses.

III One problem I face here is that the lighting is a little unclear. There seems to be both a strong light from above and a strong light source from the shelf, especially in this higher region of the image. I find it clearer to feature one dominant lighting setup, and then add in a weaker secondary light followed by accents.

IV While it's tempting to leave dark colors as just grey or black, making an effort to inject color often serves the composition well and offers the viewer more diverse visuals. In this case, the blue skirt and magenta bag add a touch of color to the design and help the character work harmoniously within the relatively colorful environment. As always, different situations require different solutions, so I keep alternative options in mind, just in case I need them.

ADJUSTMENT LAYERS

Adjustment layers are my best friends when I need to manage colors. Usually Color Balance works to harmonize the image colors as a whole while specific local colors can be managed via the Hue/Saturation tool. They can be found via the same button at the bottom of the Layers tab in Photoshop.

PHASE 4: ADJUSTMENTS

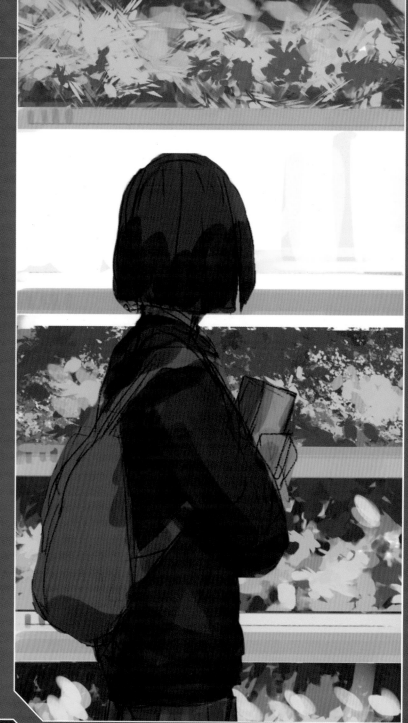

I After revisiting and adjusting the problem area in the top-left corner, the lighting looks much clearer. There is a bounce light from the ceiling, but the shelves are now decisively the primary light source. This not only separates the layers of elements in the composition, for example, making it clear that the lit shelves are in front and below the girders, it also saves a lot of rendering time finishing the otherwise lit area above. Imagination has more room to wander in dimly lit areas and this solution works perfectly to make the piece mostly dark and open to the viewer's interpretation.

II The very roughly painted foreground shelves work well as they are, without detail, because they are mostly in shadow. Instead of the clear definition the characters and brightly lit shelves require, I just need to loosely indicate light bouncing off a few protruding leaves to make this area work as part of a finished piece.

III The area of focus is always a challenging part of the composition to manage. Leaving the area too clean might give the image an unfinished look, while adding too much detail can make the design feel cluttered. Here, I aim to strike a balance. Substantial negative space around the character's head allows the silhouette to stand out, while filling in adjacent areas with detail prevents the setting from appearing too empty.

IV A readable silhouette can be created by simply indicating easily identifiable elements of a form and the viewer's mind will fill in the rest. Here, most of the cat's form blends in with the black plastic in the background, but the ears, tail, and feet are all we need to identify it, even when zoomed out. A good application of this observation is in breaking up silhouettes. While they highlight areas for attention, having a complete and unbroken silhouette also feels a little uncanny, as if the character is standing away from the background artificially.

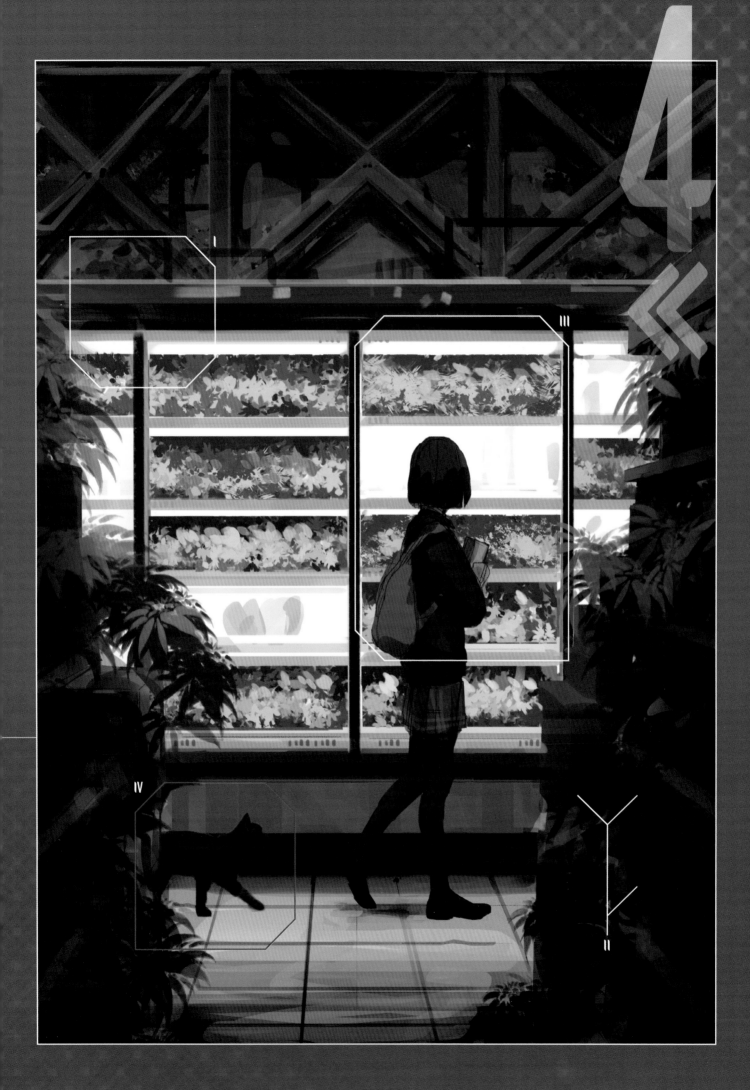

PHASE 5: REFINEMENT

I While applying the final polish to the piece, it's good to keep a lookout for bigger changes you can make. In this case, I want the plant shop to feel a little more futuristic than grungy, so I transform the floor material into an almost mirror-like surface. Super-reflective surfaces work extremely well when the lighting is dim, as rougher surfaces don't reflect enough light. Here, the bottom of the composition needs some bright values to contrast with the very dim area.

II Dimly lit girders and boxes suddenly contribute to the image much more when given a bit of light. In this case, the strange glowing bugs also add a wild touch to the otherwise almost clinical laboratory-like setting.

III Where possible, I find it worthwhile to work different materials into a scene. For example, I use a bright plastic for the horizontal shelves while the vertical supports are wrapped in black rubber. References can be very useful when approaching unfamiliar subject matter such as this.

IV In dark or dim areas, looser brushstrokes can be used and noise effects can offer the area subtle and quick detail. However, I take care to ensure that all surfaces are correctly aligned. The polish level remains low, but key mistakes are corrected to make sure the leaves read correctly.

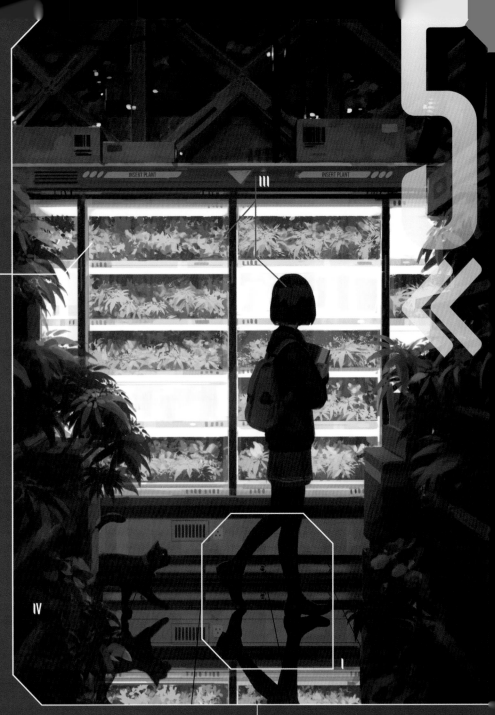

BALANCE

Finding balance is key. Too many high-contrast elements drawing attention off to the side of the composition can cause the main focus to be lost. Always consider how the audience will view the image on first glance.

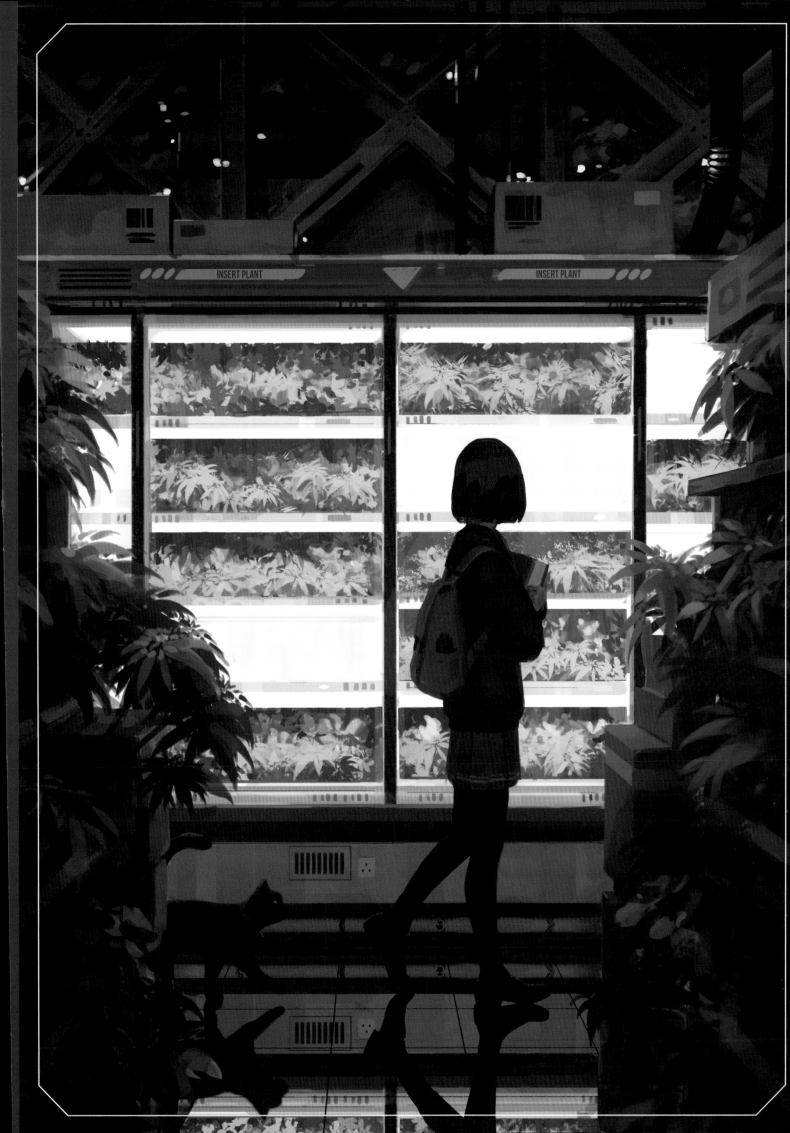

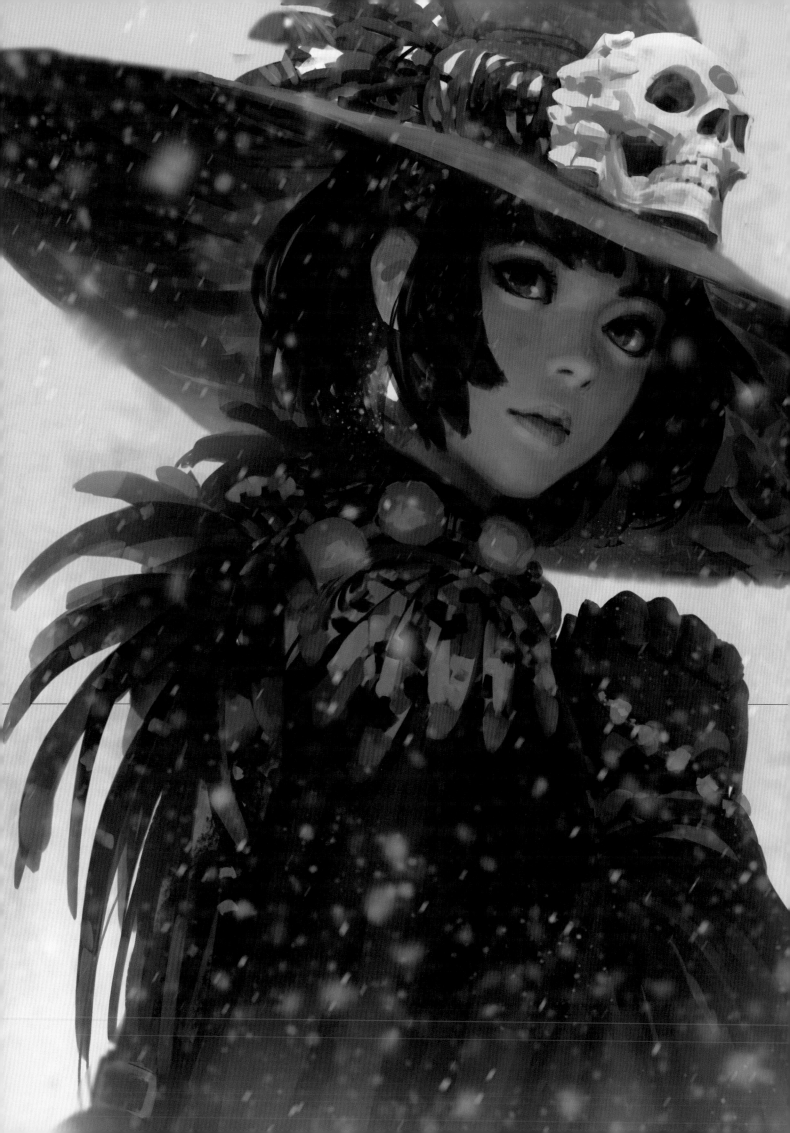

thank you

Having this book come together in such an amazing way isn't just a milestone or achievement that I can celebrate alone. So many people have been, and still are, a part of my journey – from my family and friends, to all my viewers (readers and buyers of this book, too!). Without their support, none of this would be possible.

I really appreciate my family for being so supportive, especially for accepting my difficult decision to leave university after one semester in order to pursue this tumultuous line of work. Despite no one in my family having any kind of art background, their support and trust in me to handle my own career and path has been huge. I'm so proud to be able to repay that trust, and the completion and success of this book is a big part of it.

My friends and peers are the best I could ask for; I consider myself very lucky to know them. Often I've heard people question art as a career very openly, sometimes with good reason, as it is a more niche field and not one that guarantees a "straightforward" living. I myself have had moments early on where I had doubts that this path was financially viable, but my friends always seemed to have a bold confidence in me, and that really helped me push forward.

My audience has been there every step of the way on this journey, since the very first time I posted a drawing to now, reading this book, and hopefully for the future to come as well. Knowing that there are people out there who enjoy my work is still, to this day, something I hold very dear. In fact, those people are the ones that helped make this book a reality; their overwhelming support and kindness will truly leave a deep impression on me for a long time to come.

Last but absolutely not least, I have to thank the 3dtotal team so much, from the massive amounts of editing, putting together all the logistics and frameworks for the Kickstarter campaign, and making this project possible at all, to finally just being such amazing people to work with.

It's almost difficult to put into words, but no matter whether it's posting personal drawings, or working on projects that will present my ideas and concepts in a different format later on, being able to share my creations brings so much joy, and it is something I truly look forward to continuing in the future.

Zheng Wei

SKULL
A mysterious feathery stranger with a skull-adorned hat crosses a snowy field. I really struggled with this piece at so many points, especially figuring out how to fit the pose and composition into a suitable environment. I'm sure I drew at least four complex variations before falling back onto the reliable snow field, which provides contrast and texture.

About 3dtotal

3dtotal Publishing is a trailblazing, creative publisher specializing in inspirational and educational resources for artists. Our titles feature top industry professionals from around the globe who share their experience in skillfully written step-by-step tutorials and fascinating, detailed guides. Illustrated throughout with stunning artwork, these best-selling publications offer creative insight, expert advice, and essential motivation. Fans of digital art will find our comprehensive volumes covering software including Procreate, Adobe Photoshop, and Pixologic's ZBrush. The dedicated, high-quality blend of instruction and inspiration also extends to traditional art. Titles covering a range of techniques, genres, and abilities allow your creativity to flourish while building essential skills.

Well-established within the industry, we now offer over 60 titles and counting, many of which have been translated into multiple languages around the world. With something for every artist, we are proud to say that our books offer the 3dtotal package:

LEARN | CREATE | SHARE

Visit us at 3dtotalpublishing.com

3dtotal Publishing is part of 3dtotal.com, a leading website for CG artists founded by Tom Greenway in 1999.

WONDER BEATRICE BLUE

SKETCH EVERY DAY WITH SIMONE GRÜNEWALD

COZY DAYS The Art of Iraville

the art of heikala *works and thoughts*

Sketch with Asia MANGA-INSPIRED ART AND TUTORIALS BY ASIA LADOWSKA

STILL JUST KIDDING BY CASSANDRA CALIN

the sketchbook of loish

the art of loish

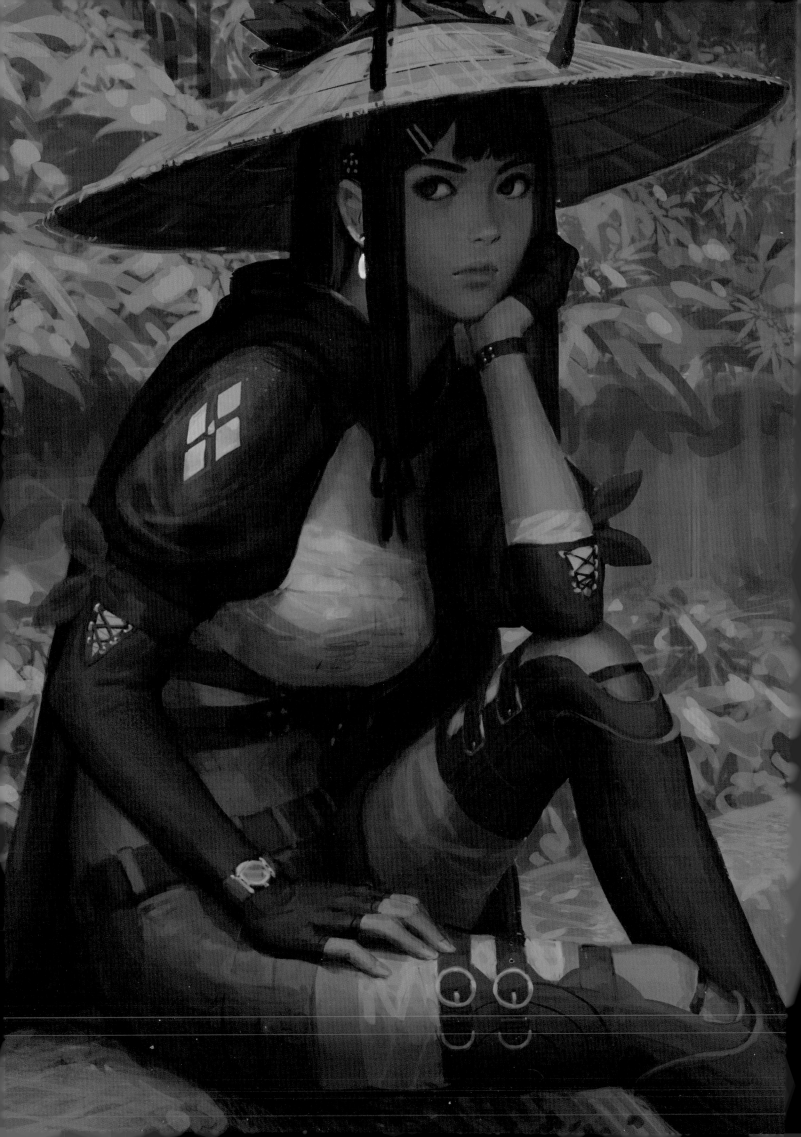